Adobe Photoshop Elements 6

Unleash the hidden performance of Elements

Mark Galer

WITHDRAWN

No longer the property of the Boston Public Library.
Sale of this material benefits the Library

I TO BE

Focal Press is an imprint of Elsevier Linacre House, Jordan Hill, Oxford OX2 8DP, UK 30 Corporate Drive, Suite 400, Burlington, MA 01803, USA

First edition 2008

Copyright © 2008, Mark Galer. Published by Elsevier Ltd. All rights reserved

The right of Mark Galer to be identified as the author of this work has been asserted in accordance with the Copyright, Designs and Patents Act 1988

No part of this publication may be reproduced, stored in a retrieval system or transmitted in any form or by any means electronic, mechanical, photocopying, recording or otherwise without the prior written permission of the publisher

Permissions may be sought directly from Elsevier's Science & Technology Rights Department in Oxford, UK: phone (+44) (0) 1865 843830; fax (+44) (0) 1865 853333; email: permissions@elsevier.com. Alternatively you can submit your request online by visiting the Elsevier web site at http://elsevier.com/locate/permissions, and selecting Obtaining permission to use Elsevier material

Notice

No responsibility is assumed by the publisher for any injury and/or damage to persons or property as a matter of products liability, negligence or otherwise, or from any use or operation of any methods, products, instructions or ideas contained in the material herein. Because of rapid advances in the medical sciences, in particular, independent verification of diagnoses and drug dosages should be made

British Library Cataloguing in Publication Data

A catalogue record for this book is available from the British Library

Library of Congress Cataloguing in Publication Data

A catalogue record for this book is available from the Library of Congress

ISBN: 978-0-240-52092-6

For more information on all Focal Press publications visit our website at: www.focalpress.com

Printed and bound in Canada

07 08 09 10 11 11 10 9 8 7 6 5 4 3 2 1

Working together to grow libraries in developing countries

www.elsevier.com | www.bookaid.org | www.sabre.org

ELSEVIER

BOOK AID

Sabre Foundation

for Dorothy

Picture Credits

Dorothy Connop, www.iStockphoto.com, Jakub Kazmierczak, Daniel Stainsby, Jennifer Stephens, Michael Wennrich.

Cover Image of Amanda Smorgan by Rodney Stewart.
All other images by the author.

Contents - part 1

Preface x
Getting Started x

Project 1
Crop and Correct
Page 2

Project 5
Contrast
Page 46

Project 2
Levels
Page 10

Project 6
Hue and Saturation
Page 62

Project 3

Camera Raw

Page 22

Project 7
Sharpening
Page 68

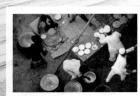

Project 4
Target Tones
Page 40

Project 8
Printing
Page 76

optimize

Contents - part 2

Project 1

Depth of Field

Page 92

Project 2
Shafts of Light
Page 102

Project 3

Black and White

Page 112

Project 4
Toning
Page 120

Project 5
Character Portrait
Page 130

Project 6
Glamor Portrait
Page 144

Project 7

Motion Blur

Page 160

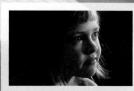

Project 8
Low Key
Page 176

Project 9
Channels
Page 184

Contents - part 3

Project 1
Creative Montage
Page 196

Project 5

Displacement
Page 244

Project 2

Replacing a Sky

Page 208

Project 6
Preserving Shadows
Page 256

Project 3

High Dynamic Range
Page 218

Project 7
Photomerge
Page 266

Project 4
Creative Type
Page 232

Project 8
Hair Transplant
Page 280

Jargon Buster Page 294

Shortcuts Page 298

Index Page 300

Contents - dvd

The DVD is a veritable treasure trove of supporting files for the projects in this book as well as a resource for your own creative projects. Just transfer the supporting files to your Photoshop Elements Organizer (see 'Getting Started - page xvii') for fast access to the images and movies. The movies are an invaluable resource, allowing you to start, stop and rewind so that the skills can be quickly and easily acquired at your own pace. The DVD also contains multilayered image files (PSDs) of the completed projects, uncompressed TIFF files with saved selections, Raw files and high-quality 16 Bits/Channel files. Loadable presets are also available to enhance your software together with a rich stock library of royalty-free images.

THE DVD PROVIDES EXTENSIVE SUPPORT IN THE FORM OF:

- Over five hours of movie tutorials to guide you through all of the projects in this book. You may need to install the QuickTime movie player from the supporting DVD to watch the movies from the Organizer within Photoshop Elements 6.
- · High-resolution, high-quality JPEG images to support all of the imaging projects.
- Full-resolution TIFF images with 'saved selections' for users interested in completing the projects in the least amount of time whilst achieving maximum quality.
- · Camera Raw and 16 Bits/Channel files.
- Five high-resolution images courtesty of iStockphoto.com.
- Multilayered Photoshop documents (PSD files) of completed projects.
- · A stock library of 100 high-resolution, royalty-free images for creative montage work.
- Adobe presets (Layer Styles and Gradients) to enhance the performance capabilities of your Adobe Photoshop Elements software.
- · Maximum Performance Action files to fast-track your workflows and editing tasks.
- Printable PDF file of keyboard shortcuts to act as a quick and handy reference guide to speed up your image-editing tasks.

Preface

The creative projects in *Adobe Photoshop Elements 6 Maximum Performance* are designed to provide you with the essential techniques for professional quality editing - without the need to upgrade to the full version of Photoshop. The projects are designed to unleash the hidden potential of the budget software through a series of workarounds, advanced techniques and loadable presets. Each creative project is supported by a QuickTime movie tutorial and high-resolution images - all available on a supporting DVD. The DVD contains full and comprehensive movie support together with a library of royalty-free, high-resolution stock images for self-initiated creative projects. Each project is designed to build the skills required so that any photographer can attain the status of 'imaging guru'. The magic is deconstructed using a series of easy to follow step-by-step projects using large clear screen grabs and jargon-free explanations. Completed multilayered project files are also available on the DVD for those users who like to have access to the completed project for comparison and analysis.

This book will act as your guide to some of Elements' less well-known and more powerful post-production editing techniques. It will enable you to attain the same high-quality images as professionals using the full version of Photoshop. This book makes Elements a viable alternative to the full version of Photoshop for imaging professionals and enthusiasts looking to extract the maximum performance from their software.

This book is primarily concerned with the post-production stage of the creative process and demonstrates how this part of the creative process can optimize and enhance the original capture or create an entirely new image out of several images (the creation of a composite photograph or photomontage). Where appropriate the book will discuss measures that can be taken by the photographer in pre-production or production to enable the highest-quality outcome as a result of the post-production stage. To ensure the best quality image from our sophisticated and professional post-production techniques we should ensure that we access quality Raw materials whenever possible - 'quality in, quality out'. The vast majority of the JPEG images on the supporting DVD were processed from either camera Raw files or high-quality 16 Bits/Channel scans. Many of the images featured in this book were captured using budget digital SLR and fixed lens digital cameras, affordable cameras used to capture information-rich images.

The term 'non-destructive image editing' refers to the process of editing an image whilst retaining as much of the original information as possible and editing in such a way that any modifications can be usually undone or modified. Editing on the base layer of the image can often mean that modifications to the pixel information cannot be undone easily or at all, e.g. sharpening an image file cannot be undone once the file has been saved and flattened. It is, however, possible to sharpen non-destructively in post-production so that the amount of sharpening can be altered when the file is opened at a later date. This latter approach would be termed 'non-destructive'. When capturing images with a digital camera many users do not realize that if the JPEG file format is used image processing starts in the camera. Color correction, contrast adjustment, saturation levels and sharpening all take place in the camera. If maximum quality is to be realized the Raw format should be chosen in preference to the JPEG format, if possible. The post-production decisions can then be left to the Adobe software, allowing the user many more options.

Photoshop Elements replaced 'Photoshop LE' (limited edition - as in limited function and not availability); both of these software packages share something in common - they offer limited elements of the full version of Photoshop. Adobe strips out some of the features that would be the first port of call for some professional image editors and photographers, but this does not mean that the same level of control cannot be achieved when using the budget software. Professional post-production image editing does NOT have to be compromised by using Photoshop Elements. With editing images there is usually more than a single way to reach the destination or required outcome. With a good roadmap the Elements user can reach the same destination by taking a slightly different course. These roads are often poorly signposted, so are often inaccessible to the casual user of the software. This book will act as your guide to enable you to attain a broad range of sophisticated post-production image-editing skills through a series of creative projects designed to circumnavigate the missing features.

Photoshop Elements IS a viable alternative to the full version of Photoshop for most professional image-editing tasks. Many professionals may disagree with this statement, as a quick glance at the Elements package may result in a long list of the elements that are missing rather than taking a long hard look at the elements that remain (a case of 'the glass is half empty' rather than 'the glass is half full'). After a decade of professional image editing I have learnt that there is more than one way to create an image. There is no 'one way'. In short, it is possible to take a high-quality image file and work non-destructively to create an image which is indistinguishable from one that has been optimized using the full version of Photoshop. This book does not aim to outline every tool in your kit (a paintbrush doesn't really require an owner's manual and some of the automated features are sometimes more trouble than they are worth). It just deals with how to adapt the tools you do have to perform the tasks you didn't think you were able to. It aims to show you that Elements is better equipped than you were led to believe. Photoshop Elements really is the proverbial wolf in sheep's clothes.

mark galer

ocation Image by Dorothy Connop

Getting Started

Most users of this book will have some experience of digital imaging and Photoshop Elements, but just check the following to make sure all is in order before you start.

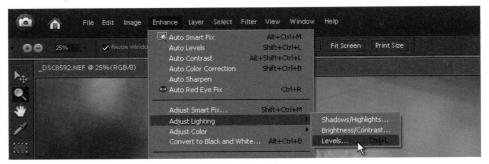

Following orders

The commands in Photoshop Elements allow the user to modify digital files and are accessed via menus and submenus. The commands used in the projects are listed as a hierarchy, with the main menu indicated first and the submenu or command second, e.g. Main menu > Command. For example, the command for applying a Levels adjustment would be indicated as follows: Enhance > Adjust Lighting > Levels. If you get stuck or are unclear, watch the movie on the supporting DVD and follow my mouse cursor to help you find what you are looking for.

Calibrate your monitor

If your images are going to look good everywhere - not just on your own monitor - it is advised that you calibrate your monitor (set the optimum color, brightness and contrast). I recommend that you use a 'Hardware White Point' or 'Color Temperature' of '6500° K (daylight)' and a Gamma of 2.2.

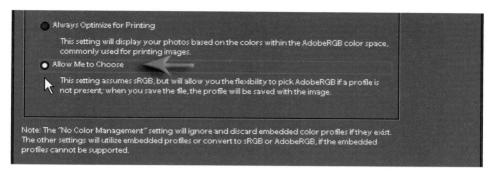

Color Settings

The colors are kept consistent between devices such as cameras, computers and printers through the use of color profiles. If you intend to print your images you would be advised to go to Edit > Color Settings and then click on the radio button that says 'Always Optimize for Printing'. Elements will now use the larger Adobe RGB profile instead of the smaller sRGB profile.

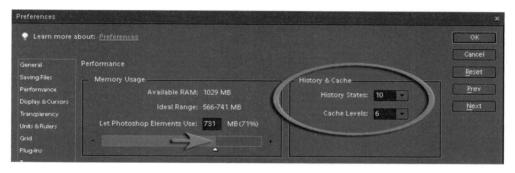

Memory

You will be working on images in excess of 5 megapixels (the supporting DVD provides high-resolution images for ALL of the creative projects in this book). This professional level of image editing can place a strain on a computer's working memory or RAM. It is advised that you install at least 512 MB of RAM (1 gigabyte or more is not considered excessive when editing very large image files) so that the image editing you are about to undertake does not begin to crawl. Shut down any other applications that you are not using so that all of the available memory is made available to Photoshop Elements. Photoshop Elements keeps a memory of your image-editing process, which it calls the 'History States'. The default setting in the General Preferences (Edit > Preferences > General) is 50 History States. Allowing the user to track back 50 commands, or clicks of the mouse, can again place an enormous strain on the working memory. I would recommend that you lower this figure to 20 for most editing work. This can be readjusted without restarting the software should you wish to increase Photoshop's memory for your editing actions. Just remember that the more memory you dedicate to what you have just done, the less you have available for what you are about to do. In Preferences > Performance you will see the Available RAM and the Ideal Range that can be assigned to Photoshop Elements. Adjust the slider so that you are using the top of the suggested range. Photoshop Elements will also be using your 'scratch disk' or 'hard drive' in the image-editing process so be sure to keep plenty of gigabytes of free space available.

Give yourself some elbow room

I recommend that you keep the 'Photo Bin' and 'Palette Bin' closed until you need them (go to Window > Palette Bin). This will maximize the area on your screen for viewing the image you are editing. Only the Layers palette is used all of the time in advanced image editing. In the default mode it is stacked with the other palettes in the Palette Bin. Locate the Layers palette and drag it out into the working area before closing the Bins. Similarly the Tools palette on the left side of the screen can be dragged to new locations so that it can be close to the action. I prefer to view the image in a window rather than in 'Maximize' mode. This allows me to see the additional information that is displayed in the title bar together with the magnification. I like to view my images at 50% or 100% (actual pixels) to gain a more accurate idea of the image quality. This information is also available in the Navigator palette but, as I use 'keyboard shortcuts' for moving and zooming in and out of images, I usually keep this palette closed as well.

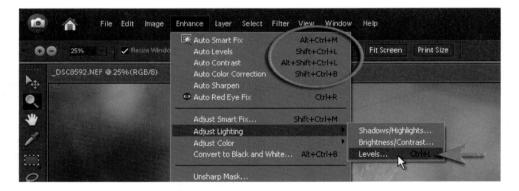

Keyboard shortcuts

Many commands that can be accessed via the menus and submenus can also be accessed via keyboard shortcuts. A shortcut is the action of pressing keys on the keyboard to carry out a command (rather than clicking a command or option in a menu). Shortcuts speed up digital image processing enormously and it is worth learning the examples given in the study guides. If in doubt use the menu (the shortcut will be indicated next to the command) until you become more familiar with the key combinations. See the 'Keyboard shortcuts' section at the end of the book for a list of the most frequently used shortcuts.

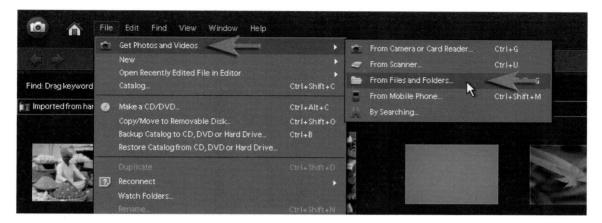

Accessing the support images and movies

Open the Organizer from the Photoshop Elements welcome screen or click on the Organize icon directly above the Options bar in the Edit workspace. Install the DVD and click on the 'Organize and Edit' option if asked. Alternatively, go to the File > Get Photos and videos in the Organizer workspace (the little camera) and choose the 'From Files and Folders' option. Then locate the DVD (My Computer > Maximum Performance) and the resource folder you want to import. The JPEG files are high quality and will not take up much space on your hard drive. The TIFF files take up a little more room on your hard drive but have the advantage of containing saved selections that can be used to speed up the completion of the projects.

IMPORTANT: Download one folder of images or movies at a time so they are separated in the Organizer space. You may need to install the QuickTime movie player that is available on the DVD before watching the movies in the Organizer workspace.

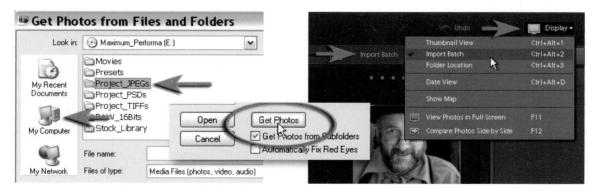

When the Get Photos and Videos dialog box opens deselect the 'Automatically Fix Red Eyes' option and then click on the Get Photos button. Your images or movies will be imported and organized. Click on the 'Import Batch' option from the Display menu in the Organizer window (top right-hand corner) to see the images as a collection. Use the keyboard shortcut Ctrl + I to open any image in the Editor workspace. Double-click on any movie icon to watch the movie within the Organizer workspace.

Maximum Performance actions

On the DVD is a folder titled MP6_Actions. This folder contains a series of files that may enable you to perform automated editing procedures for fast-tracking some of the skills presented in this book - a single click of the mouse that instructs Photoshop Elements to conduct an automated series of steps in just a few seconds. These actions may complete the editing task or just fast-track some of the repetitive editing procedures with the minimum of fuss. The actions may be installed using the Max performance installer package (automated installation) on the DVD or manually by adding a series of XML files that classify the new content for Elements 6 and then adding the new content itself.

Note > Watch the video tutorial inside the MP6_actions folder for detailed guidance on this procedure. After installation you must restart Photoshop Elements. Photoshop may take more than 10 minutes to rebuild its database before the new content appears in the Effects palette.

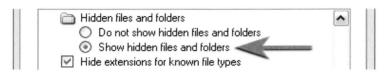

IMPORTANT: Some of the folders you need to find in order to add these files manually are 'hidden'. To find these folders you MUST select 'Show hidden files and folders' in the 'Folder Views' advanced settings of your computer's operating system.

DISCLAIMER: The Maximum Perfomance actions will only work when using an English language version of Photoshop Elements. There is no guarentee that the Maximum Performance actions can be made to work on your computer. Every effort has been made to ensure that these actions can be implemented on standard systems running either Windows XP or Windows Vista, but it is possible that a particular system setup or configuration may prevent these actions from working. Consult your local IT consultant if in doubt about any of these procedures.

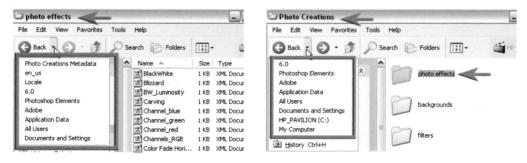

Locating the folders in Windows XP for manual installation

If you install the new content manually you will need to locate two folders on your computer. You can find the folder for the xml files in <windows volume>:\Documents and Settings\All Users\ ApplicationData\Adobe\Photoshop Elements\6.0\Locale\cinstalled locale>\Photo Creations Metadata. The content folder is located at <windows volume>: (usually C:)\Documents and Settings\All Users\ Application Data\Adobe\Photoshop Elements\6.0\Photo Creations\Photo Effects.

Note > Restart Elements after installing new content.

Locating the folders in Windows Vista for manual installation

Like application data on XP, program data resides in a hidden folder, so the user will need to show hidden folders to find these folders. The XML files are placed in the Locale file: <windows volume>: (usually C:)\Program Data\Adobe\Photoshop Elements\6.0\<installed locale>\Photo Creations Metadata. The Photo Creations folder on Vista is in C:\Program Data\Adobe\Photoshop Elements\6.0\Photo Creations.

Loading the Maximum Performance actions manually

- 1. Drag the contents of the MP6_XML folder into the Photo Effects folder located in the Photo Creations **Metadata** folder (do not place the folder only the contents).
- 2. Drag the contents of the MP6_Actions folder into the Photo Effects folder in the **Photo Creations** folder (do not place the folder only the contents).
- 3. Delete the MediaDatabase.db3 and ThumbDatabase.db3 files (see illustration above).
- 4. Launch Photoshop Elements and wait while the Photoshop Elements database rebuilds itself (this may take more than 10 minutes).
- 5. In the Effects palette click on the Photo Effects icon.
- 6. From the menu choose MP6 Actions.

PROBLEMS: If the MP6_Actions do not appear check the correct installation folders were selected. Ensure the two database files were deleted before restarting Photoshop Elements. If you cannot locate the required folders use the search option of your computer, ensuring that you have the 'search for hidden files and folders' option selected.

Deleting content

To delete actions or content such as layer styles you must delete the content and also the 'MediaDatabase' file in the 'Locale/<Installed Locale>' folder and the 'ThumbDatabase' file in the '6.0' folder. When Photoshop Elements is restarted the database will be rebuilt using the remaining content installed. Rebuilding the database may also help to locate any new content that has been installed.

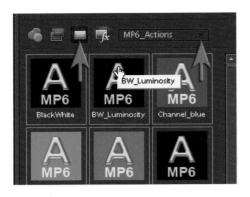

When you see the Maximum Performance Action logo in Part 2 and Part 3 of this book certain steps can be fast-tracked with just a few clicks of your mouse.

Using the actions

The actions can be accessed through the Effects palette. Click on the Photo Effects icon in this palette and choose MP6_Actions from the menu. Click on an action and then click the Apply button. Some of the actions may require opacity changes in the layers to fine-tune the effect or some further work as in the case of the Dodge and Burn action. Try combining various actions to create different effects.

Note > The masking actions are intended for the montage projects outlined in Part 3 of this book and will only work when a second layer named Layer 1 is sitting above the background layer.

BlackWhite and **BW_Luminosity** - converts color images into a black and white images using non-destructive adjustment layers or blend modes (*see* Module 2, Project 3, and Module 2, Project 8).

Channel_Blue, Channel_Green and Channel_Blue - extracts the red, green or blue channel information from a color image and places it as a gray layer above the background layer (*see* Module 2, Project 9).

Dodge-Burn - places a gray layer in the Overlay blend mode that can be used for non-destructive dodging and burning.

Mask_black and Mask_white - can be used to fast-track extracting a subject from a black or white background (*see* Module 3, Project 8).

Mask_HDR - fast-tracks the montage of two separate exposures to achieve an image with a higher dynamic range (*see* Module 3, Project 3).

Sharp_Print and Sharp_Screen - applies a composite layer and sharpens the image for screen or for print.

Softer_3-6MP and Softer_6-12MP - creates smooth tone images that are either 3 to 6 megapixels or 6 to 12 megapixels (*see* Module 2, Project 6).

Tone _1, Tone_2 and Tone_3 - creates split tone images using a non-destructive adjustment layers and gradient presets (*see* Module 2, Project 4).

Vignette_dark and Vignette_light - darkens or lightens the corners of an image using a non-destructive layer and blend mode.

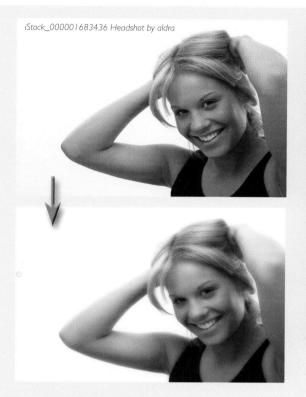

MAXIMUM PERFORMANCE ACTIONS

This stock image (courtesy of www.iStockphoto.com) was created using multiple actions. The soft focus effect was first applied and then followed by the Vignette, Dodge and Burn, Split Tone and Sharpen actions. A Transform command was used on the vignette and a little painting in the Dodge and Burn layer was needed to brighten the teeth and eyes in this 3-minute makeover.

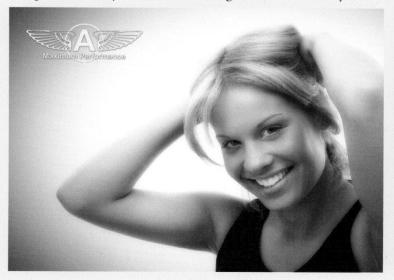

part.

optimize

Project 1

Crop and Correct

This simple project will unmask some of the hidden features of the Straighten and Crop tools, enabling you to optimize your images for print or screen viewing. You will learn that you can straighten, resize and crop your image with just a few clicks and that the Free Transform command can correct any unnatural perspective resulting from using wide-angle lenses. Quality starts here.

Ensure the horizon lines of your images do not resemble ski slopes by making use of the fabulous Straighten tool

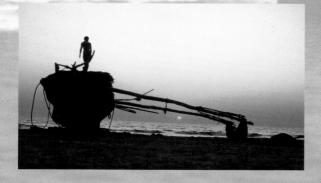

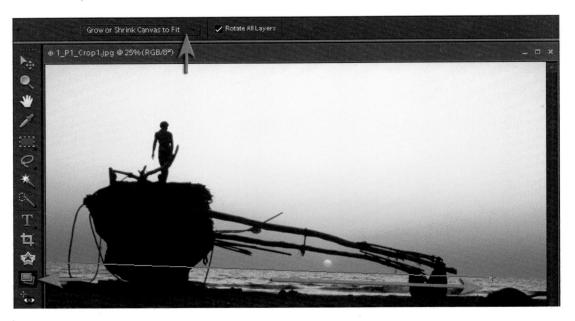

1. Open the image from the supporting DVD in the Standard Edit workspace. Click on the 'Straighten tool' in the Tools palette. Select the option 'Grow or Shrink Canvas to Fit' in the Options bar above the image window. Now click on the horizon line and, with the mouse button held down, drag a line along the horizon line of the image. The image will automatically be straightened.

2. Select the Crop tool in the Tools palette and view the options in the Options bar. When we size an image we should select the width and height in pixels for screen or web viewing, and in centimeters or inches for printing. Typing in 'px', 'in' or 'cm' after each measurement will tell Photoshop Elements to crop using these units. If no measurement is entered in the field then Photoshop Elements will choose the default unit measurement entered in the preferences (Preferences > Units & Rulers). The preference can be quickly changed by right-clicking on either ruler (select 'View > Rulers' if they are not currently selected).

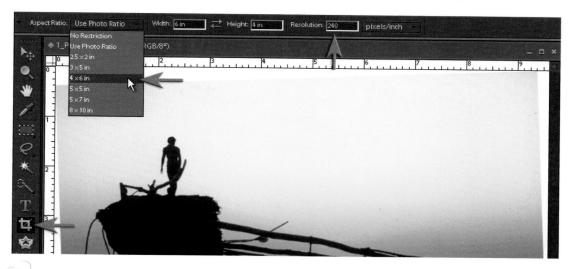

3. The action of entering measurements and a resolution at the time of cropping ensures that the image is sized (pixel dimensions altered) and cropped (shaped) in one action. Entering the size at the time of cropping ensures the aspect ratio or shape of the final image will match the printing paper, photo frame or screen where the image will finally be output.

Note > If an aspect ratio or both width and height measurements are entered into the measurement fields, the proportions of the final crop will be locked. This new aspect ratio may differ from that of the original capture and this in turn may prevent you from selecting either the full width or full height of the image, e.g. if you have entered the same measurement in both the width and height fields the final crop proportions are constrained to a square.

PERFORMANCE TIP

The process of cropping an image to a specific size and resolution will change the total number of pixels in the image file to the optimum number of pixels for the image size and output device, no more, no less. If you need to crop to a specific shape, but are uncertain as to whether it is destined for screen or print, you should leave the 'Resolution field' in the Options bar blank. This will maintain the original number of pixels until you know where this image is going to be presented. You also have the option of choosing an alternate shield color when cropping images by going to 'Edit > Preferences > Display and Cursors > Crop Tool'.

4. Drag the cropping marquee over the image to create the best composition. Drag any of the corner handles, or click and drag inside the crop marquee, to adjust the composition and then commit the crop by clicking on the check mark or double-clicking inside the crop marquee. The image should get smaller on the screen as excess pixels are discarded. If the image grows on screen, Photoshop Elements is upsampling (adding pixels). This is caused by the dimensions in the Crop tool options being larger than the size of your original image, and can reduce the quality. It is important to save this cropped version using a different name to ensure the higher resolution master file is preserved.

PERFORMANCE TIP

To use the Straighten tool to straighten a vertical rather than a horizontal, hold down the Ctrl key while you drag the line.

You can also straighten an image using only the Crop tool. First create the crop marquee on the edge of a horizontal or vertical line within the image. Move the cursor to a position just outside one of the corner handles of the cropping marquee and when the double-headed curved arrow appears you can rotate the cropping marquee to align it with the horizontal or vertical within the image. Then extend the cropping marquee by dragging one of the corner handles.

Note > The Straighten tool is disabled for 16 Bits/Channel images.

Correct Camera Distortion

When a camera is tilted up or down with a short focal length lens (wide angle) the verticals within the image can lean excessively inwards or outwards (converging verticals). Professional architectural photographers use cameras with movements or special lenses to remove this excessive distortion. To correct perspective use the Correct Camera Distortion filter.

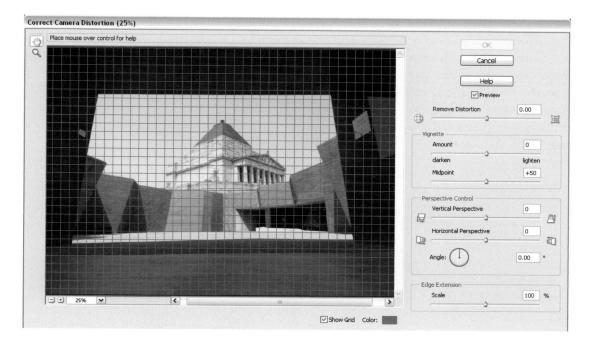

1. Select Filter > Correct Camera Distortion. The grid should be on by default and you can change its color if it's not clear against the subject you are viewing. The top slider in this dialog box corrects either barrel distortion or pincushion distortion, which sometimes results when using the extreme focal lengths of the zoom lens. Both result in curved straight lines which are usually most noticeable with the curvature of a horizon line when using a short focal length lens (wide angle).

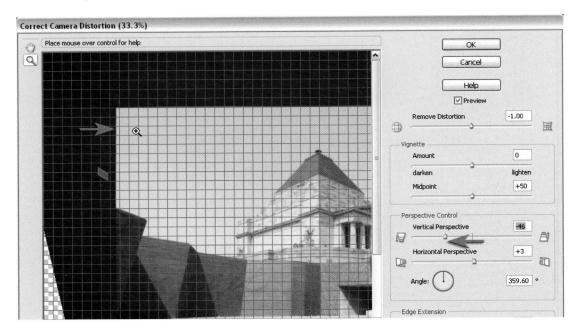

2. To render all the vertical lines in the image used in this illustration parallel, drag the Vertical Perspective slider in the Perspective Control section of the dialog box to the left. Use the grid lines to align the verticals within the image. Use the keyboard shortcuts to access the Zoom tool (Control + Spacebar and Alt + Spacebar) if you need to zoom in on a vertical to check the accuracy of the correction. You may need to alter the angle to ensure absolute accuracy.

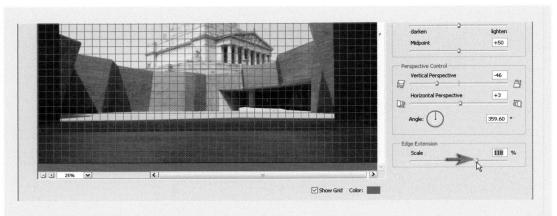

PERFORMANCE TIP

As the corrected image is narrower on one or more edges after using the Remove Distortion or Perspective Correction sliders you can use the Edge Extension slider at the bottom of the dialog box so that the corrected image fills the image window. As this process involves Photoshop adding pixels to grow the image you may want to crop the image instead of scaling the image in this dialog box.

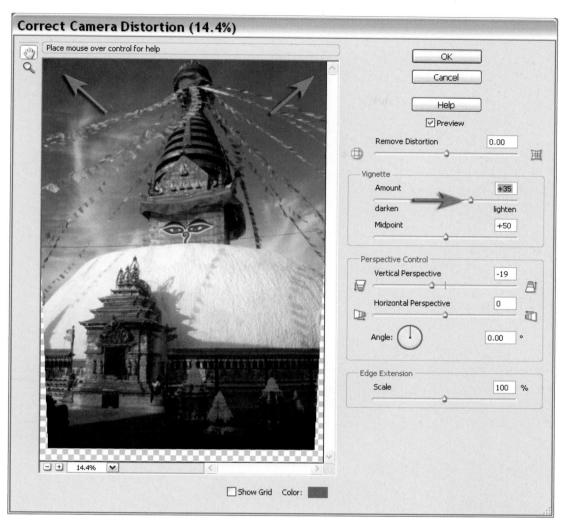

3. The Correct Camera Distortion filter also has control over vignetting (where the tone in the corners of the image appears darker or lighter than the overall tones within the rest of the image). Vignettes are often used for creative reasons to fade an image to black or white at the edges and corners. Some wide-angle lenses vignette when used at very wide apertures and these effects can be reduced or removed using the sliders in the Correct Camera Distortion dialog box. In the example image above a value of +35 is used to remove the darkened corners of the image that resulted from using a wide-angle lens. The Midpoint slider should be used to control the width of the correction, i.e. raising the value of the Midpoint slider will restrict the lightening effect to just the extreme outer regions of the image window whilst lowering the value will broaden the lightening effect. In later projects the Correct Camera Distortion filter can be used to creatively darken the corners of images to increase the sense of drama and mood.

Levels

This project will guide the user safely through the tricky mountain passes of this primary and essential technique used to achieve quality digital images. The adjustment feature is called 'Levels', but when you are presented with the virtual mountain range on opening the Levels dialog box, you begin to wonder what the clever people at Adobe were thinking of when they gave this indispensable adjustment feature its wonderful name (I think it's called irony).

Levels - optimized quality starts here

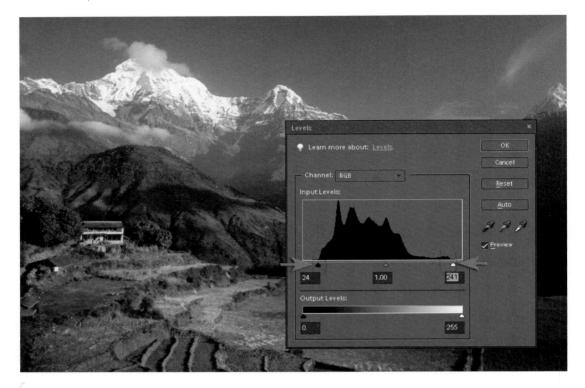

1. In the illustration above one might be forgiven for thinking that the black peaks in the dialog box are an indication of how high the mountains are in the image, but no, the pixel mountains (called a histogram) are really an indication of how many pixels of each tone are present in the image. If the image is dark then the pixel mountains or histogram in the dialog box will be higher on the left side. If the image is very light, the histogram will be taller on the right side. The first step in nearly all image-editing tasks is the need to optimize the tonality or dynamic range of the image by adjusting the Levels.

Finding your levels > To open the Levels dialog, go to the Enhance menu and choose Adjust Lighting > Levels.

If you are a newcomer to this dialog box you may simply want to click on the Auto button and then click OK. This simple procedure ensures the tonality of the digital image starts with a deep black and finishes with a bright white for optimum contrast and visual impact. If you want to perform the task manually click on the black slider underneath the mountain range (the triangle on the left) and drag it to where the histogram begins to slope upwards on the left side. If you are now looking for the little triangle at the foot of the photographic mountains instead of the virtual ones, then I suggest you go and lie down for a moment and come back refreshed. Do the same with the white slider on the right and you are almost finished. Click and drag the gray slider in the middle to make the image brighter or darker (depending on which way you drag the slider). If you want to start impressing the neighbors then you may like to start calling the gray triangle the 'Gamma slider'.

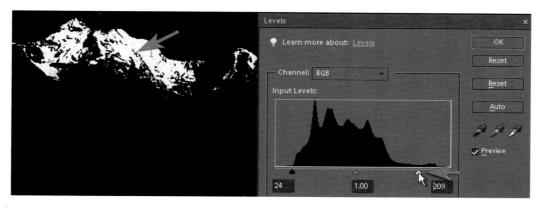

2. If you drag the sliders too far you will lose or clip information from the image file. Shadows will become black and highlights will become white (this is called clipping the shadows or highlights). Your detail will have sunk without a trace into the black holes of our virtual valleys (called level 0) or have been pushed off the top of the virtual peaks (called level 255). If you fear the numbers 0 and 255 (which every self-respecting photographer should) you could try the following tip. Hold down the Alt key and drag the Shadow or Highlight slider towards the mountains (your image will disappear momentarily but fear not). As you move the slider closer to the middle, colors will start to appear in your main image window when information is being lost. Move the sliders back until these colors disappear, but no farther. If colors are still appearing in the image window with the sliders all the way back to the edge of the histogram then your image was either underexposed or overexposed by the camera. If you are really unlucky you will have lost detail both in the shadows and in the highlights as a result of the photographer's worst enemy - excessive contrast. Not even the magic called Photoshop Elements can dig you out of this hole, my friend.

3. Users who have acquired images at a higher bit depth using Camera Raw or a scanner set to 48-bit color should now drop their images to 8 Bits/Channel (choose Image > Mode > 8 Bits/Channel.). The secret to intelligent color adjustment is that the grass may 'really' be greener on the other side. Until you have seen the other side how will you know? With this in mind Adobe has given us 'Color Variations'. It is a simple case of 'if you see something else you like - you can have it'.

16-bit editing

16-bit editing has been a reality for Elements users since version 3.0. If you have acquired your image from the Camera Raw dialog box or a 48-bit scanner then you will need to drop the bit depth to 8 bits to complete the following steps because, although Elements supports 16-bit editing, it does not support the use of adjustment layers with which to edit the bit-rich pictures. By adjusting the levels of the image in 16 bits per channel before dropping to 8 bits per channel, you'll retain maximum quality with the 16-bit capable tools in Photoshop Elements.

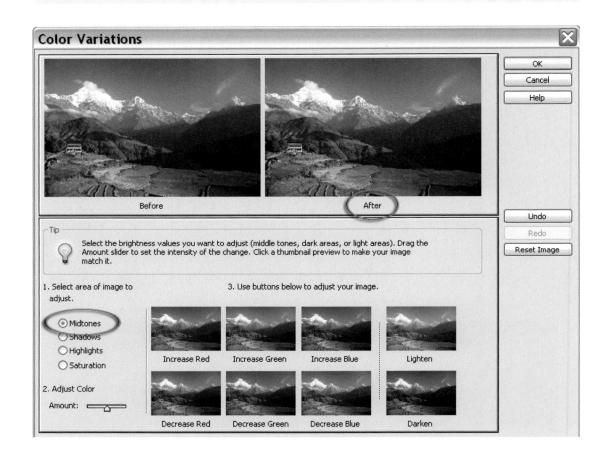

4. From the Enhance menu choose 'Variations' from the Adjust Color menu. Yes, I know it's a big box. It needs to be this size so they can get all of the lovely colors in. Just follow the numbers in the box. Start by selecting the Midtones radio button and then adjust the intensity amount in step 2 until you can see the flavored thumbnails in step 3 look about right (not too loud please), and then click on the one you like (color-blind males may need a woman's touch just about now). Then click OK. For those who have found bliss you can stop this project now - or for those who still want to take another look at that grass, press on to step 5.

Warning > Clicking on anything other than 'Midtones' in this dialog box may be harmful to the health of your pixels that you so lovingly looked after in the Levels dialog box.

5. We have just completed our global adjustments (all of the pixels in the image have changed in brightness and color). We will now set about changing just a select few. To isolate pixels for a 'localized adjustment' we have to select them with (yes - you guessed it) a selection tool. We will start with the very wobbly Lasso tool (there are three in the stack so make sure you get the right one - click, and hold your mouse button down, on the Lasso tool to see your options). Now draw (yes I know drawing isn't everybody's strong point) along the terraced fields in the foreground of the image (don't let go of the mouse button - not even when you get to the end of the field) and then circle (what else would you expect to do with a lasso?) beneath the image and around until you get back to the point where you started - now let go. A selection border will appear around the area you lassoed - we call the little moving lines 'marching ants'. Don't worry about how wobbly your drawing is at this stage.

Note > If you did happen to let go (even though I told you not to) before you had finished the selection, go to the Select menu, choose Deselect, and then start again (this time paying closer attention to not letting go of your mouse button).

Now if your drawing (like mine) leaves a lot to be desired, we can fix it up by painting it better in the next step (my painting isn't much better than my drawing either, but at least with the brush we can let go of the clicker without unleashing the mad ants and take a breather for a while).

PERFORMANCE TIP

Elements users do not have a Quick Mask mode that is found in the full version of Photoshop. They must use the Selection Brush tool to fix up the very disturbing attempts with the lasso or the not-so-magic Magic Wand tool. The Selection Brush tool icon in the Tools palette has a circle of ants emanating from the tip of the brush (wow - a brush that paints ants - how wonderful). Now painting ants is too weird for me so I usually choose 'Mask' from the Mode menu in the Options bar (positioned above the image window) to replicate the Quick Mask mode found in the full version of Photoshop.

6. Choose the Selection Brush tool (behind the Quick Selection tool in the Tools palette) and the Mask option in the Options bar. Set the brush hardness to 100% and start painting your mask better. If you accidentally paint over the line and onto the terraced hills, hold down the Alt key to temporarily inverse the paint mode to 'erase' and remove the stray brush strokes. Take your time - no rush - zoom in if you can't see what you are doing and paint on the bigger picture.

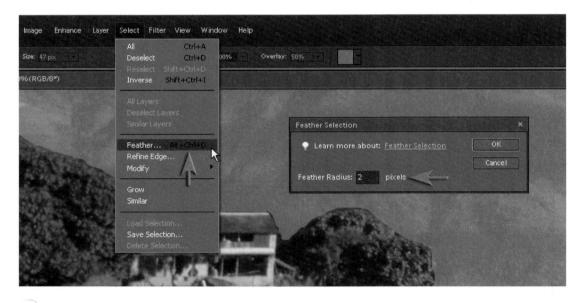

Just trust me on the next step OK. I want you to feather your selection. Choose Feather from the Select menu and then enter a value of 2 in the 'Feather Radius' field.

When you click OK watch the edge of your brushwork - it goes sort of soft. If you missed it go to the Edit menu and choose 'Undo' and then 'Redo'. Zoom in if you still didn't see it change. I need you to see it change so you don't think I am messing with your head on this one. So why is soft better than hard you ask? Soft is good (in this instance) because it is hard to pick out a soft transition between pixels that have been adjusted and those that missed the boat, i.e. no one will be able to tell that you have been 'tweaking' (aka enhancing) your image. At the moment, however, you have not tweaked anything, merely isolated it for tweaking.

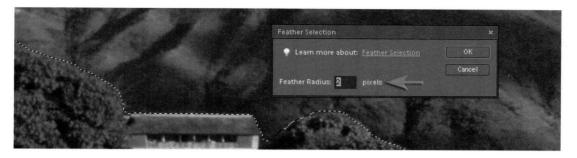

Note > If the terminology Feather Selection, when you are in fact looking at a mask, is troubling you then you have my permission to select Selection in the Options bar instead of Mask before feathering. The advantage to feathering or blurring the selection, when it is being viewed as a mask, is that you can see whether the amount of feather is appropriate, and adjust the pixel radius according to the softness of the edge that looks right for your image. Bigger images (more megapixels) require more feathering as a rule.

Warning > Too much feathering is as bad as none at all, i.e. with too much feathering the color corrections will bleed into the adjacent image and make it look like your colors are running.

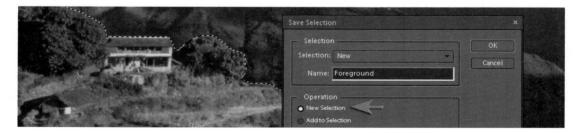

8. Because making a selection can be the most time-consuming part of the process, and because computers crash (no really they do), Adobe allows you to save your selection. Go to the Select menu and choose 'Save Selection' - give it a name, choose OK and then save your image file by going to the File menu and choosing 'Save As'. Choose a different name to save it as a different file to the original and use the Photoshop file format (the JPEG file format does not support saved selections). In this way you will have one original and one enhanced/stuffed file just for good measure. You can now lie down for five minutes to rest the gray matter and then return to your enhanced/stuffed file - go to the Select menu and choose 'Load Selection'.

9. With the marching ants running rampant all around your selected pixels I now want you to find the Layers palette. If it is hiding then you can summon it up from the depths of oblivion by going to the Window menu and selecting - yes you guessed it again - 'Layers'. Click on the little round Create Adjustment Layer icon that is half black and half white. Click on the icon and choose 'Levels' from this submenu.

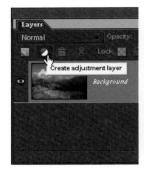

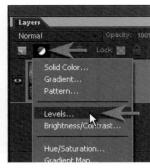

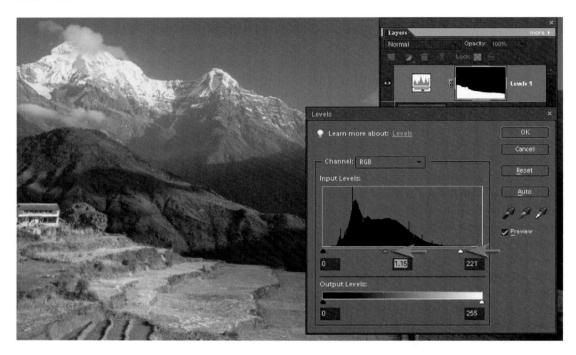

10. Now a couple of really interesting things have happened (well mildly interesting for a computer geek anyway). First, and not surprisingly, the virtual mountains have reappeared - but this time they represent only the selected pixels and not the pixels of the entire image (hence the different shape). Second, the ants have mysteriously disappeared, only to be replaced by a new layer in the Layers palette. This layer is called an 'adjustment layer' and it will play host to the adjustments we are about to make in this Levels dialog box. Third, the mask has reappeared in a little thumbnail image to the right of the Adjustment icon in the Layers palette. This is called a 'layer mask' and it will hide any adjustments we make in the unselected portion of the image (the distant mountains and sky).

Move the Highlight slider (the white triangle on the right) in towards the slopes of the histogram and move the central gray triangle (the Gamma slider) to the left to brighten the selected pixels.

Note > The Adjustment Layer icon changes with the preferences set for this palette - so don't worry if yours doesn't look the same as mine.

PERFORMANCE TIP

Now we could have picked up the Levels command from the Enhance menu, as in step 1 of this very exciting project. The difference is that adjustments made using an adjustment layer are infinitely editable. Infinite editing is great for people who are indecisive about color, want to make frequent changes and don't want to degrade the quality of their image by doing so. The changes you make when you use an adjustment layer are not actually applied to the pixels at this point. The adjustment layer acts like a filter, showing us a view of how the pixels will look when the adjustments are applied. If you make frequent changes to the pixels you can lose image detail or quality, but worse, you lose the ability to redo the changes if you change your mind. Using adjustment layers you can make changes till the cows come home. Your adjustments are applied when you save for screen viewing or print the image, but if you save the original in PSD (Photoshop) format, you can always come back and adjust it again later.

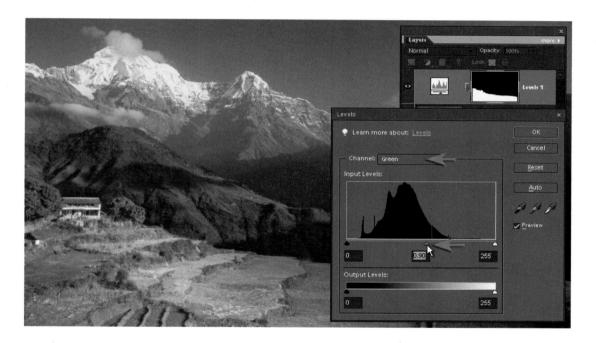

11. Because the grass is sometimes too green on the other side we can go to the 'Green' channel in the Channel menu, positioned near the top of the Levels dialog box, and move the gray triangle to the right. This will make the grass less green as more Magenta is introduced into the image. These adjustments will have the effect of making the foreground look sunnier (brighter, more contrasty and warmer usually does the trick). Select OK and sit back and admire a job well done. Zoom in to look for bleeding color or areas that should have been in the selection that were left out.

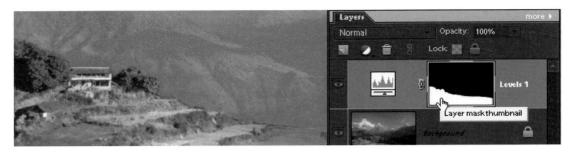

12. If you have found any errors they can usually be attributed to the mask. To work on the mask you can click on its thumbnail in the Layers palette, select the Brush tool and paint with either white or black. This time you will need to select the real brush and not the one that paints ants. Pressing the letter D on the keyboard will make sure the colors in the Tools palette are set to their default settings of white and black. Black will remove the adjustments and white will allow the adjustments to affect the pixels below (pressing the letter X on the keyboard will switch the foreground and background colors). In the Options bar choose a soft-edged brush to match the softening you have done to your mask. If you want to see the mask during this operation you will need to hold down the Alt and the Shift keys at the same time whilst clicking on the layer mask thumbnail. Repeat this action to return to the normal view.

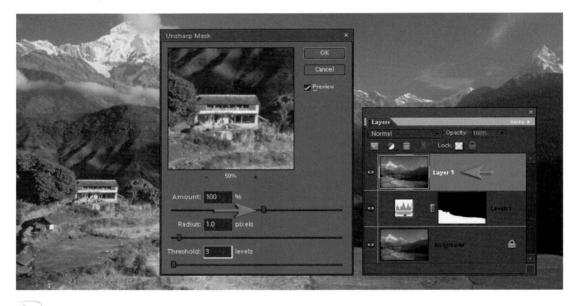

Don't forget the final step of any editing procedure is the Unsharp Mask. I always prefer to create a separate layer for the sharpening process - especially if I am intending to make a print. My procedure is to choose Select All from the Select menu, Copy Merged and then Paste, both from the Edit menu. Set the view to Actual Pixels from the View menu before going to the Enhance menu to choose the Unsharp Mask option. Standard settings are around 100% for the amount, 1.5 for the Radius when sharpening a 5 or 6 megapixel image with a threshold of around 3, or slightly more if your image is slightly noisy or has already been sharpened in-camera.

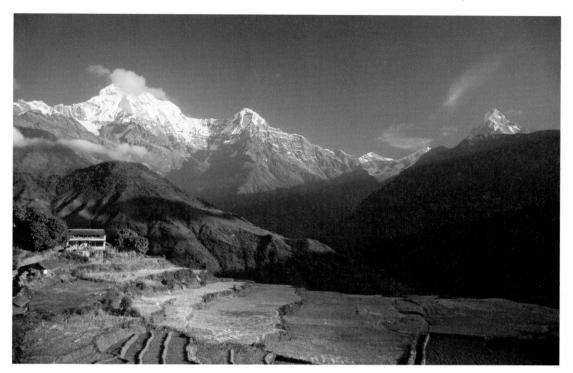

A print has a habit of looking less sharp than the screen image so a little bit of oversharpening on screen may be required to get things looking perfect on paper. If you can't see any sharpening then you need to check that you do not have the adjustment layer selected. You cannot sharpen invisible pixels, i.e. there are no pixels on an adjustment layer to be sharpened. Project 7 will look at advanced skills for sharpening localized areas of the image.

PERFORMANCE TIP

If this sharpening layer is beneath the adjustment layer, the adjustments will be applied twice, and then your image will look like it has had a tussle with the ugly stick. If this happens you should drag the new layer to the top of the layers stack. Remember that when you choose 'Paste' from the Edit menu the pixels are always pasted into a new layer above the active layer.

Camera Raw

All digital cameras capture in Raw but only digital SLRs and the medium-to highend 'prosumer' cameras offer the user the option of saving the images in this Raw format. Selecting the Raw format in the camera instead of JPEG or TIFF stops the camera from processing the color data collected from the sensor. Digital cameras typically process the data collected by the sensor by applying the white balance, sharpening and contrast settings set by the user in the camera's menus. The camera then compresses the bit depth of the color data from 12 to 8 bits per channel before saving the file as a JPEG or TIFF file. Selecting the Raw format prevents this image processing taking place. The Raw data is what the sensor 'saw' before the camera processed the image, and many photographers have started to refer to this file as the 'digital negative'. This digital negative allows you to take control over the conversion process to access maximum quality.

For maximum quality choose to save your files using the camera Raw format. This image was further edited in the main editing workspace using techniques from the Hue and Saturation and Glamor Portrait projects

Processing Raw data

White balance, brightness, contrast, saturation and sharpness can all be assigned as part of the conversion process in Adobe Camera Raw rather than in the camera. Performing these image-editing tasks on the full high-bit Raw data enables you to achieve a higher quality end result. After the image has been processed in the Camera Raw dialog box the file is then opened into the image-editing workspace and the Raw file closes and remains in its Raw state, i.e. unaffected by the processing procedure. Although the Camera Raw dialog box appears a little daunting at first sight, it is reasonably intuitive and easy to master.

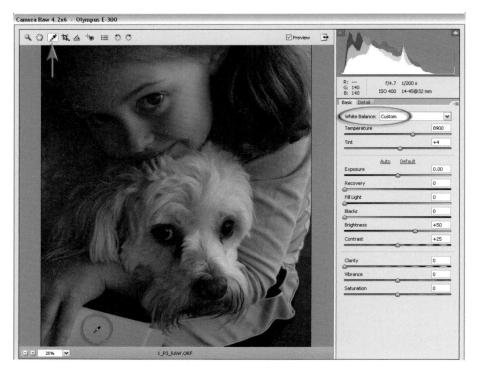

1. Basic adjustments - White balance

Open the Raw file from the supporting DVD. Set the white balance by clicking on the White Balance eyedropper in the small tools palette (top left-hand corner of the dialog box) and then click on any neutral tone you can find in the image. In this image click on the white paper the girl is holding. You can also set the white balance by choosing one of the presets from the drop-down menu or manually adjusting the Temperature and Tint sliders to remove any color cast present. The Temperature slider controls the blue/yellow color balance whilst the Tint slider controls the green/magenta balance. Moving both the sliders in the same direction controls the red/cyan balance.

Note > Although it is a 'White Balance' you actually need to click on a tone that is not so bright that it has become clipped (255). Clicking on any light neutral tone (one without any color) is preferable. A photographer looking to save a little time later may introduce a 'gray card' or 'white balance' reference card in the first frame of a shoot to simplify this task.

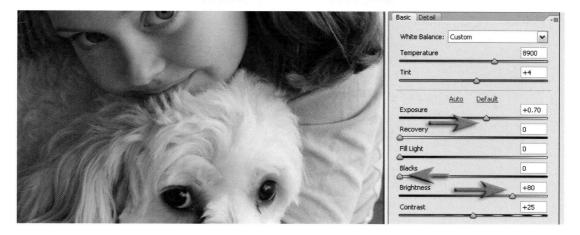

2. Basic adjustments - Tonality

Set the tonal range of the image using the Exposure, Blacks and Brightness sliders. These sliders behave similarly to the input sliders in the Levels dialog box and will set the black and white points within the image. The Brightness slider adjusts the midtone values in a similar way to the Gamma slider when using Levels dialog. When tall peaks appear at either end of the histogram you will lose shadow, highlight or color detail when you open the file to the main editing software. Careful adjustment of these sliders will allow you to get the best out of the dynamic range of your imaging sensor, thereby creating a tonally rich image with full detail.

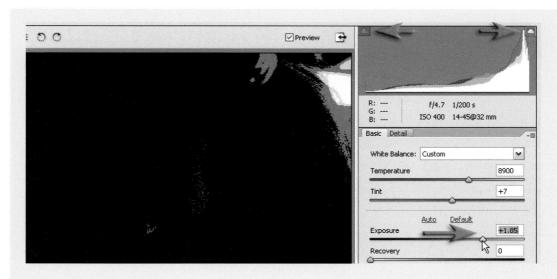

PERFORMANCE TIP

Hold down the Alt key when adjusting either the Exposure or Shadows slider to view the point at which highlight or shadow clipping begins to occur (white or black indicates the point at which pixels lose detail in all channels). Alternatively you can check the Shadows and Highlights boxes above the main image window instead of holding down the Alt key.

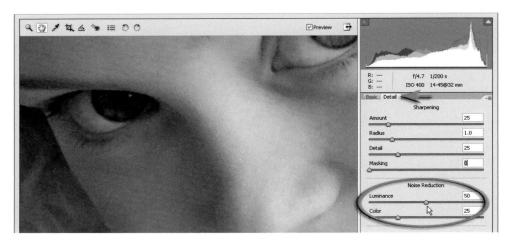

3. Detail

Set the image to 100% and click on the Detail tab to access the Sharpening and Noise Reduction controls. Sharpening controls can be left at their default settings if you intend to implement the advanced sharpening techniques (*see* Project 7) or use the techniques outlined on page 38 if you wish to apply sharpening settings to a batch of images. The Luminance Smoothing and Color Noise Reduction sliders (designed to tackle the camera noise that occurs when the image sensors' ISO is high) should only be raised from 0 if you notice image artifacts such as noise appearing in the image window.

In the project image the sensor was set to 400 ISO on a budget DSLR. Both luminance and color noise are evident when the image is set to 100%. When cameras are set to 100 or 200 ISO it may be possible to leave the Luminance slider at 0 as noise will be low or non-existent. It is recommended that you only perform a gentle amount of sharpening in the Raw dialog box if you intend to selectively sharpen the image in the main image-editing workspace (*see* 'Project 7 - Sharpening' for localized sharpening techniques that are unavailable in the Camera Raw dialog box).

PERFORMANCE TIP

The Luminance Smoothing and Color Noise Reduction sliders can remove subtle detail and color information that may go unnoticed if the photographer is not careful to pay attention to the effects of these sliders. Zoom in to 100% to see the effects of these sliders and unless you can see either little white speckles or color artifacts set these sliders to 0.

4. Depth

Select the 'Depth' in the lower left-hand corner of the dialog box and then click OK. If the user selects the '16 Bits/Channel' option, the 12 bits per channel data from the image sensor is rounded up - each channel is now capable of supporting 32,769 levels instead of 256. Many of the advanced editing features are unavailable in 16 Bits/Channel mode so the user may choose to go for the '8 Bits/Channel' option now. This is OK so long as the tonality (black and white points) and color have been corrected in the Camera Raw dialog box.

If the color and tonal information is edited significantly in the main editing space, with the files in 8 Bits/Channel mode, the final quality will be compromised. If the digital image has been corrected sufficiently for the requirements of the output device in the Raw dialog box the file can be edited in 8-bit mode with no apparent loss in quality.

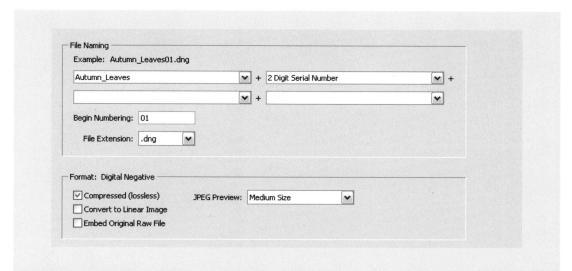

PERFORMANCE TIP

Adobe has created a universal Raw file format called 'DNG' (Digital Negative) in an attempt to ensure that all camera Raw files (whichever camera they originate from) will be accessible in the future. The 'Save' option in the Camera Raw dialog box gives you access to convert your camera's Raw file to the Adobe Digital Negative format with no loss of quality. The conversion will ensure that your files are archived in a format that will be understood in the future. Expect to see future models of many digital cameras using this DNG format as standard. One thing is for sure - Raw files are a valuable source of the rich visual data that many of us value, and so the format will be around for many years to come.

New features and workflows

Photoshop Elements users who purchased version 5.0 were able to take advantage and enjoy the advances made to the Adobe Camera Raw (ACR) interface over the last 12 months. Things started really improving in ACR after Photoshop Lightroom was released at the start of 2007. The new Camera Raw plug-ins that Adobe made available on their website (Versions 4.0 and higher) shared the much improved Raw engine that first saw the light of day in Photoshop Lightroom. With the release of Elements 6 users can now enjoy, not just the increased number of controls and features, but also synchronize the adjustments over an entire shoot or folder of images opened into the ACR space.

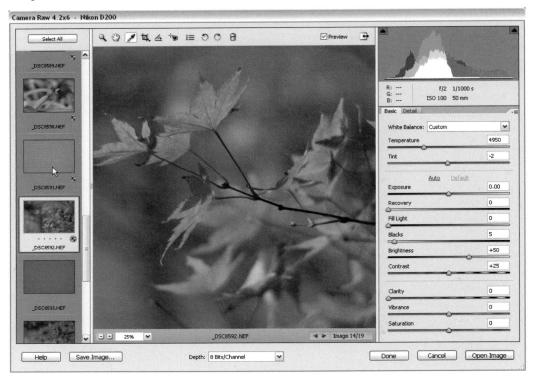

The ability to batch process Raw files is perhaps the most significant new feature of Photoshop Elements 6.0. We can now optimize, crop and process all of the files ready for print or for web with the minimum of fuss but with an astonishing amount of control.

This tutorial will look at the following new features:

- Straighten and Crop
- Recovery and Fill Light
- Clarity
- Vibrance
- Batch processing
- Sharpening (including the new Radius, Detail and Masking controls)

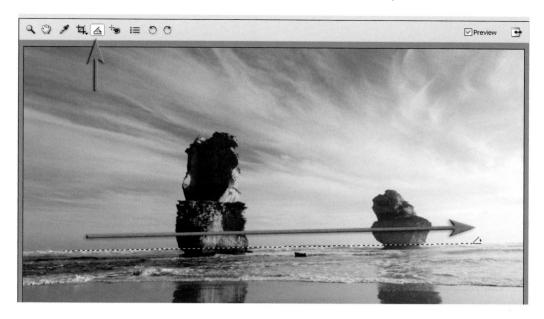

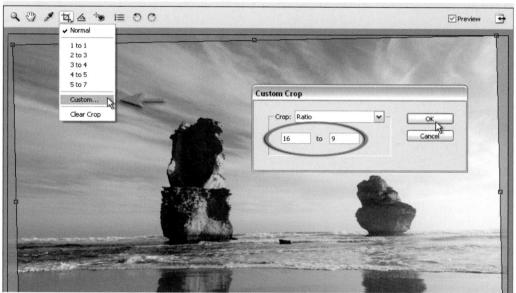

1. Straighten and Crop

It is now possible to straighten and crop images in the Adobe Camera Raw interface; it is important to remember that these adjustments, just like all other adjustments in the Adobe Camera Raw interface, are non-destructive. Pixels are not permanently removed by the cropping process, i.e. all the original pixels are preserved and you can crop to a different format or shape at any time. The Crop menu allows you to select the format (image shape) that you wish to crop to. In the example above I have created a custom Crop setting using the popular widescreen 16:9 format. This format will be added to the Crop presets for future use.

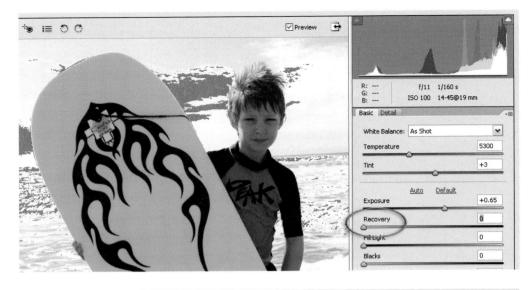

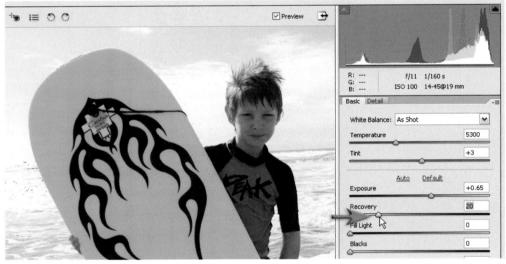

2. Recovery and Fill Light

The Recovery and Fill Light sliders can rescue bright highlights that have become clipped and dark shadows that may otherwise be too dark to print. When the contrast of the scene is very high (bright sunlight) many good quality digital cameras can be set to warn us of overexposure by blinking the overexposed highlights. Sometimes we can lower the contrast by using a reflector or fill flash and sometimes we can rescue the highlights in Adobe Camera Raw. In the illustration above the highlight warning has been switched on by clicking on the triangle in the top right-hand corner of the histogram window. The red color indicates overexposure (pixels that would be rendered 255 if left unadjusted). Dragging the Recovery slider to the right brings these overexposed tones back under 255 and will allow them to print with texture and detail.

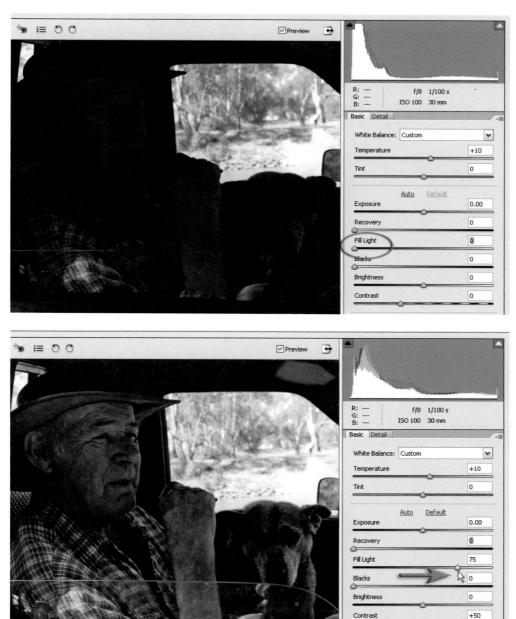

Great care needs to be taken when using the Fill Light slider to rescue dark shadow tones. In this example an extreme adjustment is being made to rescue the shadow tones that have been accidentally underexposed due to the bright tones in the center of the viewfinder. Be careful with raising the Fill Light value too high, especially with photos taken with a high ISO, as Fill Light will also brighten noise in the photo and make it more apparent. Photos taken at a lower ISO, like ISO 100, will be more forgiving to the Fill Light slider and not expose problems like noise and tonal banding so readily.

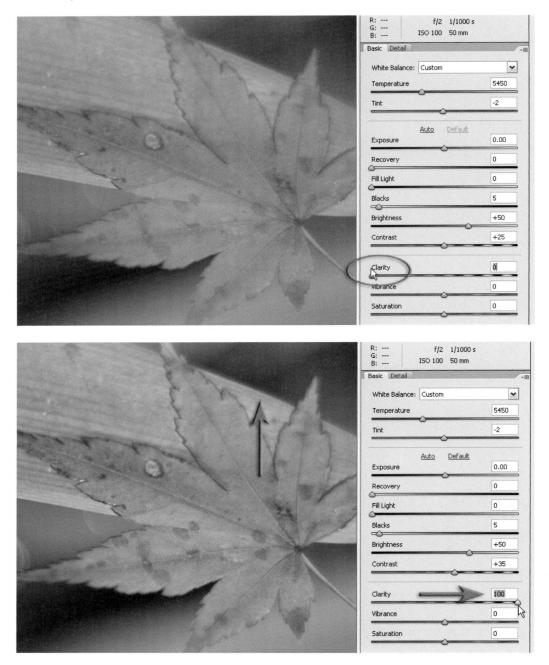

3. Clarity

The Clarity slider can be used to effectively increase localized contrast and make images appear to have more depth (and sometimes a little sharper). Notice how contrast is raised both in the areas of fine detail and the broader areas of continuous tone. Unlike the Recovery and Fill Light sliders that have to be used in moderation, this slider is slow to introduce unpleasant artifacts - especially in images where the light quality was soft and even.

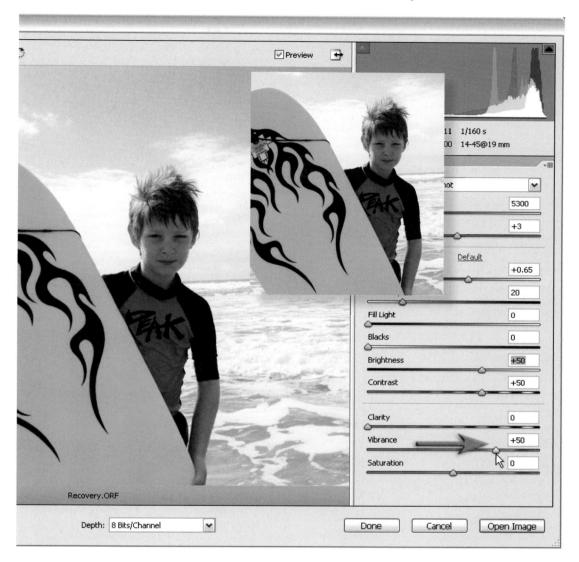

4. Vibrance

Increasing saturation in Adobe Camera Raw can lead to clipping in the color channels. Clipping saturated colors can lead to a loss of fine detail and texture. The Vibrance slider applies a non-linear increase in saturation (primarily targeting pixels of lower saturation more than colors that are already vibrant). The adjustment feature has also been designed to protect skin tones from becoming oversaturated and unnatural. The Vibrance adjustment feature should lead to less problems when compared to the Saturation control and should be used for most situations where increased color saturation is required.

Note > Choosing Adobe RGB in the Color Settings dialog box in the main editing space (Edit > Color Settings) will enable a working space with a larger color gamut than sRGB. This will allow saturation or vibrance to be increased to a greater degree before clipping occurs.

5. Correcting the White Balance across a batch of images

As we have seen with editing the previous image, it is sometimes quick to use the White Balance tool in the Adobe Camera Raw interface to quickly color-correct an image by simply clicking on a neutral tone within the image to quickly set the correct color temperature and tint.

If the subject you wish to capture does not have an obvious neutral tone then you can introduce a neutral tone as reference point in the first image of the shoot. This will enable you to measure the precise temperature and tint required to color-correct all the other images that share the same lighting conditions.

In this image a white balance card (a 'WhiBal' is used in the image above) has been introduced into the image and then the White Balance tool is used to set accurate temperature and tint settings.

In some scenes there may be no neutral tones to click on and no opportunity to include a white balance reference card into the scene. In these instances it is important to either create a custom white balance setting in the camera at the time of capture, or capture a reference image using a product such as the 'Expodisc'. The Expodisc is placed in front of the lens and an image captured by pointing the camera back towards the light source (with the camera set to manual focus). The resulting image provides the photographer with a reference image that can be used to assign the correct white balance to all of the images captured in those lighting conditions.

When you want to assign the correct white balance across a group of images, select multiple Raw files in the Organizer space and then open them in the Adobe Camera Raw interface.

Click on the reference image thumbnail on the left-hand side of the Adobe Camera Raw interface. Then hold down the Shift key and click on the last thumbnail in the group of images that share the same lighting conditions. Select the White Balance tool and click on the main reference image preview to assign the correct white balance to all of the images.

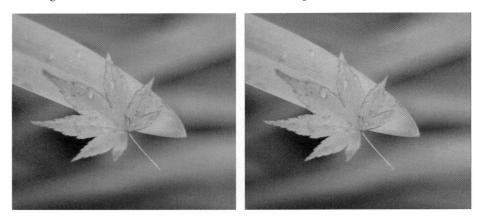

This is before and after and clearly demonstrates how the Auto White Balance setting in the camera has misjudged the correct white balance for these images of Autumn leaves.

Note > The Expodisc can also be used create custom white balance settings in the camera, take accurate incident light meter readings and also help locate any dust on the camera's sensor (go to www.expodisc.com for more details about this useful product).

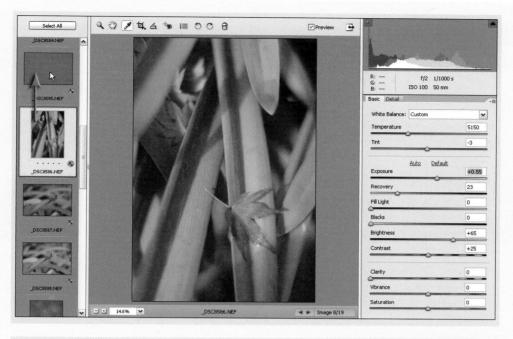

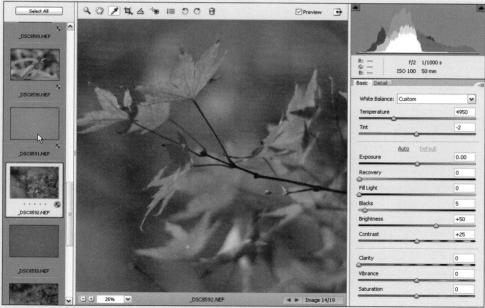

PERFORMANCE TIP

So long as the photographer takes frequent reference images as the lighting conditions change, e.g. cloudy, sunny, time of day etc., color accuracy is assured with just a few clicks. Remember this color accuracy can only be fully appreciated if both the computer monitor and printer are calibrated to display accurate color (*see* Project 8 - Printing).

6. Sharpening

Just as a white balance setting can be applied across multiple images open in Adobe Camera Raw, the same batch processing can be achieved when sharpening images. Although the sharpening controls have vastly improved in the Adobe Camera Raw interface for Elements 6 it is still recommended that you sharpen in the main editing space to achieve maximum performance when sharpening (*see* Project 7 - Sharpening).

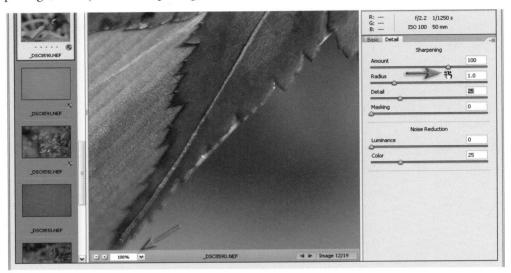

Set the magnification of the image to 100% before sharpening any image in Adobe Camera Raw as the results are not visible at smaller magnifications. Start by increasing the Amount slider until the edges that have the most contrast are suitably sharp. Amounts up to 100% are considered normal. Generally it is recommended to leave the Radius slider at its default setting of 1.0.

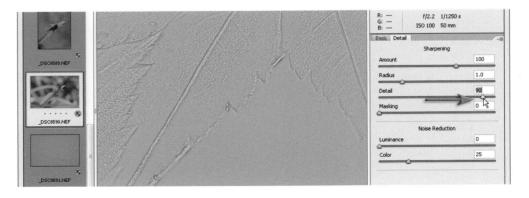

Hold down the Alt key and drag the Detail slider to left or right to observe the amount of detail that will be targeted for sharpening. Drag to the right to increase detail in the areas of continuous tone and to the left to decrease apparent detail. Let go of the Alt key to observe the effect on the image.

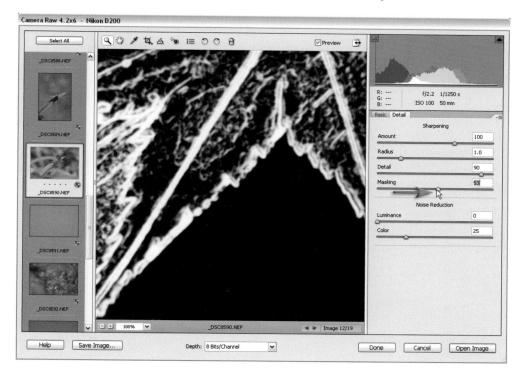

To eliminate the sharpening process from areas of continuous tone we can drag the Masking slider to the right. Hold down the Alt key as you drag this slider to observe the areas of the image that will not be sharpened (as indicated by the black mask).

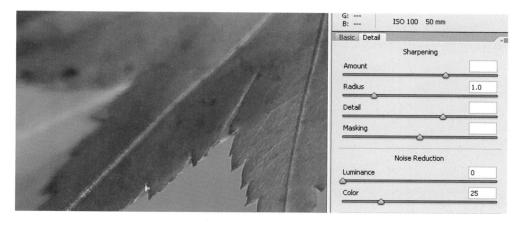

To apply these setting to the other images in the shoot simply choose the Select All option above the thumbnails on the left side of the Adobe Camera Raw interface. The numbers for each slider will be blank if the settings are not the same for all of the selected images. Click on each slider in turn to sync the sharpening settings for all images. Click on Done to apply all of these changes and close the Adobe Camera Raw dialog box, 'Save' to process files using these Raw settings or select one or more images to open into the main editing space of Elements.

Target Tones

Setting the levels in a digital image is only the first step to achieving optimized images. It is also necessary to optimize the image for the intended output device. To achieve optimum tonal quality in your digital images it is important to target both the highlight and shadow tones within each image. When using Elements the Eyedropper tool is a key to unlocking the quality that lies dormant in any one of your images which has been correctly exposed.

What you see is not what you always get - target your levels to your output device for predictable results

To achieve maximum quality set the target levels in images that are in 16 Bits/Channel mode (accessed through the camera Raw format or via scans from film that have been requested as 48-bit output scans). If you are optimizing your files in 8 Bits/Channel mode (via JPEG files) be sure to use an adjustment layer rather than an adjustment from the Enhance menu.

Part 1: Optimize

Ansel Adams was responsible for creating the famous/infamous 'Zone System' in order to precisely control the tonal range of each of his masterpieces. If you look carefully at one of his beautiful landscape photographs you will notice that only the light source (or its reflection - something termed a 'specular highlight') appears as paper white. All the rest of the bright highlights reveal tone or texture. Likewise, the shadows may appear very dark, but they are not devoid of detail. Ansel was careful only to render holes as black (the absence of a surface). Any surface, even those in shadow, would render glorious amounts of subtle detail.

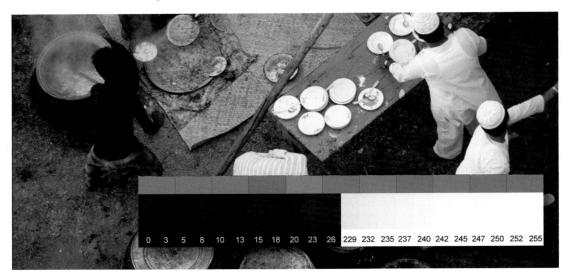

Even though you have set your levels (as guided in Project 2 or 3) it is no guarantee that your highlight or shadow tones will be visible in the final print. To make sure the highlight detail does not 'blow out' (become white) and the shadow detail is not lost in a sea of black ink it is possible to target the highlights and shadows in your image to the brightest and darkest tones that the printer can reproduce. The default settings of the eyedroppers to be found in the Levels dialog box are set to 0 (black) and 255 (white). These settings are only useful for targeting the white overexposed areas or black underexposed areas. These tools can, however, be recalibrated to something much more useful, i.e. tones with detail. A typical photo quality inkjet printer printing on premium grade photo paper will usually render detail between the levels 15 and 250. Precise values can be gained by printing a 'step wedge' of specific tones to evaluate the darkest tone that is not black and the brightest tone that is not paper white (see 'Project 8 - Printing' for more guidance on this subject).

PERFORMANCE TIP

The precise target values for images destined for the commercial printing industry are dependent on the inks, papers and processes in use. Images are sometimes optimized for press by skilled operatives during the conversion to CMYK. Sometimes they are not. If in doubt you should check with the publication to get an idea of what you are expected to do and what you should be aiming for if the responsibility is yours.

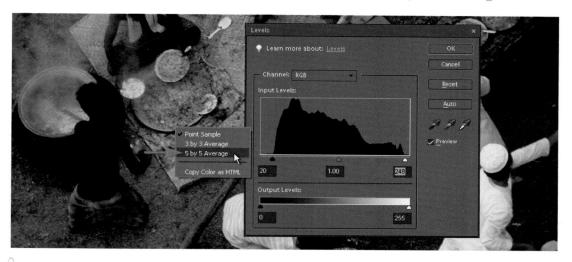

1. For maximum quality you would be wise to optimize your histogram in camera Raw or in 16 Bits/Channel mode. If the file is in 16 Bits/Channel mode you will need to access a levels adjustment from the Enhance > Adjust Lighting submenu. If the file is in 8 Bits/Channel mode (due to being captured using the JPEG file format) you are advised to create a Levels adjustment layer by clicking on the Create New Fill or Adjustment Layer icon in the Layers palette. A tall peak at either level 0 or level 255 is a strong indicator that detail has already been lost either by excessive subject contrast or inappropriate exposure during the capture stage. If this is the case your shadow or highlight detail is already irrecoverable.

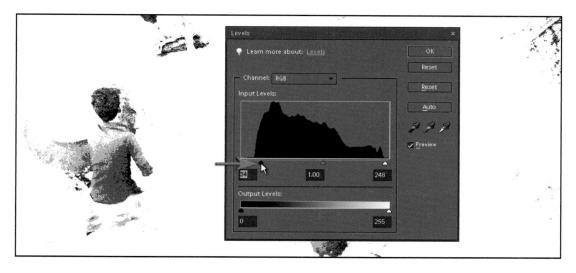

2. Hold down the Alt key and drag the Shadow slider to the right. Keep dragging the slider until the darkest shadows become visible in the image window. Carefully view the image to locate the darkest shadow or surface within the image. Be careful to make a mental note of the position of a representative tone, e.g. a dark surface rather than a dark hole, and then return the Shadow slider to level 0.

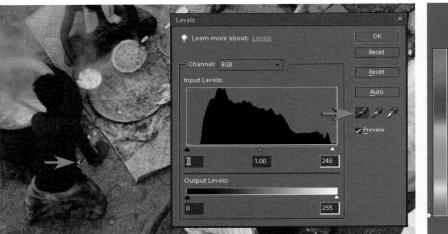

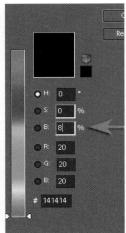

3. Double-click the Set Black Point eyedropper in the Levels dialog box to display the Color Picker. Enter a value of 6 to 8 in the 'Brightness' field (part of the hue, saturation and brightness or HSB controls) and select OK. The precise value is dependent on your printer, paper and ink choice. You can experiment with alternative values later when you have completed the printing project. Move your mouse cursor into the image window and click on the darkest shadow tone that requires visible detail. This action will set your shadow tone.

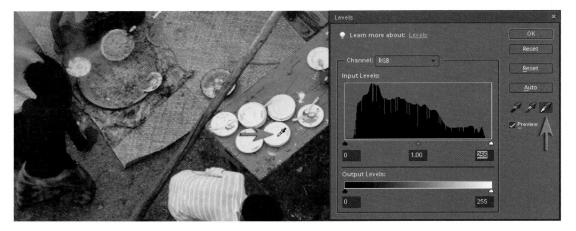

4. Double-click the Set White Point eyedropper to display the Color Picker again. This time enter a value of 98 in the 'Brightness' field and select OK. Locate the brightest highlight within the image. Do not select a specular highlight such as a light source or a reflection of the light source that should be 255. With the Set White Point eyedropper still selected move into the image window and click on the target highlight to set this as the brightest highlight tone within your image.

Note > When targeting highlights and shadows of a color image a color cast may be introduced into the image if the tones to be targeted are not neutral or desaturated. This can be rectified using the Gray eyedropper to correct any cast introduced.

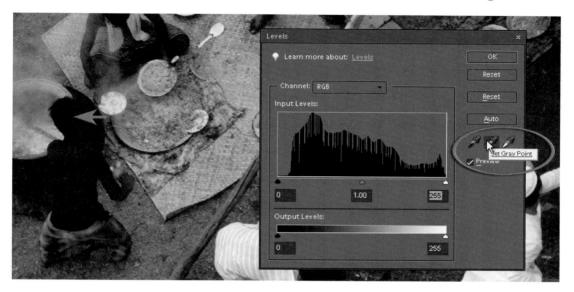

5. Select the Set Gray Point eyedropper (between the black and white point eyedroppers). Click on a suitable tone you wish to desaturate in an attempt to remove the color cast present in the image (try clicking on the black hair or cooking pots). The neutral tone selected to be the 'Gray Point' can be a dark or light tone within the image. If the tone selected is not representative of a neutral tone the color cast cannot be rectified effectively.

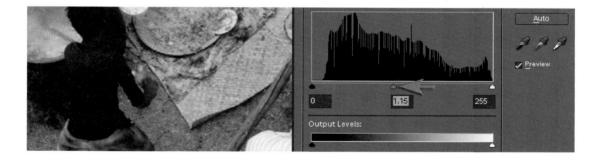

- 6. Move the Gamma slider to fine-tune the overall brightness of the midtones. Excessive movement of the Gamma slider, however, will upset the targeted tones set previously.
- 7. Click OK to apply the tonality changes to the image. When presented with the dialog box that reads 'Save the new target colors as defaults?' you can select 'Yes'. This will ensure that when you use the eyedroppers on your next image all you need do is click once with each of the three eyedroppers.

Contrast

One of the most important image adjustment features in a professional photographer's workflow is Curves (a sort of Levels command on steroids). Adobe in their wisdom decided to include this feature in Photoshop Elements 5.0. Colo Curves now made a welcome appearance in the Enhance menu but it is still not available as an adjustment layer. This project shows you several ways to controcontrast using adjustment layers to increase your post-production editing power to maximum performance.

Create dramatic images by building in some non-destructive contrast

The revised Brightness/Contrast adjustment feature

If you have been image editing for some time you will know that 'Levels' has always been a superior option to enhance the brightness and contrast of your image rather than the Brightness/ Contrast feature. Adjusting the brightness or contrast of an image using the Brightness/Contrast adjustment used to be very destructive, e.g. if you wanted to make the shadows brighter and elected to use the Brightness/Contrast control, all of the pixels in the image were made brighter (not just the shadows) - causing the pixels that were already bright to fall off the end of the histogram and lose their detail or become white (level 255). The Brightness/Contrast adjustment feature has now been fully revised so that its behavior falls in line with the non-destructive nature of the Brightness and Contrast sliders in Adobe Camera Raw.

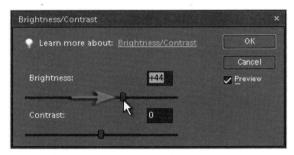

Using the Brightness slider is now like moving the center (Gamma) slider in the Levels adjustment feature, i.e. the image is made brighter whilst preserving the black and white points within the image. The Contrast slider, on the other hand, makes the shadows darker and the highlights brighter but not at the expense of the black and white points of the image. The only problem with new Brightness/Contrast adjustment feature is that it cannot focus its attention on a limited range of tones, e.g. make the shadows darker or lighter but leave the midtones and highlights as they were.

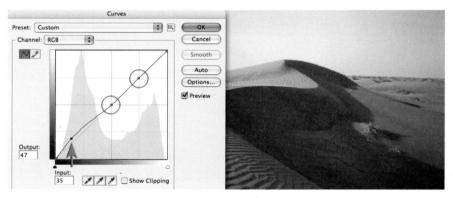

The Curves adjustment feature as seen in the full version of Photoshop CS3

The Curves adjustment feature allows the user to target tones within the image and move them independently, e.g. the user can decide to make only the darker tones lighter whilst preserving the value of both the midtones and the highlights. It is also possible to move the shadows in one direction and the highlights in another. In this way the midtone contrast of the image can be increased with a great deal more control than the new Brightness/Contrast adjustment feature.

Resolving the problem

Now there are four ways to enable you to harness the power of curves in Adobe Elements 6. The first way is 'Adjust Color Curves' (Enhance > Adjust Color > Adjust Color Curves) and is a user-friendly version of the Curves adjustment feature found in the full version of Photoshop.

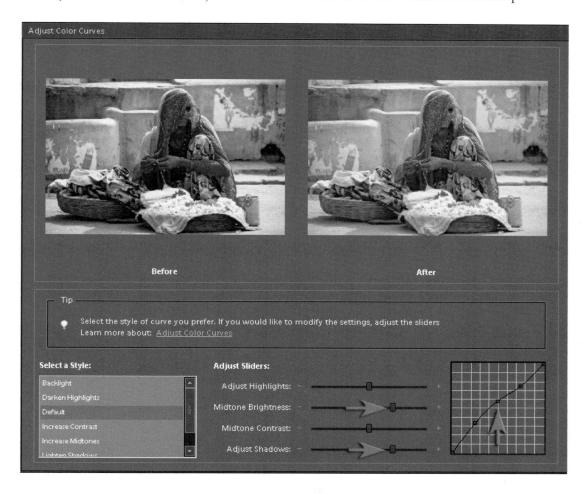

Method 1 - Color Curves

'Adjust Color Curves' can be accessed from the Enhance menu (Enhance > Adjust Color > Adjust Color Curves). The user should first set the levels of the image file by using the techniques outlined in Project 2. Unfortunately 'Adjust Color Curves' is not available as an adjustment layer so it would be advisable to first duplicate the background layer and apply the changes to this duplicate layer. Start by clicking on the thumbnail of your choice and then click on the advanced options to access the sliders that are required to fine-tune the tonality of your image. It may be necessary to add a Hue/ Saturation adjustment layer to modify any changes in the color saturation that may have occurred as a result of the Color Curves adjustment.

Accessing curves as an adjustment layer

The second way of using curves, but this time as an adjustment layer, is a bit cheeky and is available if you have access to a multilayered file created in the full version of Photoshop (check out the supporting DVD to download the file used in the example below).

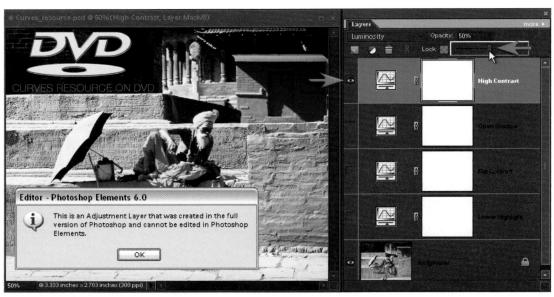

A Photoshop file opened in Elements will allow the user limited functionality to modify the adjustments

Method 2 - Grand theft

One of the great mysteries of life is that although you can't 'create' a Curves adjustment layer in Photoshop Elements you can 'open' an image that already has one. Photoshop Elements allows you to see the effects of the Curves adjustment layer (that was created in the full version of Photoshop), switch it off and on, and lower the opacity of the Curves adjustment layer (enabling you to lower the effect of the adjustment layer gradually). You can also drag this Curves adjustment layer into any other image file that is open in Elements (just click on the adjustment layer thumbnail in the Layers palette and drag it into another image window). Theoretically this means that if you had a single file that was created in Photoshop with a wide range of Curves adjustment layers to suit your everyday image-editing tasks you could use this as a 'Curves resource' - just drag, drop and adjust the opacity to suit the needs of each image you are editing. The sort of adjustment layers that would be particularly useful would be those that enabled the Photoshop Elements user to increase and decrease image contrast, raise or lower shadow brightness independently, and raise or lower highlight brightness independently. If the adjustment layers contain generous adjustments they can be simply tailored to suit each new image-editing task by just lowering or increasing the layer opacity. The adjustment layers are resolution independent, which is another way of saying that they will fit any image, big or small - naughty but very nice!

Method 3 - Gradients

The third version is for users of Elements who want a little more control, have a guilty conscience or prefer to explore the advanced features of the package they have purchased rather than the one they have not. This third method allows you to access the ultimate tonal control that Curves has to offer using a different adjustment feature not really designed for the job but which, when push comes to shove, can be adapted to fit the needs of the cash-strapped image editor seeking quality and control.

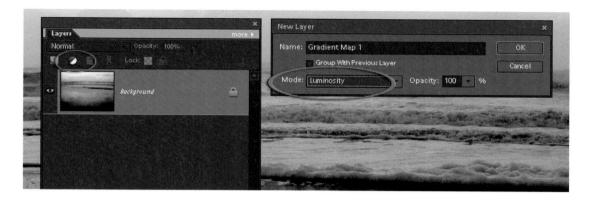

1. The first step is to hold down the Alt key and mouse button whilst selecting the Gradient Map adjustment layer from the Create adjustment layer menu in the Layers palette. This will open the New Layer dialog box. Select 'Luminosity' from the Mode menu and select OK.

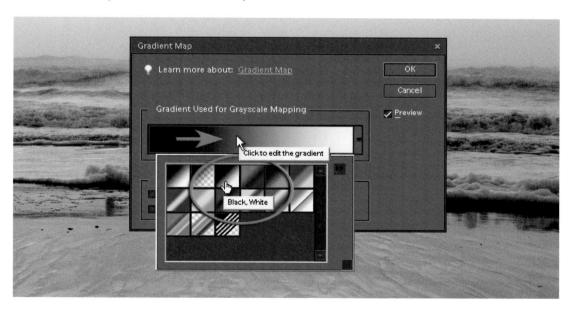

2. Click on the third gradient swatch in the presets menu (Black, White). Click on the gradient in the dialog box to open the Gradient Editor.

Part 1: Optimize

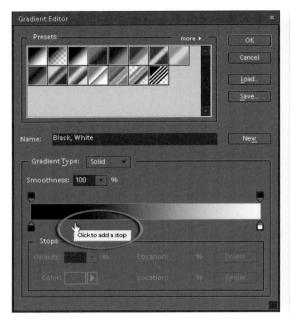

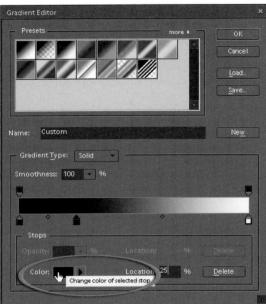

3. Move the cursor to just below the gray ramp and click to add a 'stop' slightly left of center. Type in 25% as the location and double-click on the color swatch to open the Color Picker.

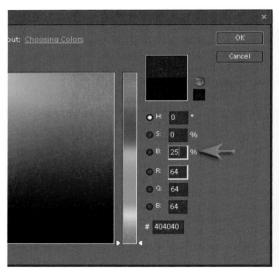

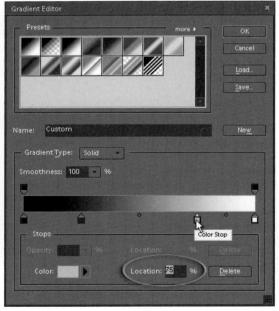

4. Choose a brightness value of 25% and click OK (ensure a value of 0 is entered in the other two fields of the HSB radio buttons). Add another stop right of center (at a location of approximately 75%) and again click on the color swatch to open the Color Picker. This time choose a brightness value of 75% and again click OK.

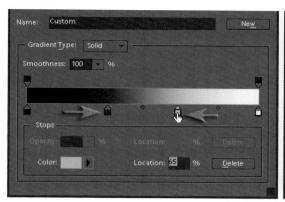

5. The 'Black/White' Gradient Map in Luminosity mode will leave the existing tonal values of your image the same as before. The magic starts when you start to drag the stops you created to new positions on the gray ramp. Moving the two sliders further apart will lower the contrast whilst dragging them closer together will increase contrast. A 'Color Midpoint' also appears between the two stops that you are adjusting to allow you to fine-tune your adjustment. In this project drag the two sliders together to increase the contrast but move the color midpoint to the left so that deep shadows do not become too dark. Be amazed - you are exercising absolute control over the brightness values of your image! This technique allows all of the versatility of a Curves adjustment layer when editing the luminosity of your image.

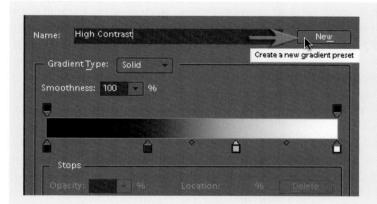

PERFORMANCE TIP

When you have created a modified gradient map you can name and add the map to the list of presets for future use. Download the Gradient presets file (Tonal_Gradients.grd) from the supporting DVD and use either your 'Preset Manager' from the Edit menu to add them to your gradient library or load them directly using the Gradient Editor by clicking on the Load button.

Note > Moving stops too close together can create steps or bands in the tonality of your image, creating an effect that is posterized and unnatural. It is important to realize there are limits to how much tonal manipulation an image is capable of handling before the quality suffers.

Part 1: Optimize

The Gradient Map adjustment layer set to Luminosity mode acts like a 'hot-wired' Levels adjustment layer. Its advantage is that you can set as many stops or 'sliders' as you like, giving the user total control. Any localized areas that require further attention can simply be masked on the adjacent layer mask and tackled separately on a second Gradient Map layer.

Note > If you have a selection active when you choose the Gradient Map adjustment layer it automatically translates the selection into a layer mask, restricting any adjustments to the selected area.

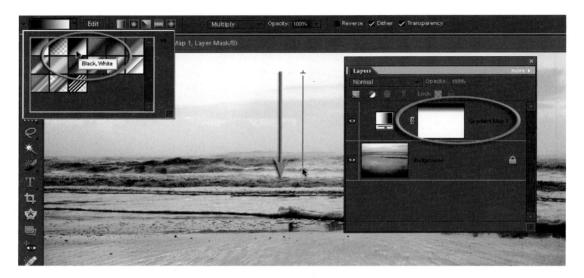

6. If you are looking to achieve a simple global contrast adjustment the project is complete. If, however, you want to enhance the image further using more gradients try the following techniques. Select the Gradient Map adjustment layer, choose the 'Gradient tool' from the Tools palette (or type the letter G on the keyboard). Choose the 'Black/White' and 'Linear' options and then drag a gradient from the top of the image window to just below the horizon line. This will shield the sky from the contrast adjustment applied by the Gradient Map adjustment layer.

7. We will now balance the tonality in the image by darkening the sky. Click on the Create a New Layer icon in the Layers palette and set the blending mode of this new layer to 'Soft Light'.

8. Ensure that black is the foreground default color (type the letter D on the keyboard) and then choose the 'Foreground to Transparent' gradient. Drag a gradient from the top of the image to a position just below the horizon line. Holding down the Shift key as you drag a gradient will 'constrain' the gradient to ensure that it is absolutely straight. Try changing the blend mode of this gradient layer to 'Overlay' and 'Multiply' to see the variations of tonality that can be achieved.

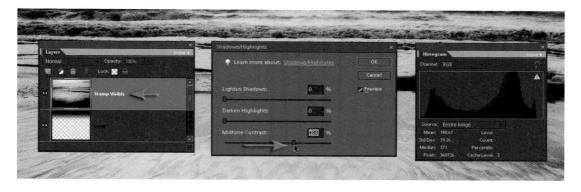

9. Yet another way of targeting tones for adjustment is using the Shadows/Highlights adjustment feature. This very useful adjustment feature is not available as an adjustment layer so you will need to create a 'composite' layer of the work carried out so far before you can apply it. This action of creating a composite layer (merging the visible elements from all of the other layers) is called 'Stamp Visible' by professional image editors (Adobe does not list this command in their menus). Select the top layer in the Layers palette and then hold down the Shift + Alt + Ctrl keys whilst you type the letter E on the keyboard. The new layer should appear on top of the layers stack. Double-click the name of the layer to rename it 'Stamp Visible'. Now choose 'Shadows/Highlights' from the Enhance > Adjust Lighting submenu. Set the Lighten Shadows and Darken Highlights sliders to 0 and raise the Midtone Contrast to +30. You can watch the effects of raising this slider by clicking on the Preview box and by viewing the histogram in the Histogram palette.

10. Create another new layer and this time set the blend mode to 'Multiply'. As with the previous gradient you can experiment with alternative blend modes after you have finished creating this second gradient.

Note > You can also set the blend mode for a new layer in the New Layer dialog box.

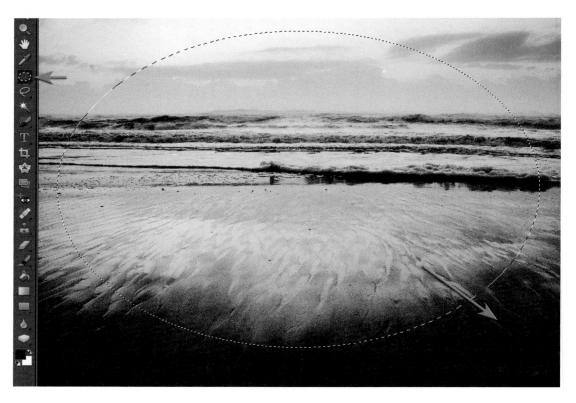

11. Choose the 'Elliptical Marquee tool' from the Tools palette and choose a large amount of feather (increase the amount of feather as the resolution of the file gets bigger). Draw an elliptical selection in the image window.

Note > You can check how soft this edge is by choosing the 'Selection Brush tool'. Choose Mask from the Mode drop-down menu in the Options bar.

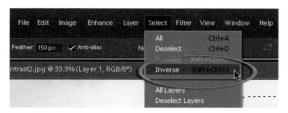

12. From the Select menu choose 'Inverse' (Shift + Ctrl + I) and then from the Edit menu choose the command 'Fill Selection'. From the Contents section of the dialog box choose 'Foreground Color'. Move the mouse cursor into the image and choose a deep blue color from the image window and then click OK. Lower the opacity of the layer until the vignette is subtle.

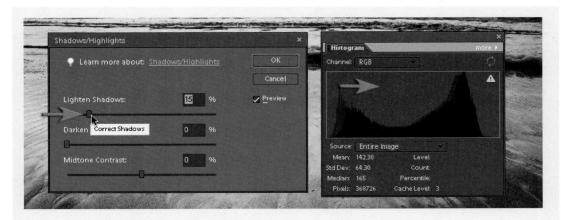

PERFORMANCE TIP

Use the Shadows/Highlights adjustment feature on the Stamp Visible layer if the darkening of the shadows becomes excessive as a result of the vignette.

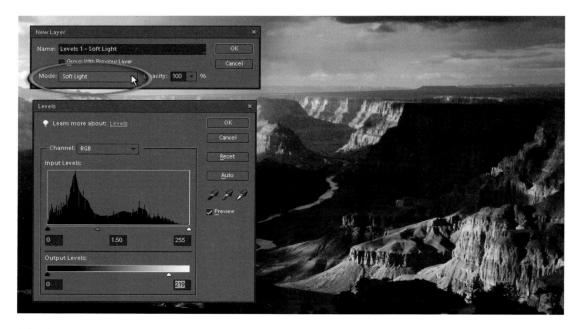

Method 4 - Blend modes

Blend modes are one of the most useful, but least understood, editing features to be found in Elements. One of the groups of layer blend modes that can be applied to layers leads to an increase in contrast of the resulting image. These blend modes can be assigned to any adjustment layer.

1. Open the canyon image from the supporting DVD and hold down the Alt key and the mouse button as you select a Levels adjustment layer. In the New Layer dialog box that opens select 'Soft Light' as the mode. What you now see (if you have the preview box checked in the dialog box) is instant contrast. This contrast is adjustable by moving any of the sliders beneath the histogram. You are able to target shadows, midtones or highlights using these sliders. Select OK to apply the changes.

2. Select 'Black' as the foreground color and with a soft-edged brush at a reduced opacity paint out any localized contrast that is not beneficial to the final image. You should see the effects of the painting in the image and in the layer mask of the adjustment layer.

3. Create another new Levels adjustment layer and this time set the blend mode of the layer to 'Multiply'. This blend mode will darken the entire image but we will mask the lower portion of the image later. Focus your attention on just the sky and when you have increased the drama a little, select OK. Although we are focussing our attention primarily on the tonality it is still possible to change the color using the individual color channels in the Levels dialog box.

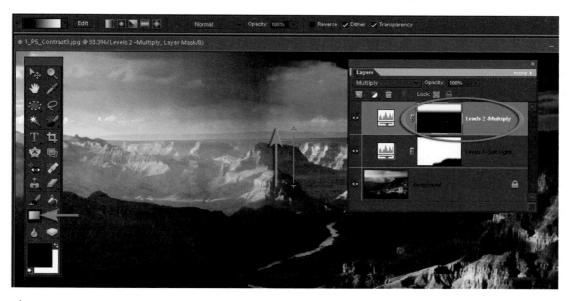

4. Select the 'Gradient tool' from the Tools palette. Select the 'Black, White' option and drag a short gradient from the center of the image up to the horizon line. The resulting mask will release the lower portion of the image from the grip of the Multiply mode but leave the drama and depth in the sky and distant landscape.

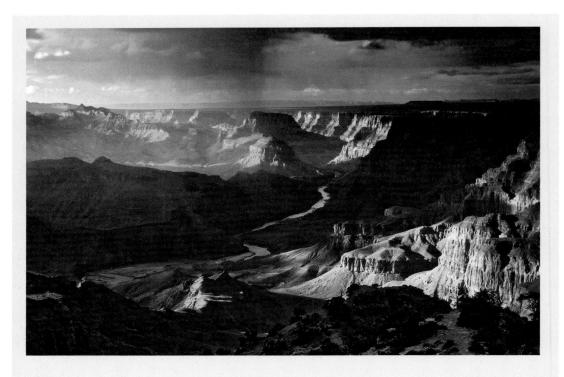

PERFORMANCE TIP

For even more drama and depth duplicate the 'Soft Light' levels adjustment layer (Ctrl + J). Lower the opacity of this layer until you achieve the contrast you are looking for. As with the previous method it is worth keeping the Histogram palette open when making these contrast adjustments so you will notice when the deepest shadows are possibly getting so dark that they will be difficult to print (below level 15). Use the Shadows/Highlights adjustment feature if this becomes the case - either on the background layer or on a new Stamp Visible layer.

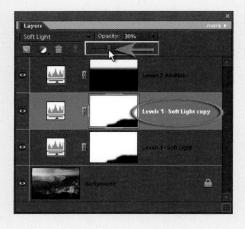

Summary

The Gradient Map adjustment layer in Luminosity mode, a Levels adjustment in Soft Light mode and the targeted adjustments offered by the Shadows/Highlights adjustment feature make the need for a Curves adjustment feature redundant. Absolute tonal and color control is just a blend mode away.

Project 6

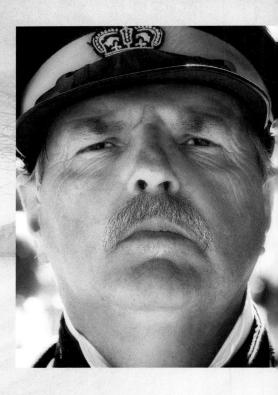

Hue and Saturation

Levels is a powerful adjustment feature for controlling tonality and overall color balance. It cannot, however, target and control limited ranges of color values or the saturation of color in general. For this final level of control we need to master the powerful Hue/Saturation adjustment feature. In this project we will target specific colors and then change the hue and saturation of these targeted colors to both repair and creatively enhance images. This technique is not recommended as an alternative to an effective sunscreen or a good broad-rimmed hat!

Hue/Saturation - targeted color adjustment techniques for absolute control

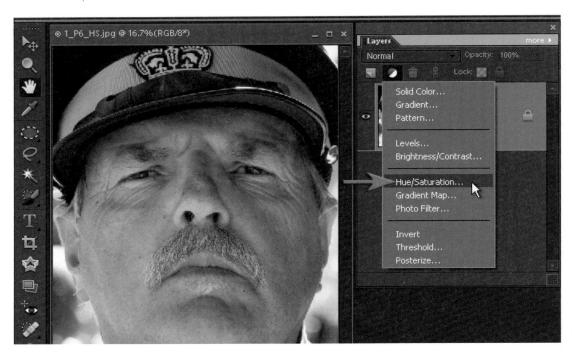

1. From the Layers palette click on the Create Adjustment Layer icon and choose 'Hue/Saturation' to open the Hue/Saturation dialog box.

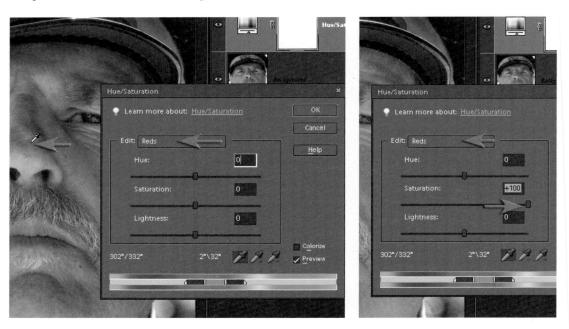

2. From the Edit menu in the Hue/Saturation dialog box choose 'Reds' and then increase the Saturation slider to full strength (+100). Increasing the saturation will help us target a very precise range of reds that we wish to adjust.

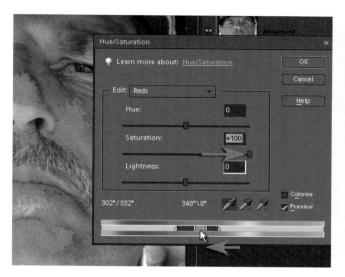

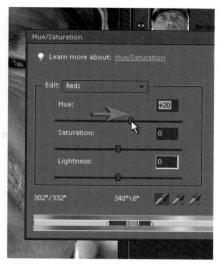

3. At the moment all of the warm colors in the face fall in the broad range of reds and are, as a result, excessively saturated. We will now limit or restrict this range of reds so that only those that represent the sunburnt areas of the face are targeted. On the color ramp in the dialog box you will find four sliders. Move the inner two closer together by dragging them towards each other. Then click between the two sliders and move the range of reds to the left slightly (towards the magenta colors). The aim is to make the skin colors in the image window lose their excessive saturation. When this happens they are no longer targeted. Move the outer sliders inwards. As the target colors move closer to these outer sliders they progressively fall beyond any resulting adjustment. When you have effectively targeted the colors of the sunburnt skin, drop the Saturation slider back to '0' and then move the Hue slider to the right to render these colors the same as the rest of the face. Select OK to apply these changes.

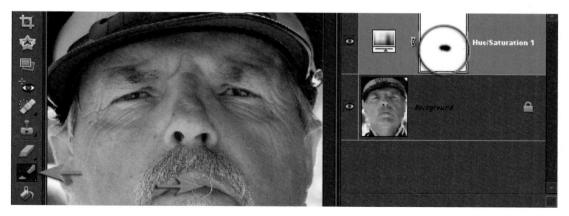

4. Select the 'Paintbrush tool' in the Tools palette with black as the foreground color. Choose a soft-edged brush from the Options bar and paint in the layer mask in the area of the lips and eyes to return these to their normal and healthy (not sunburnt) color.

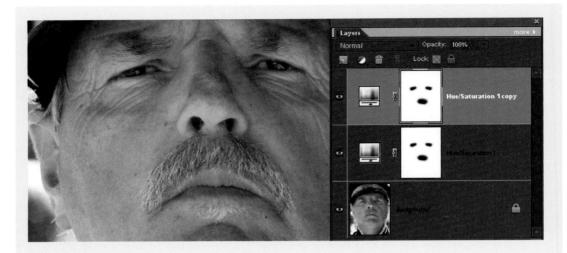

PERFORMANCE TIP

It may be necessary to create a second Hue/Saturation layer to target and fine-tune any remaining colors. Duplicating the adjustment layer by dragging it to the New Layer icon will ensure your masking work is retained. Double-click the Adjustment Layer icon to fine-tune the colors.

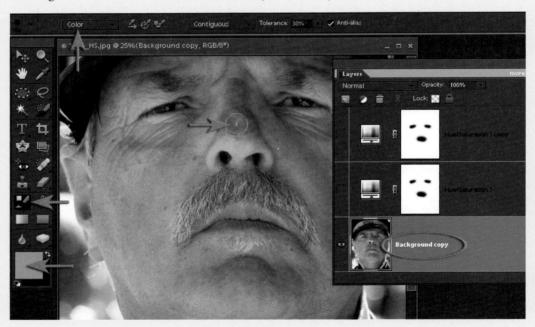

Although not as controlled as using a Hue/Saturation adjustment layer, it is possible to make color corrections using the Color Replacement Brush. Sample a 'preferred' color by holding down the Alt key and clicking the mouse. Using a soft-edged paintbrush paint over a color that needs to be replaced. It is advised that you work on a duplicate background layer and then lower the opacity of this layer to blend in your corrective surgery.

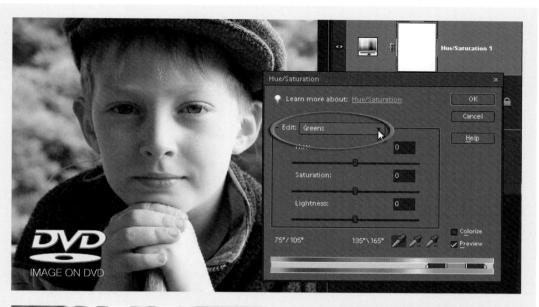

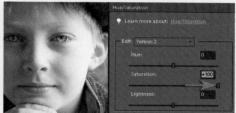

The Hue/Saturation technique has many applications - from changing one odd bloom in a bouquet of flowers to color coordinating a background color with your subject. If you can't capture your subject against the perfect color backdrop it is usually an option to capture it against a color that has nothing in common with the general skin tones and hair color of your subject, e.g. blue sky or green foliage - just remember to mask the blue or green eyes.

Project 7

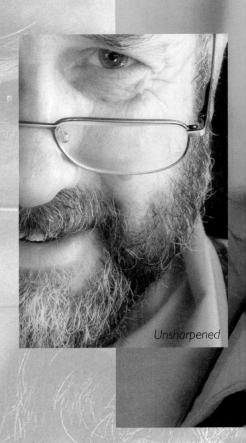

Sharpening

All digital images require sharpening - even if shot on a state-of-the-art digital SLF in focus. Most cameras can sharpen in-camera but the highest quality sharpening is achieved in post-production. Elements will allow you to select the amount and the areas that require sharpening most. For images destined for print the monito preview is just that - a preview. The actual amount of sharpening required for optimum image quality is usually a little more than looks comfortable on screen especially when using an LCD/TFT monitor (flat panel).

Advanced sharpening - targeted sharpening for maximum impact

The basic concept of sharpening is to send the Unsharp Mask filter on a 'seek and manipulate' mission. The filter is programmed to make the pixels on the lighter side of any edge it finds lighter still, and the pixels on the darker side of the edge darker. Think of it as a localized contrast control. Too much and people in your images start to look radioactive (they glow), not enough and the viewers of your images start reaching for the reading glasses they don't own.

The art of advanced sharpening

The best sharpening techniques are those that prioritize the important areas for sharpening and leave the smoother areas of the image well alone, e.g. sharpening the eyes of a portrait but avoiding the skin texture. These advanced techniques are essential when sharpening images that have been scanned from film or have excessive noise, neither of which needs accentuating by the Unsharp Mask. So let the project begin.

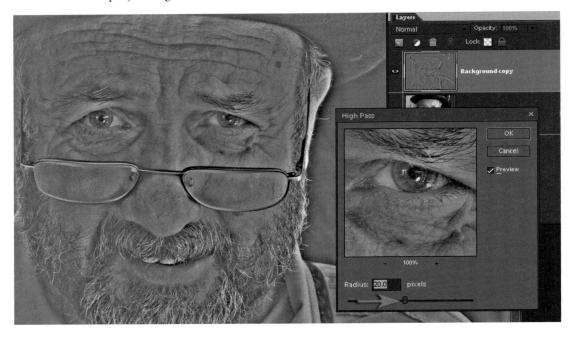

1. Duplicate the background layer by dragging it to the New Layer icon in the Layers palette. Go to 'Filter > Other > High Pass'. Increase the pixel Radius to around 20 to 30 pixels for a 6 to 12 megapixel image. Select OK. Apply the Despeckle filter (Filter > Noise > Despeckle) and also the Dust and Scratches filter (Filter > Noise > Dust and Scratches) using a Radius value of 1 pixel and the Threshold slider set to 0 Levels.

Note > The High Pass filter is sometimes used as an alternative to the Unsharp Mask if the duplicate layer is set to 'Overlay' or 'Soft Light' mode. In this project, however, we are using the High Pass filter to locate the edges within the image only.

PERFORMANCE TIP

If you have any sharpening options in your camera or scanner it is important to switch them off or set them to minimum or low. The sharpening features found in most capture devices are often very crude when compared to the following technique. It is also not advisable to sharpen images that have been saved as JPEG files using high-compression/low-quality settings. The sharpening process that follows should also come at the end of the editing process, i.e. adjust the color and tonality of the image before starting this advanced sharpening technique.

2. Apply a Threshold filter to the High Pass layer from the Filter > Adjustments submenu. The threshold will reduce this layer to two levels - black and white - depending on the brightness value.

3. Drag the slider just below the histogram to isolate the edges that require sharpening. The aim of moving these sliders is to render all of those areas you do not want to sharpen white (or nearly white). Select OK when you are done. You are half way to creating a sharpening mask. The mask will restrict the sharpening process to the edges only (the edges that you have just defined). Increasing or decreasing the radius in the High Pass filter will render the lines thicker or thinner.

4. Paint out any areas that were not rendered white by the Threshold adjustment that you do not want to be sharpened, e.g. in the portrait used in this example any pixels remaining in the skin away from the eyes, mouth, nose and background were painted over using the Brush tool with 'White' selected as the foreground color.

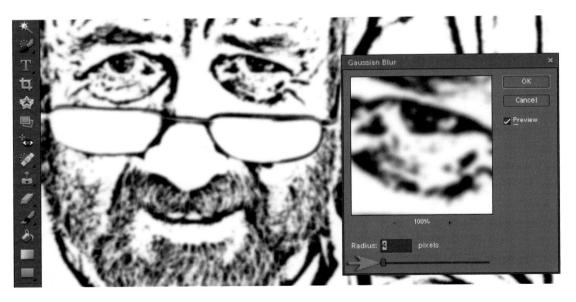

5. Go to 'Filter > Blur > Gaussian Blur' and apply a 4-pixel Radius to blur this layer. This step will ensure that the sharpening process will fade in slowly rather than have an abrupt edge.

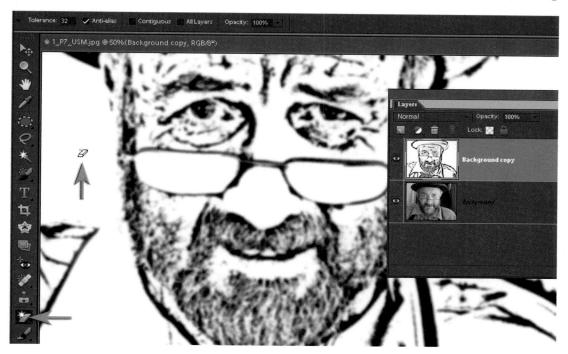

6. Select the 'Magic Eraser tool' in the Tools palette (behind the Eraser tool). Deselect the 'Contiguous' option in the Options bar and then click on any white area within the image. You should be left with only the edge detail on this layer and none of the white areas. The image will appear a little strange until we complete the next couple of steps.

/. Duplicate the background layer and drag this duplicate layer to the top of the layers stack. Ensure the image is zoomed in to 100% for a small image or 50% for a larger print resolution image. From the Layer menu select 'Group with Previous' or position the mouse cursor between the two layers in the Layers palette, hold down the Alt key, and then click when the Group with Previous icon appears. The transparent areas on the Threshold layer will act as a mask so only the important areas of the image will appear sharpened.

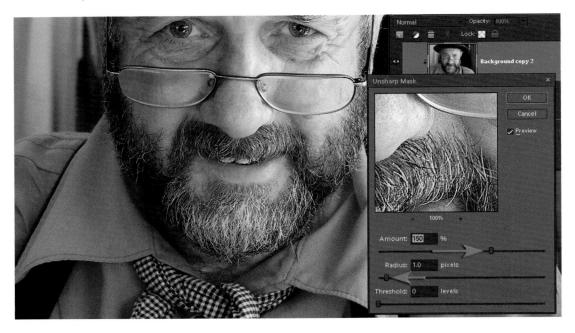

8. Go to 'Enhance > Unsharp Mask'. Adjust the Amount slider to between 80 and 150%. This controls how much darker or lighter the pixels at the edges are rendered. Choose an amount slightly more than what looks comfortable on screen if the image is destined for print rather than screen. The Radius slider should be set to 0.5 for screen images and between 1 and 2 pixels for print resolution images. The Radius slider controls the width of the edge that is affected by the Amount slider. The Threshold slider helps the Unsharp Mask decide where the edges are. If the Threshold slider is raised the Unsharp Mask progressively ignores edges of lower contrast.

PERFORMANCE TIP

If you are sharpening an excessively 'noisy' or 'grainy' image the Threshold slider is moved progressively higher to avoid sharpening non-image data. The exact Threshold setting is not so critical for this advanced technique.

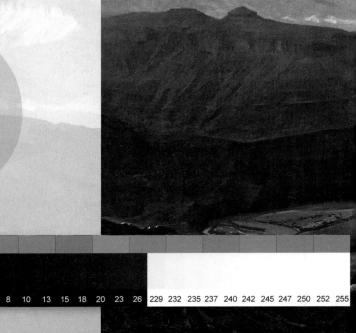

Printing

The secret to successful printing is to adopt a professional print workflow that takes the frustration out of seeing the colors shift as your image moves from camera to monitor, and from monitor to print. Color consistency has never beer more easy and affordable to implement for the keen amateur and professional photographer. This project guides you along the path to ultimate print satisfaction so that you will never say those often heard words ever again – 'why do the colors of my print look different to my monitor?'

Adopt a color management workflow that delivers predictable prints every time

The reward for your effort (a small capital outlay and a little button pushing) is perfect pixels – color consistency from camera to screen to print. Once the initial work has been carried out predictable color is a real 'no-brainer', as all of the settings can be saved as presets. As soon as you start printing using your new color-managed workflow you will not only enjoy superior and predictable prints, but you will also quickly recover the money you outlaid to implement this workflow (no more second and third attempts).

The problem and the solution

Have you ever walked into a TV shop or the cabin of an aircraft and noticed that all the TVs are all showing the exactly the same TV program but no two pictures are the same color? All of the TVs are receiving exactly the same signal but each TV has its own unique way of displaying color (its own unique 'color characteristics'). Different settings on each TV for brightness, contrast and color only make the problem worse.

One signal - different pictures (image courtesy of iStockphoto.com)

In the perfect world there would be a way of making sure that all of the TVs could synchronize their settings for brightness, contrast and color, and the unique color characteristics of each TV could be measured and taken into account when displaying a picture. If this could be achieved we could then send 10 different TVs the same picture so that the image appeared nearly identical on all TVs, irrespective of make, model or age. In the world of digital photography, Adobe has made the illusive goal of color consistency possible by implementing a concept and workflow called Color Management. Color Management, at first glance, can seem like an incredibly complex science for the keen amateur to get their head around, but if just a few simple steps are observed and implemented then color consistency can be yours.

Don't position your monitor so that it faces a window and lower the room lighting so that your monitor is the brightest thing in your field of vision (image courtesy of iStockphoto.com)

Step 1 - Preparing your print workshop

The first step is to optimize the room where your monitor lives. Ideally, the monitor should be brighter than the daylight used to light the room and positioned so the monitor does not reflect any windows or lights in the room (the biggest problems will all be behind you and over your shoulders as you sit at the monitor). Professionals often build hoods around their monitors to prevent stray light falling on the surface of the monitor but if you carefully position the monitor in the room you should be able to avoid this slightly 'geeky' step. Stray light that falls on your monitor will lower the apparent contrast of the image being displayed and could lead you to add more contrast when it is not required. The color of light in the room (warm or cool) is also a critical factor in your judgement of color on the screen. It is advisable to light the room using daylight but this should not be allowed to reflect off brightly colored surfaces in the room, e.g. brightly painted walls or even the brightly colored top you may be wearing when you are sitting in front of your monitor. If the room is your own personal space, or your partner supports your passion/obsession/ addiction for digital imaging, then you could go that bit further and paint your walls a neutral gray. The lighting in the room should be entirely daylight - without the possibility of warm sunlight streaming into the room at certain times of the day. The brightness of the daylight in the room can be controlled with blinds or you can introduce artificial daylight by purchasing color corrected lights, e.g. Solux halogen globes or daylight fluorescent lights. If the above recommendations are difficult to achieve - lower the level of the room lighting significantly.

Overview of step 1 > Position your computer monitor so that it does not reflect any windows, lights or brightly colored walls in the room (when you sit at the monitor a neutral colored wall, without a window, should be behind you). Use daylight or daylight globes to light the room and make sure the room lighting is not as bright as the monitor (the monitor should be the brightest thing in your field of view).

Step 2 - Preparing the monitor

Purchase a monitor calibration device (available for as little as US\$100 from X-Rite, ColorVision or Pantone) and follow the step-by-step instructions. The calibration process only takes a few minutes once you have read through the instructions and adjusted a few settings on your monitor. It is now widely accepted that photographers should choose a D65 whitepoint (how cool or warm tones appear on your monitor) and a Gamma of 2.2 (this controls how bright your midtones are on your monitor). The next time you use your calibrated and profiled monitor, Photoshop Elements will pick up the new profile to ensure you are seeing the real color of the image file rather than a version that has been distorted by the monitor's idiosyncrasies and inappropriate default settings.

MONITOR CALIBRATOR RECOMMENDATIONS

If you are on a budget I recommend the ColorVision Spyder 2 Express or the Pantone Huey. If you have a little more money and are looking for a really professional tool, then the Eye One Display 2 is my personal favorite, although it costs a little more. If you decide on the Spyder 2 Express I found the only hiccup in an otherwise easy-to-follow guide was the instruction on how to decide whether your LCD monitor had a 'brightness' or 'backlight' control. As the vast majority of LCD monitors use a 'backlight' to control brightness I think this information is a possible source of confusion. The tiny Pantone Huey is really easy to use, completes the process in just a few minutes, and has an option to measure the brightness of the room and then adjust the brightness of the monitor accordingly. I would recommend that you lower the brightness of the LCD monitor to a setting of between 50 and 75% before calibrating an LCD screen with the Huey. The automatic brightness adjustment of the monitor is only useful if you can't maintain a standard level of illumination in your room. If you think small is cute, then the Huey will do an admirable job and you can put it in your shirtpocket when you're done.

If you are working on a tired and old CRT monitor (one of the ones that look like an old TV) and would like to pursue color consistency, now might be the time to treat yourself to that sleek new LCD monitor you have been promising yourself for ages (the useful life expectancy for a CRT for color critical work is no more than three years). If you currently use a laptop screen I would recommend that you purchase a separate desktop monitor for your color-critical editing work

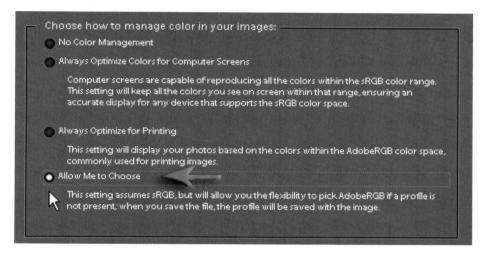

Step 3 - Preparing Photoshop Elements' 'Color Settings'

Photoshop Elements can work with the range of colors (called a color gamut) that can be displayed on a monitor and also those that can be printed using inks and dyes. To work with these additional colors that are out of the range of most monitors, Adobe implemented the concept of using a 'working space' instead of a monitor space for editing digital images. Photoshop Elements has a choice of two working spaces, sRGB and Adobe RGB. When creating images for screen or web viewing use the sRGB working space and when preparing images for print use the Adobe RGB working space. The Adobe RGB color space makes use of a larger color gamut than sRGB - a range of colors that can typically be reproduced by inkjet printers. Go to your Edit menu in Photoshop and open the 'Color Settings' dialog box. Select the 'Allow Me to Choose' option.

PERFORMANCE TIP

When preparing the same images for both print and the web use the Adobe RGB profile. After optimizing the images for print you can then duplicate the images and convert the color profile of the images destined for the web to sRGB (Image > Convert Color Profile > Apply sRGB Profile).

Step 4 - Preparing to print to your own inkjet printer

Just as the color characteristics of the monitor had to be measured and profiled in order to achieve accurate color between camera and monitor, a profile also has to be created that describes the color characteristics of the printer. This ensures color accuracy is maintained between the monitor and the final print. When an accurate profile of the printer has been created Photoshop Elements, rather than the printer, can then be instructed to manage the colors to maintain color consistency. Photoshop Elements can only achieve this remarkable task because it knows (courtesy of the custom profile) how the printer skews color.

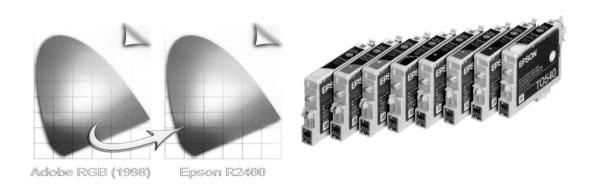

If you hope to achieve optimum print quality at home it is recommended that you use a photoquality printer (one with six or more inks), one that will let Photoshop Elements manage the colors for the best results. A custom profile is only accurate so long as you stick to the same ink and paper. Additional profiles will need to be created for every paper surface you would like to use. Printers come shipped with profiles, but these are of the 'one size fits all' variety, affectionately known as 'canned profiles'. For optimum quality, custom printer profiles need to be made for the unique characteristics of every printer (even if they are of the same brand and model number).

PERFORMANCE TIP

In an attempt to make the first time not too memorable, for all the wrong reasons, check that your ink cartridges are not about to run out of ink and that you have a plentiful supply of good quality paper (same surface and same make). Refilling your ink cartridges with a no-name brand and using cheap paper is not recommended if you want to achieve absolute quality and consistency. I would recommend that you stick with the same brand of inks that came shipped with your printer and use the same manufacturer's paper until you have achieved your first successful workflow.

Step 5 - Download a profile target

You can profile your printer, but the equipment is expensive. You can, however, print out a sample pattern and mail it to a company that has the equipment and will make the profile for you. Download a profile target from the website of the company who will create your custom printer profile. The target print can be mailed back to the company and your profile can be emailed back to you once it has been created by analyzing the test print you created.

Step 6 - Open the profile target file in Photoshop Elements

Open the target print you have downloaded from your profile service provider and select 'Leave as is' in the 'Missing Profile' dialog box. If the file opens and no dialog box appears then close the file and check that you have changed the Color Settings as outlined in step 3. The color swatches on the target print must remain unchanged by the color management mechanisms for this process to be effective.

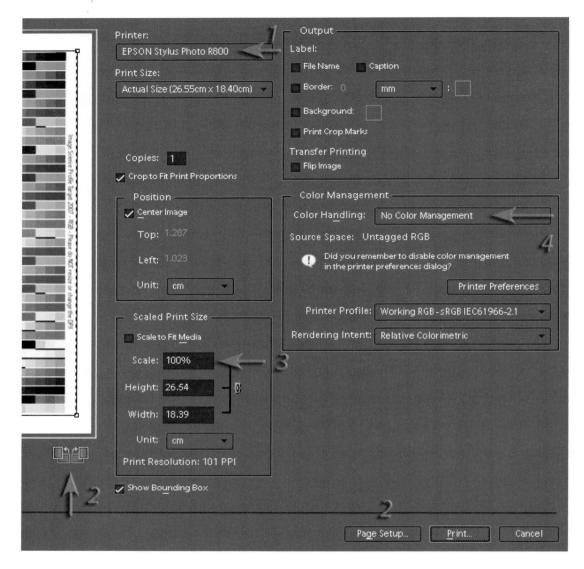

Step 7 - Print settings in Photoshop Elements

When the target image is open in Photoshop Elements proceed to 'File > Print'.

- 1. Select your printer from the 'Printer' menu.
- Click on the 'Page Setup' to choose the size of your printing paper (large enough to print the
 target image at 100%). Note > You can also rotate the image or rotate the paper orientation
 within the Page Setup dialog box.
- 3. Make sure that the scale is set to 100%.
- 4. In the 'Color Management' section of the dialog box choose 'No Color Management' for the Color Handling option. The Source Space should read 'Untagged RGB' and there will be a reminder to switch off the color management in the Printer Preferences dialog which we will do in the next step.

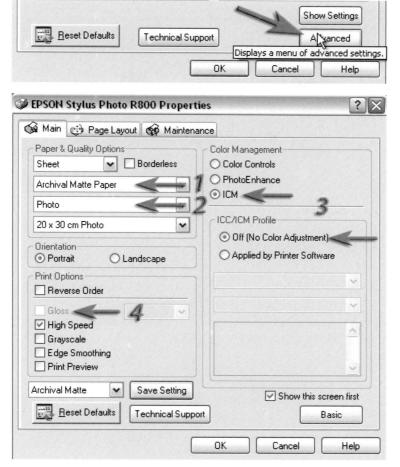

The printer driver of an Espon R800 - the layout and naming of the various options will vary between different makes and models of printers

Step 8 - Printer Preferences

Click on Printer Preferences in Photoshop's printer dialog box (in the Color Management section) and then choose the 'Advanced' options in your printer driver if available. In the printer driver dialog box choose the paper or media type (1), photo print quality (2) and switch off the color management (3), any Auto settings, a 'Gloss' option (4) if available and, for owners of Canon printers, make sure the 'Print Type' is set to 'NONE'. The precise wording for switching off the color management in the printer driver will vary depending on the make of the printer and the operating system your are using. When using an Epson or Canon printer you may see that color management is referred to as ICM or ICC. Other manufacturers may refer to letting the software (Photoshop Elements) manage the color. When you print this target print, the colors are effectively printed in their raw state. In this way the lab that creates your profile can measure how the colors vary from one printer to another and they can then create a unique profile that best describes what your printer does with standard 'unmanaged' color.

Part 1: Optimize

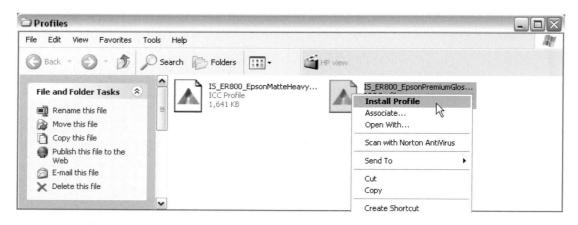

Step 9 - Install your custom profile

Send the target print to the profiling company so that it can be measured using the sophisticated and expensive profiling hardware and software that is best left to the experts. They will email you the profiles after just a few days as an attachment. Right-click the profile and choose Install, and Windows will install it in the correct location.

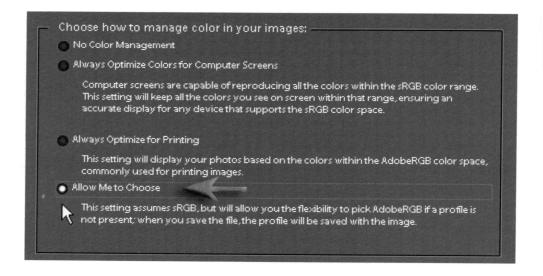

Step 10 - Tag your images with the Adobe RGB profile

When you have installed your custom printer profile make sure that most of your images destined for print are tagged with the Adobe RGB profile. Select the Adobe RGB profile in the camera if possible (digital SLR cameras and many prosumer fixed-lens digicams allow the photographer to choose this setting). Change the Color Settings in Photoshop Elements (Edit > Color Settings) to 'Always Optimize for Printing'. Changing the 'Color Settings' to Always Optimize for Printing in Photoshop Elements will ensure any files being opened from Adobe Camera Raw will automatically be tagged with the Adobe RGB profile rather than the sRGB profile.

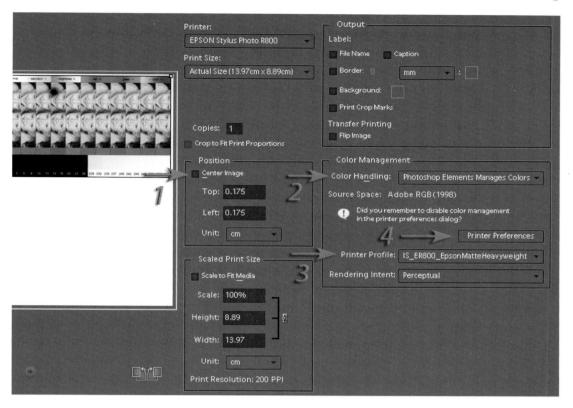

Step 11 - Select Photoshop Elements Manages Colors

It is recommended that the first print you make using your custom profile is a test image - one that has a broad range of colors and tones. A test image with skin tones can be very useful for testing the accuracy of your new print workflow. A small test image is provided on the supporting DVD. When you next open the 'Print' dialog box make sure you change the previous setting used to print the profile target from 'Printer Manages Colors' to 'Photoshop Elements Manages Colors'. Then select your new custom profile from the Printer Profile menu.

Step 12 - Making printer presets for quick and easy printing

From the Printer Preferences menu select the same settings that were used to print the profile target (don't forget to ensure the color management is turned 'OFF'). Save a 'Preset' or 'Setting' for all of the printing options so that you only choose this one setting each time your revisit this dialog box. View your first print using bright daylight and you will discover, if you have followed these directions to the letter, that you have almost certainly found a solution to one of the mysteries of digital color photography - the search for predictable color.

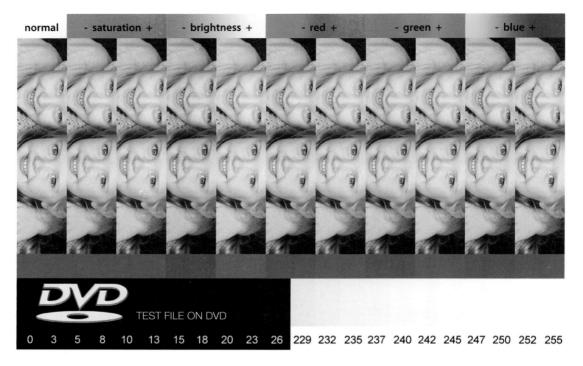

Use the test file to help you target the perfect color balance quickly and efficiently

Step 13 - Assessing the test print for accuracy

View the print using daylight (not direct sunlight) when the print is dry, and look for differences between the print and the screen image in terms of hue (color), saturation and brightness.

- 1. Check that the color swatches at the top of the image are saturated and printing without tracking marks or banding (there should be a gradual transition of color). If there is a problem with missing colors, tracking lines or saturation, clean the printer heads using the Maintenance setting in the Printer Driver.
- 2. View the skin tones to assess the appropriate level of saturation.
- 3. View the gray tones directly beneath the images of the children to determine if there is a color cast present in the image. The five tones on the extreme left are gray in the image file. If these print as gray then no further color correction is required.

PERFORMANCE TIP

Any differences between the monitor and the print will usually now be restricted to the differences in color gamuts between RGB monitors and CMYK printers. The vast majority of colors are shared by both output devices but some of the very saturated primary colors on your monitor (red, green and blue) may appear slightly less saturated in print. Choose a printer with an inkset that uses additional primary inks if you want to achieve the maximum gamut from a printer.

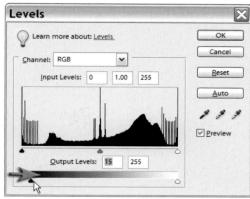

Step 14 - Maximizing shadow and highlight detail

Examine the base of the test strip to establish the optimum highlight and shadow levels that can be printed with the media you have chosen to use. If the shadow tones between level 15 and level 20 are visible on screen but are printing as black then you could either try choosing an alternative media type in the printer driver or establish a Levels adjustment layer to resolve the problem in your Photoshop Elements. The bottom left-hand slider in the Levels dialog box should be moved to the right to reduce the level of black ink being printed (raise it to a value of no higher than 10 if you wish to preserve your black point). This should allow dark shadow detail to be visible in the second print.

Note > It is important to apply these Output level adjustments to an adjustment layer only as these specific adjustments apply only to the output device and media you are currently testing.

PERFORMANCE TIP

Materials

Start by using the printer manufacturer's recommended ink and paper. Use premium grade 'photo paper' for maximum quality.

Monitor

Position your monitor so that it is clear of reflections.

Let your monitor warm up for a while before judging image quality.

Calibrate your monitor using a calibration device.

Adobe

Set the Color Settings of the Adobe software to allow you to use the Adobe RGB profile.

Select 'Photoshop Elements Manages Color'.

Use a six-ink (or more) inkjet printer or better for maximum quality.

Select the 'Media Type' in the Printer Software dialog box.

Select a high dpi setting (1440 dpi or greater) or 'Photo' quality setting. Use a custom printer profile.

Proofing

Allow print to dry and use daylight to assess color accuracy of print.

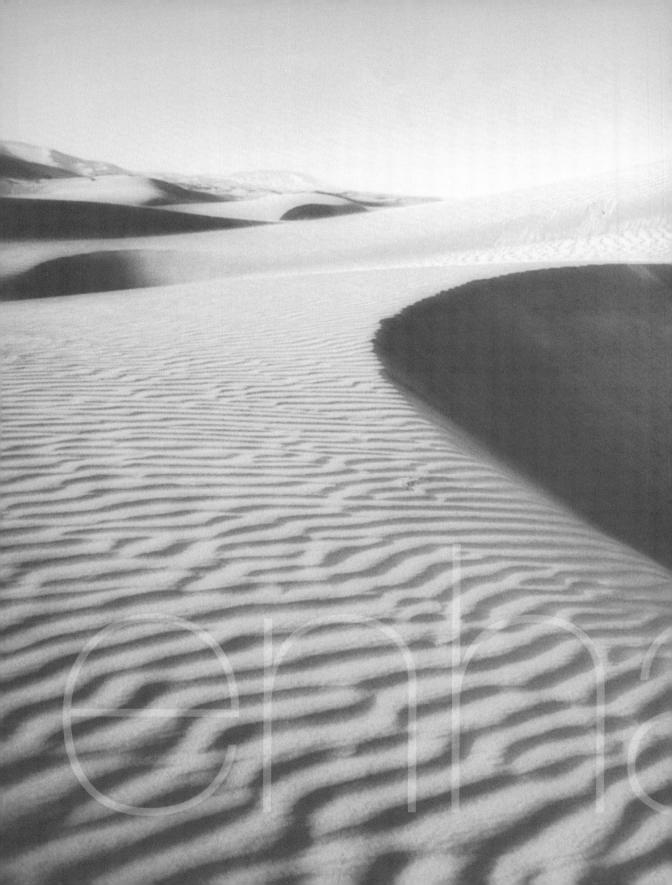

part 2

enhance

Project 1

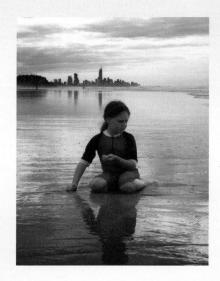

Depth of Field

The Gaussian Blur filter can be used creatively to blur distracting backgrounds. Most digital cameras achieve greater depth of field (more in focus) at the same aperture when compared to their 35 mm film cousins, due to their comparatively small sensor size. This is great in some instances but introduces unwelcome detail and distractions when the attention needs to be firmly fixed on the subject.

There is often a lot to think about during the capture of an image, and the time required to consider the appropriate aperture and shutter speed combination for the desired visual outcome often gets the elbow. Photoshop Elements can, however, come to the rescue and drop a distracting background into a murky sea of out-of-focus oblivion. Problems arise when the resulting image, all too often, looks manipulated rather than realistic. A straight application of the Gaussian Blur filter will have a tendency to 'bleed' strong tonal differences and saturated colors into the background fog, making the background in the image look more like a watercolor painting than a photograph. The Gaussian Blur filter will usually require some additional work if the post-production technique is not to become too obvious.

Decrease the depth of field to emphasize your subject

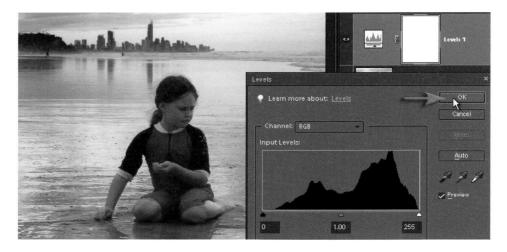

1. Not all subjects lend themselves to automated extraction processes. Professionals using the full version of Photoshop often make use of 'Channels' to start the process of creating a mask where there is not sufficient contrast between the subject and its background. As channels are off limits for Photoshop Elements users (Photoshop Elements uses them but you are not allowed to see them) we need to use a workaround. We can borrow or hijack a layer mask from an adjustment layer for our purposes in this project.

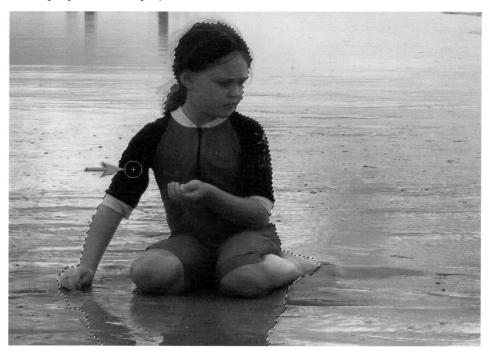

Choose the Quick Selection tool from the Tools palette and drag the tool over the girl and her reflection in the water. The Quick Selection tool will probably include the water underneath the girl's arm as part of the initial selection.

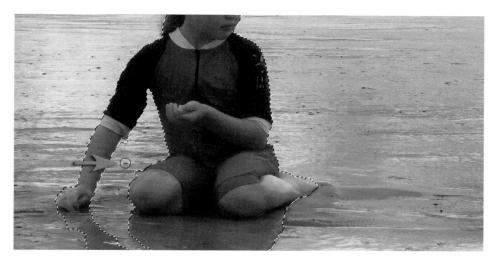

2. Reduce the diameter of the brush size by clicking on the Brush picker icon in the Options bar. Hold down the Alt key and then paint over any areas of water that need to be excluded from the selection.

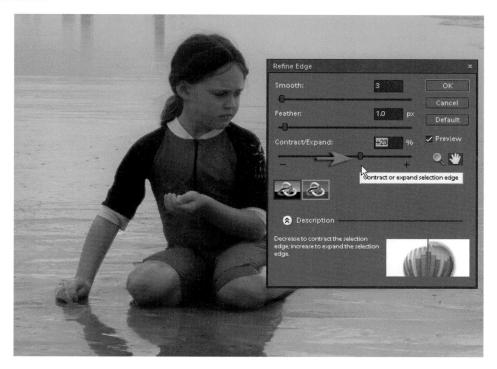

3. Click on the Refine Edge button in the Options bar and choose to view the selection with a mask by selecting the Custom Overlay Color option. Set the Smooth to a value of 3 and enter a 1-pixel feather to soften the edge of the selection. Drag the Contract/Expand slider to the right so that the edge of the mask color sits directly over the edge of the girl. Select OK to apply these adjustments to the selection.

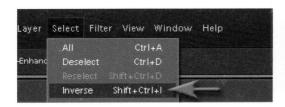

4. From the Select menu choose Inverse. In the Layers palette select Levels from the Create adjustment layer pull-down menu. The selection will create a layer mask and this will become the area of sharp focus. Make no adjustment in the Levels dialog box - just select OK. Hold down the Alt key and click on the layer mask to view the contents of the mask.

5. Focus is not a brick wall, i.e. it does not start and end suddenly - it gradually fades in and out. Think Gradient tool when you are thinking of fading between masked and unmasked (sharp and unsharp). Choose the 'Gradient tool' in the Tools palette. Choose the 'Black/White' and 'Reflected gradient' options in the Options bar and set the mode to Multiply. Drag a gradient from the base of the girl to somewhere around the horizon line in the distance (holding down the Shift key as you drag will constrain the gradient so that it is not crooked). Drag the gradient a second time to darken the mask further. The resulting gradient will extend the focus in front and behind the girl. This will become our plane of focus.

Note > The TIFF file for this project has a saved selection (Selection > Load Selection > DOF). Creating a layer mask with this active selection will automatically create the layer mask in step 5.

6. Switch to the Linear option in the Options bar, set the mode to Screen and select the Reverse Option. Drag a gradient from the base of the image to the point just below where the girl is in contact with the sand. This will help to reduce focus in the reflection slightly.

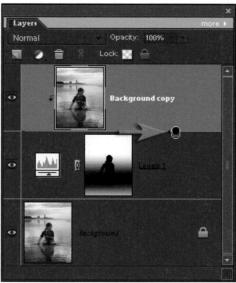

7. Drag the background layer to the New Layer icon and then drag it to the top of the layers stack (shortcuts - Ctrl + J to duplicate background layer, then Ctrl + Shift + J to move this duplicate layer to the top of the layers stack). Group this background copy layer with the adjustment layer below (Layer > Group or Ctrl + G or by holding down the Alt key and clicking on the dividing line between the two layers).

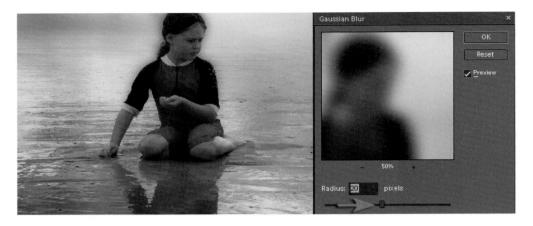

8. Go to Filter > Blur > Gaussian Blur and apply a generous amount of blur (20 pixels in this project). How much you drop the focus is pretty much a subjective step. Very shallow depth of field is achieved with larger apertures, a close vantage point and larger format cameras. If you are generous with the pixel radius in the Gaussian Blur filter the image will appear as though it was created with a large format film camera - something that is impossible to achieve with a digital compact unless you are shooting an insect or flower in macro mode. The power of this effect is to remove distracting background clutter from the image, isolate the subject and keep the focus entirely on the focal point of the image. Unfortunately the effect at this stage has a few shortcomings. The effect of blurring the background has bled some of the darker and more saturated tones into the lighter more desaturated background. A tell-tale halo is forming that indicates this effect has been achieved in post-production rather than in-camera.

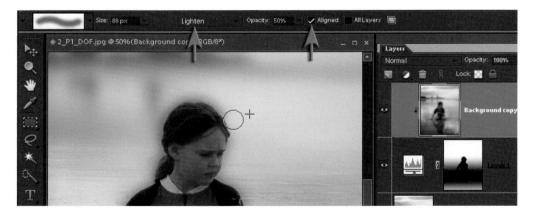

9. The problem is resolved by careful application of the Clone Stamp tool. Select the background copy layer, then pick the Clone Stamp tool. In the Options bar, check the Aligned option and set the Mode to Lighten, and hold down the Alt key as you select some pixels further away from the edge, where the bleed has not extended to, and paint these pixels back into the affected border regions. Switch from Lighten to Darken modes if you encounter brighter tones bleeding into a darker background.

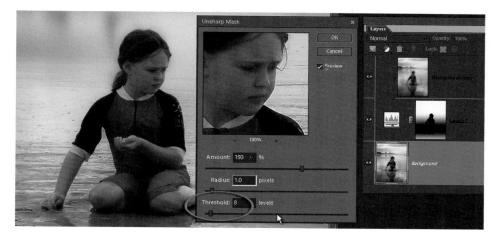

10. Adjustment to the sharpness of the image can be made to the background layer as this is the only portion of the image that remains in focus. There is some noise present in this image so sharpening is best achieved using the Unsharp Mask (Enhance > Unsharp Mask) with the Threshold slider raised to 7 or 8.

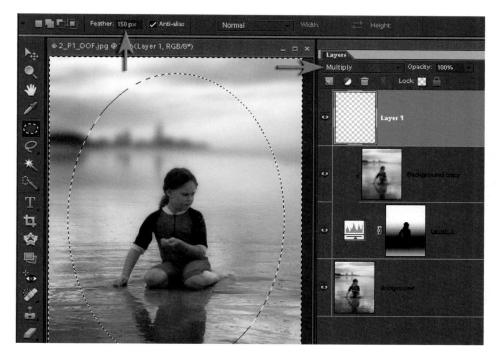

11. The viewer's attention can be further restricted to the central subject by adding a subtle vignette so that the image progressively gets brighter towards the center (we are visually drawn to the light). Create an empty new layer and set the mode to Multiply. Select the Elliptical Marquee tool and set the feather in the Options bar to 150 pixels. Create a large elliptical selection and from the Select menu choose Inverse.

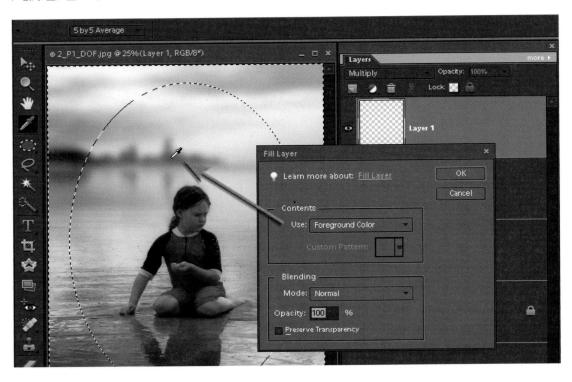

12. Choose 'Edit > Fill Selection' and choose Foreground Color from the Contents section of the dialog box. Choose a dark blue from within the image window and then select OK. Reduce the opacity so the vignette sits on the edge of your perception for the most subtle effect.

FUTURE DEVELOPMENTS SHIFTING FOCUS

If digital cameras are eventually able to record distance information at the time of capture this could be used in the creation of an automatic depth map (the Lens Blur filter in the full version of Photoshop can already use channels or layer masks to create automated depth of field effects, but the channel must still be created manually using the techniques outlined in this project). Choosing the most appropriate depth of field could be relegated to post-production image editing in a similar way to how the white balance is set in camera Raw.

Shafts of Light

Here we explore the science of making good photographs even more memorable. Discover how to add drama to your landscape images using the 'Fingers of God' tool (aka the Gradient tool with customized settings). Creating effective landscape images is not exactly rocket science. Choose a beautiful landscape just after dawn, or just before sunset, and add dramatic natural lighting to create emotive and memorable landscape images.

Let there be light - create dramatic lighting effects to enhance the drama of your images

Clear blue skies are great for holidays on the beach but the best natural lighting for photography is provided by broken or filtered sunlight through partial cloud cover. The most memorable of all lighting is when shafts of light break through the clouds. Finding partial cloud cover when the sun is low is relatively easy; being present when shafts of light flood your selected vista, however, can be an elusive and rare event. This final and quintessential ingredient requires patience, persistence and good fortune - or a good helping of post-production editing courtesy of Photoshop Elements.

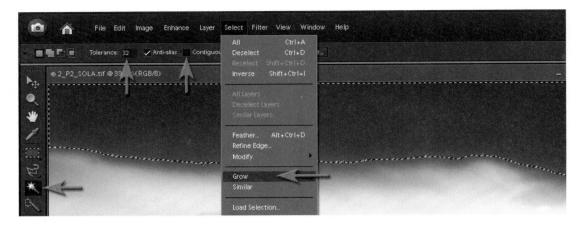

1. Choose the 'Magic Wand' in the Tools palette and deselect the 'Contiguous' option in the Options bar. Click on the dark blue sky at the top of the image to make a selection that excludes the yellow sky (this region will play host to the shafts of light). Hold down the Shift key and keep selecting areas/colors with the Magic Wand until everything except the yellow sky is selected. Selecting the Grow command from the Select menu to expand the selection may also help in making this selection.

Note > Deselecting the 'Contiguous' option will allow the Magic Wand to select all similar pixels, even if they are not adjoining the area clicked on.

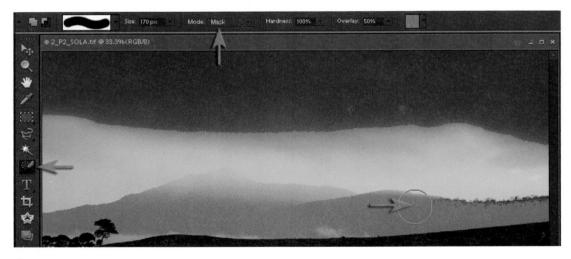

2. Choose the 'Selection Brush tool' from the Tools palette and choose the 'Mask' option from the Options bar. The 'Mask' option enables you to see your selection as a painted mask so you can easily see what areas are selected. Choose an appropriate brush size and paint to add areas of the sky missed by the Magic Wand. Hold down the Alt key as you paint to remove any areas of the mask (and resulting selection) that are not required.

Note > You can choose an alternative color for the overlay mask and adjust the opacity in the Options bar to make the selection process easier.

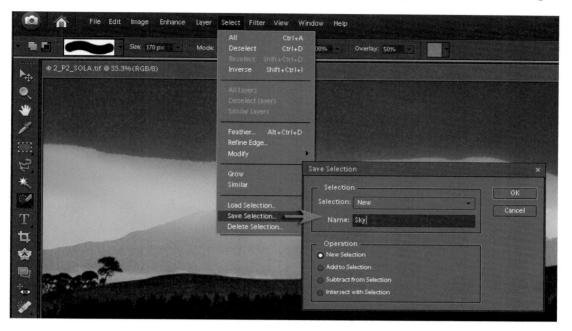

3. Go to the Select menu and choose 'Save Selection'. You can give your selection a name to help you locate this for a later stage in the editing process. Choose 'Deselect' from the Select menu.

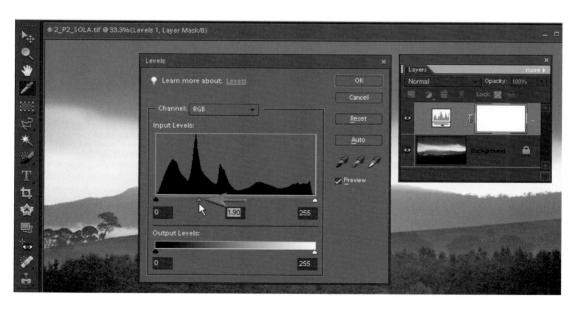

4. From the top of the Layers palette click on the Create New Fill or Adjustment Layer icon and choose 'Levels' from the menu. Drag the central Gamma slider in the dialog box to the left to substantially brighten the image. The tonality for the majority of the image will be returned to normal by creating a sophisticated layer mask for this adjustment layer in the next stages of the tutorial.

5. Select black as the Foreground color and the 'Gradient tool' in the Tools palette and then click on the Edit button in the Options bar to open the Gradient Editor. Click on the 'Transparent Stripes' gradient. Edit the gradient using the following pointers. The aim of editing the gradient is to make the stripes irregular widths with softer edges to emulate the irregular and softer nature of shafts of light. The white stops on the top of the editing ramp indicate full transparency whilst the black stops indicate full opacity of the foreground color. Click and drag the stops into groups of four. A white stop should be on either end of a grouping of four with two black stops next to each other in the middle. Moving the black stops further apart will broaden the stripe. Moving the white stop further away from the central black stops will broaden the area of transition between full opacity and full transparency. To add a stop hold down the Alt key and drag an existing stop a short distance. To remove a stop drag the stop away from the gradient ramp. To add this modified gradient to the Presets click on the New button and give your shafts of light a suitable name (don't worry that the shafts are colored black for the moment). This gradient can be loaded from the Preset that is available on the DVD.

Note > A black stop can be changed to a white stop or vice versa by clicking on the stop and then adjusting the Opacity slider in the bottom Stops section of the Gradient Editor.

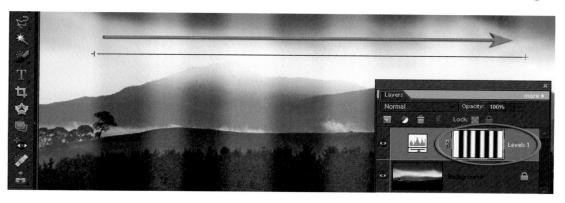

6. Make sure the 'Linear' gradient option is selected in the Options bar and set the opacity to 100% and the mode to 'Normal'. The foreground color should still be set to black. Click on the left side of the image window and drag your mouse cursor to the right side of the image window. The length of the line you draw will be the initial width of the shafts, although this can be modified using the Transform command outlined in the following step.

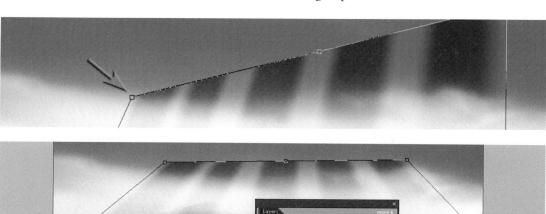

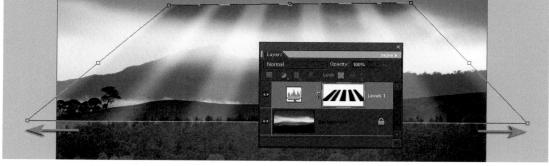

7. From the Image menu select 'Distort' from the Transform submenu. Click on each of the corner handles and drag them to fan the shafts of light. Move the cursor into the Transform bounding box, and click and drag the bounding box to reposition the shafts of light. When you're satisfied with the shape, double-click inside the distorted bounding box to accept the transformation.

Note > You may need to extend the image window so that you can drag the corner handles to the required angle.

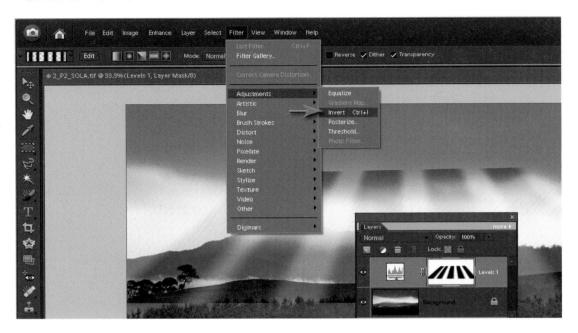

8. Go to the Filter menu and select 'Invert' from the Adjustments submenu. This will turn the black stripes to white and return the brightness level of the rest of the image to normal. The next step will aim to limit the shafts of light to the selection made at the start of the tutorial.

9. From the Select menu choose 'Load Selection' and load the selection saved at the start of the tutorial. From the Edit menu choose the 'Fill Selection' command and select 'Black' as the fill color and then select OK. This will further limit the shafts of light to the desired location.

10. Select the Gradient tool and choose the 'Foreground to Transparent' gradient. Drag a short gradient from the start of the shafts of light to conceal their hard edges.

11. To soften the mask further choose Filter > Blur > Gaussian Blur. Select a pixel Radius that will soften the edges of the mask so the cut-off of the lighting behind the distant hill is subtle. The only problem with this technique is that it is almost too effective and therefore tempting to sneak it into too many images in your personal portfolio. When this happens the cat will be well and truly out of the bag.

Note > It is possible to increase the intensity of the shafts of light by switching the blend mode of the adjustment layer to 'Screen'. Adjust the opacity to fine-tune the effect.

PERFORMANCE TIP

Create a focal point by introducing some birds that will be silhouetted against the shafts of light. Open the second image file and drag the thumbnail from the background layer (in the Layers palette) into the image window of the project. Holding down the Shift key when you let go of the file will center it in the host image. Switching the blend mode to 'Multiply' will render the white background of this layer invisible. Good just got better.

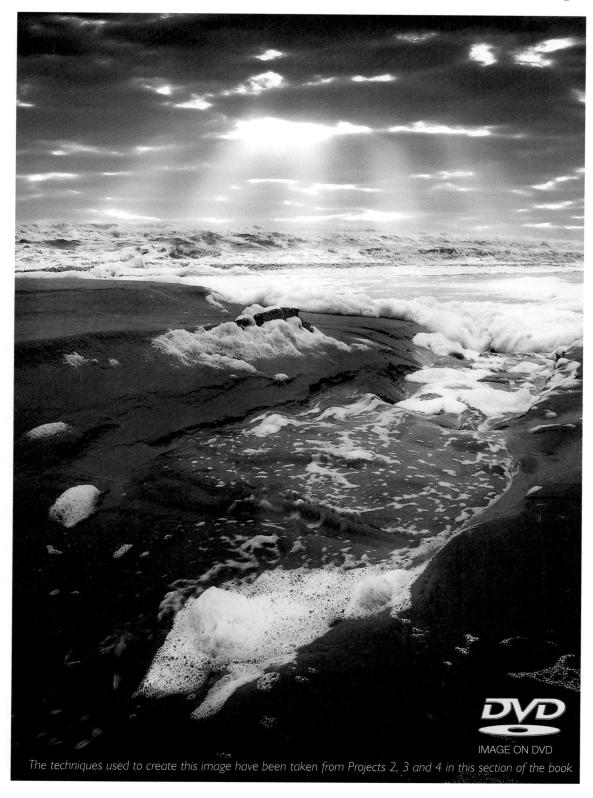

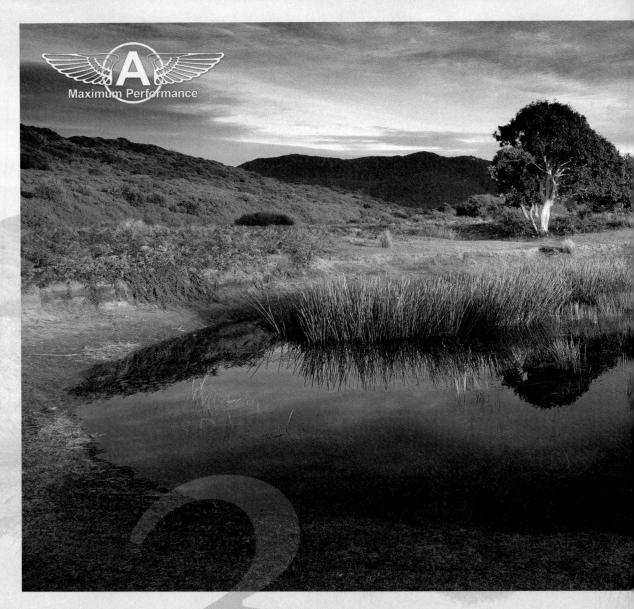

Project 3

The original color image and the result of choosing the less than satisfactory Remove Color command

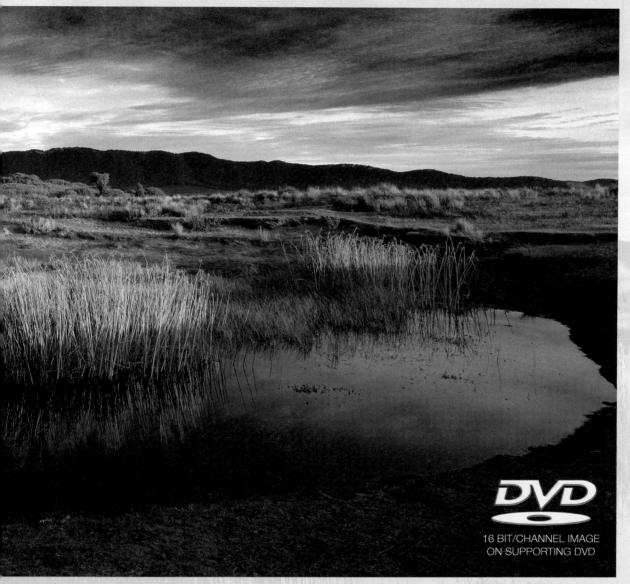

Black and white - when 'luminance' is more important than color. Original image by Michael Wennrich

Black and White

When color film arrived over half a century ago the pundits who presumed that black and white images would die a quick death were surprisingly mistaken. Color is all very nice but sometimes the rich tonal qualities that we can see in the work of the photographic artists are something certainly to be savored. Can you imagine an Ansel Adams masterpiece in color? If you can - read no further.

The conversion from color to black and white

The creation of dramatic black and white photographs from your color images is a little more complicated than simply converting your image to Grayscale mode or choosing the Desaturate command. Ask any professional photographer who is skilled in the art of black and white and you will discover that crafting tonally rich images requires a little knowledge about how different color filters affect the resulting tonality of a black and white image.

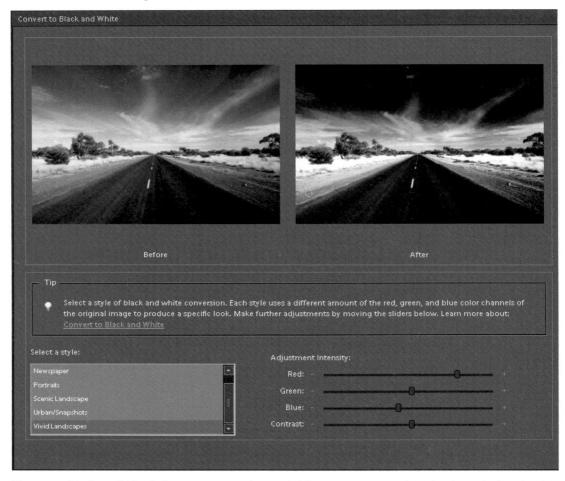

'Convert to Black and White' allows you to mix the tonal differences present in the color channels. Simply select a style and then adjust the intensity sliders to create your own custom conversion

As strange as it may seem, screwing on a color filter for capturing images on black and white film has traditionally been an essential ingredient of the recipe for success. The most popular color filter in the black and white photographer's kit bag, which is used for the most dramatic effect, is the red filter. The effect of the red filter is to lighten all things that are red and darken all things that are not red in the original scene. The result is a print with considerable tonal differences compared to an image shot without a filter. Is this a big deal? Well, yes it is - blue skies are darkened and skin blemishes are lightened. That's a winning combination for most landscape and portrait photographers wanting to create black and white masterpieces.

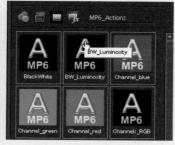

PERFORMANCE TIP

The Maximum Performance Actions included on the DVD includes a series of automated black and white conversions (see the introductory section for installing Maximum Performance Actions). The Black&White_Luminosity action creates a single monochrome layer containing the Luminosity values of the RGB file (usually a superior black and white conversion when compared with the Remove Color command). The Red, Green and Blue channel actions allow you to place one of the three color channels as a black and white layer. These actions would also be useful for accessing the best contrast in order to create a mask, as in the Depth of Field project.

In the image to the left the red channel was used as this offered the best detail in the dark skin tones. The contrast was then increased by duplicating the layer and switching the blend mode to 'Soft Light'. The opacity of this duplicate layer was then dropped to 30%. A vignette was added to complete the project

Part 2: Enhance

The Convert to Black and White command (Enhance > Convert to Black and White) allows the user to selectively mix the differences in the tonality present in the three color channels, but unfortunately it is not available as an adjustment layer. This means we are unable to make use of the layer mask that typically comes with an adjustment layer. It also means that we would be unable to modify the color conversion at a later date without returning to the original color file. This approach to the conversion (although vastly superior to anything present in previous versions of the software) limits the usefulness of the technique for those users who wish to extract the maximum amount of control and flexibility over the process of black and white conversion. The famous digital guru, Russell Preston Brown, has come up with a workaround that enables us to retain complete control over the black and white conversion using multiple adjustment layers.

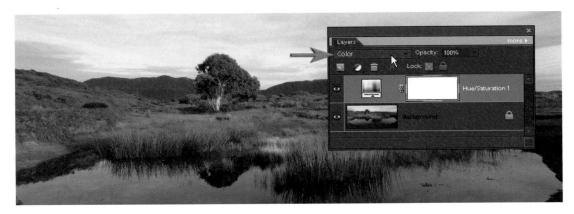

1. Drag the Layers palette from the Palette Bin (this will be your command center for this technique). Click on the Adjustment Layer icon in the Layers palette and scroll down the list to select and create a Hue/Saturation adjustment layer. You will make no adjustments for the time being but simply select OK to close the dialog box. Set the blend mode of this adjustment layer to 'Color'.

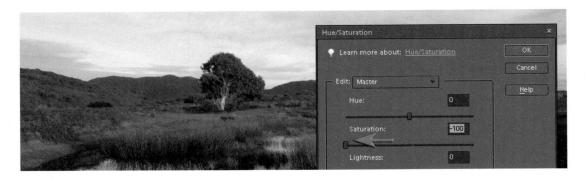

2. Create a second Hue/Saturation adjustment layer. Slide the Saturation slider all the way to the left (–100) to desaturate the image. Select OK. The image will now appear as if you had performed a simple Convert to Grayscale or Desaturate (remove color) command.

Note > This second adjustment layer should be sitting on top of the layers stack.

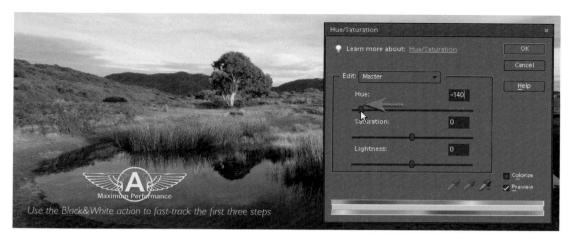

3. Select the first Hue/Saturation layer that you created and double-click the layer thumbnail to reopen the Hue/Saturation dialog box. Move the Hue slider in this dialog box to the left. Observe the changes to the tonality of the image as you move the slider. Blues will be darkest when the slider is moved to a position around –150. Select OK. The drama of the image will probably have been improved quite dramatically already but we can take this further with some dodging and burning.

Note > A Maximum Performance Action is available to fast-track the first three steps in this project (see the introductory section for installing and using Maximum Performance Actions).

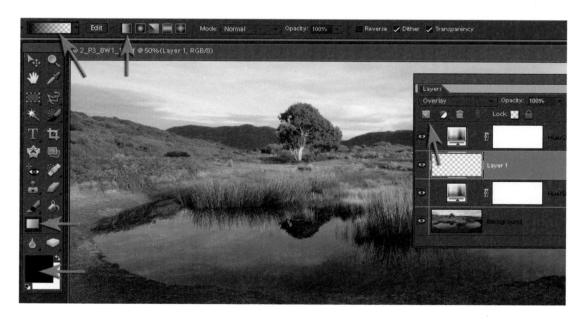

4. Click on the New Layer icon in the Layers palette. Set the blend mode of the layer to 'Overlay'. Set the color swatches in the Tools palette to the default black and white (click on the small black and white swatch icon, or press D on the keyboard). Select the 'Gradient tool' and in the Options bar select the 'Foreground (black) to Transparent' and 'Linear' gradient options.

Part 2: Enhance

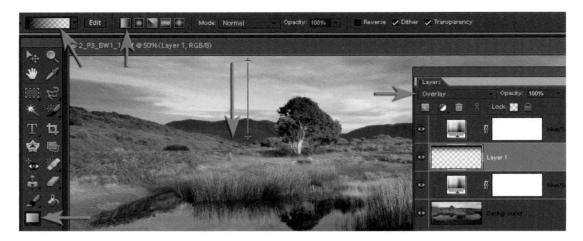

5. Drag a gradient from the top of the image window to the horizon line. This will have the effect of drawing the viewer into the image and will create an increased sense of drama. Lower the opacity of the layer if the effect is too strong and duplicate the layer if you want to increase the drama further.

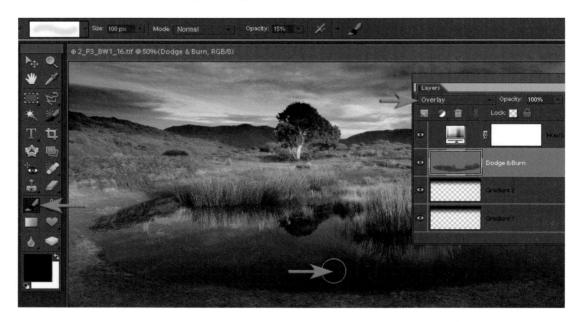

6. Press the Alt key and click on the New Layer icon. In the New Layer dialog box set the blend mode to 'Overlay' and select the Fill with Overlay-neutral color (50% gray) option. Select the 'Brush tool' and select a soft-edged brush from the Options bar and lower the opacity to 10–15%. A layer that is 50% Gray in Overlay or Soft Light mode is invisible. This gray layer will be used to dodge and burn your image non-destructively, i.e. you are not working on the actual pixels of your image. Paint onto the gray layer with black selected as the foreground color to burn (darken) the image in localized areas or switch to white to dodge (lighten) localized areas. You can fill or paint using selections to control the dodging and burning process if required.

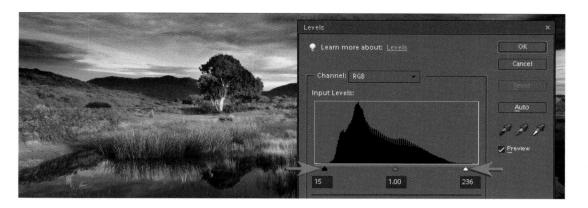

7. Select the top layer and then create a Levels adjustment layer (one adjustment layer to rule them all) to sit above all of the other layers. Make sure the histogram extends all the way between the black and white sliders. Move the sliders in to meet the histogram if this is not the case.

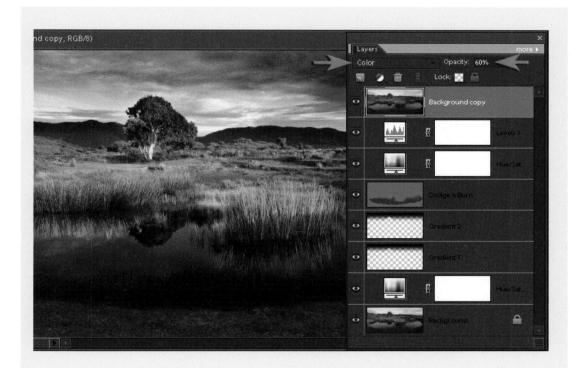

PERFORMANCE TIP

Try experimenting with the introduction of some of the original color. Duplicate the background layer by dragging it to the New Layer icon. Then drag the background copy further up the layers stack to a position just below the Levels adjustment layer. Reduce the opacity of this layer and set the blend mode to 'Color' to let the black and white version introduce the drama once more.

Project 4

Toning

Burning, toning, split-grade printing and printing through your mother's sill stockings are just some of the wonderful, weird and positively wacky techniques used by the traditional masters of the darkroom waiting to be exposed (or ripped off) in this tantalizing digital project designed to pump up the mood and ambience of the flat and downright dull. The tonality of the project image destined for the toning table will be given a split personality. The shadows will be gently blurred to add depth and character whilst the highlights will be lifted and left with full detafor emphasis and focus. Selected colors will then be mapped to the new tonality to establish the final mood.

A FINE OF 10 CENTS WILL BE CHARGED FOR LOSS OF THIS CARD. CARD FROM THE BOOK POCKET

DO NOT REMOVE THIS

Toned images - exploring the land between black and white and color

It probably comes as no small surprise that 'color' injects images with mood and emotional impact. Photographers, however, frequently work on images that are devoid of color because of the tonal control they are able to achieve in traditional processing and printing techniques. Toning the resulting 'black and white' images keeps the emphasis on the play of light and shade but lets the introduced colors influence the final mood. With the increased sophistication and control that digital image-editing software affords us, we can now explore the 'twilight zone' between color and black and white as never before. The original image has the potential to be more dramatic and carry greater emotional impact through the controlled use of tone and color.

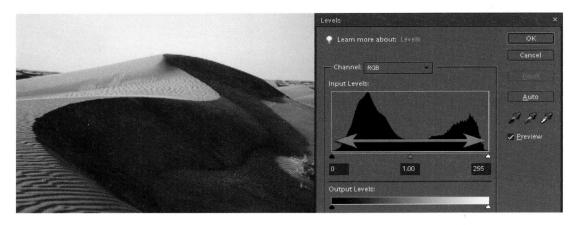

1. For the best results choose an image where the directional lighting (low sunlight or window light) has created interesting highlights and shadows that gently model the three-dimensional form within the image. Adjust the levels if necessary so that the tonal range extends between the Shadow and Highlight sliders.

2. Bright areas of tone within the image can be distracting if they are not part of the main subject matter. It is common practice when working in a black and white darkroom to 'burn' the sky darker so that it does not detract the viewer's attention from the main focal point of the image. In the project image the overly bright sky detracts from the drama in the foreground hills. Make an initial selection of the sky using the Magic Wand tool, feather the selection by 2 pixels (Select > Feather) and then save the selection (Select > Save). Create an empty new layer and set the blend mode in the Layers palette to 'Overlay'. Click on the foreground color swatch in the Tools palette to open the Color Picker. Select a deep blue and select OK. In the Options bar select the 'Foreground to Transparent' and 'Linear Gradient' options. Drag a gradient from the top of the image to just below the horizon line to darken the sky. Holding down the Shift key as you drag constrains the gradient, keeping it absolutely vertical.

PERFORMANCE TIP

After adding a gradient it is recommended that a small amount of noise is added to the gradient to match the noise quality of the rest of the image and to prevent banding - both on screen and in the final print. Go to 'Filter > Noise > Add Noise'. A small amount of 1 or 2% of monochromatic noise will usually do the trick.

3. Duplicate the background layer (the one without the gradient) and then drag it to the top of the layers stack. Select 'Remove Color' from the Enhance > Adjust Color menu or alternatively you could use a Hue/Saturation adjustment (Enhance > Adjust Color > Adjust Hue/Saturation) and move the Saturation slider all the way to the left.

Part 2: Enhance

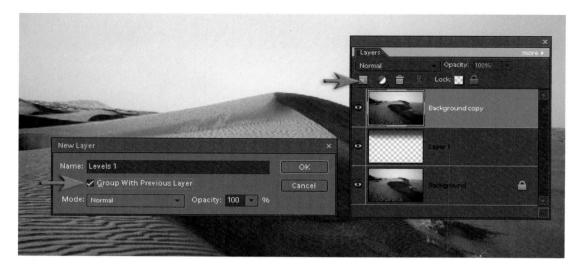

4. Hold down the Alt key on the keyboard and click on the Create Adjustment Layer icon. In the New Layer dialog box check the 'Group With Previous Layer' option. Click OK to open the Levels dialog box.

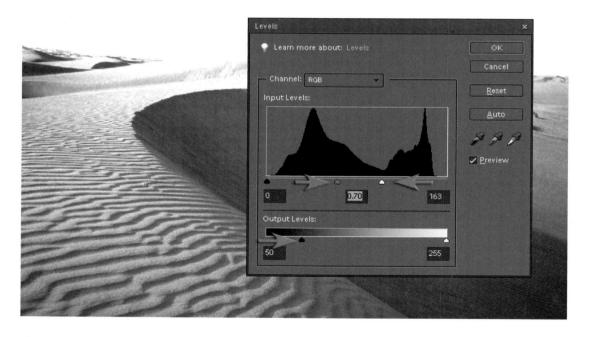

5. Drag the Highlight slider to the left until most of the highlights disappear. Move the Gamma slider (the one in the middle) until you achieve good contrast in the midtones of the image. Move the Shadow Output slider to the right to prevent the deeper shadow tones from becoming too dark when the blend mode is applied in the next step. Select OK to apply the Levels adjustment.

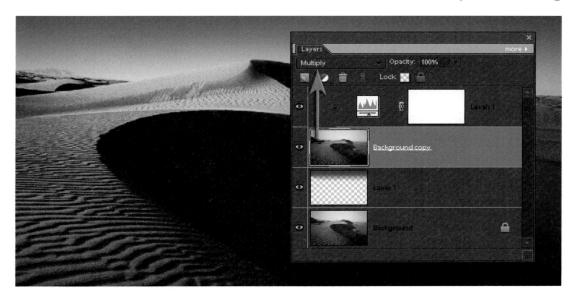

6. In the Layers palette switch the mode of this Grayscale layer to 'Multiply' to blend these modified shadow tones back into the color image.

7. Go to the Select menu and choose 'Load Selection'. Choose your saved selection from step 2 and choose the 'Invert' option. Go to 'Filter > Blur > Gaussian Blur' and increase the Radius to spread and soften the shadow tones (approximately 6 pixels). With the preview on you will be able to see the effect as you raise the amount of blur. Go to 'View > Zoom In' to take a closer look at the effect you are creating. The selection will prevent the dark shadow tones bleeding into the sky.

Note > This effect emulates the silk-stocking technique when it is applied only to the high-contrast part of the split-grade printing technique made famous by Max Ferguson and digitally remastered in his book *Digital Darkroom Masterclass* (Focal Press).

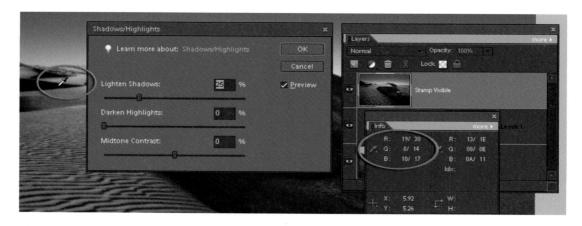

8. Create a Copy Merged layer by going to the Select menu and choosing 'All'. Then from the Edit menu choose 'Copy Merged'. Again from the Edit menu choose 'Paste'. This copies all of the information from the visible layers and pastes it to a new layer. The keyboard shortcut for these three steps is to hold down the Ctrl+Alt+Shift keys and then type the letter E (sometimes referred to as 'Stamp Visible'). Drag this new merged layer to the top of the layers stack if it is not already there. Use the Highlight/Shadow adjustment feature (Enhance > Adjust Lighting Shadows/Highlights) to lighten the overly dark shadows (a result of the 'Multiply' blend mode). A setting of 25–40% is usually sufficient to rescue the shadow tones. An alternative to this approach of lightening the shadows is to use a Levels adjustment layer in Screen mode. Move the Highlight Output slider in the bottom right-hand corner of the Levels dialog box to the left to restrict the lightening to predominantly the shadow tones.

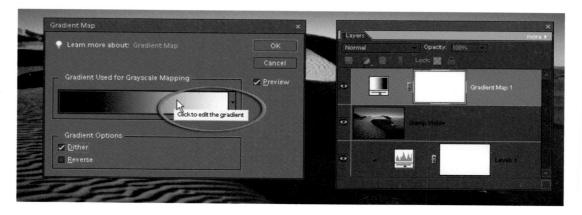

9. Set the foreground colors in the Tools palette to their default black and white settings. Click on the Create Adjustment Layer icon in the Layers palette and choose 'Gradient Map' from the menu. Check the 'Dither' option and then click on the gradient in the Gradient Map dialog box to open the Gradient Editor dialog box.

Note > The gradient must start with black and end with white, otherwise your image will not use the full dynamic range possible.

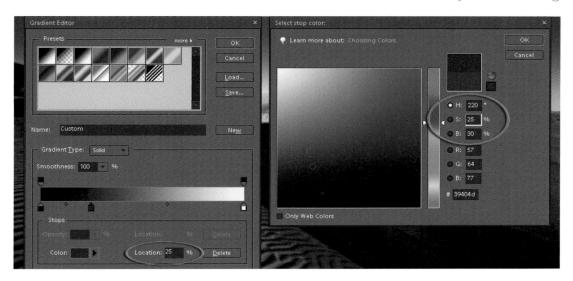

10. The Gradient Editor dialog box allows you to assign colors to shadows, midtones and highlights. Click underneath the gradient to create a new color stop. Slide it to a location that reads approximately 25% at the bottom of the dialog box. Click on the color swatch to open the Color Picker dialog box. Cool colors such as blue are often chosen to give character to shadow tones. Create another stop and move it to a location that reads approximately 75%. This time try choosing a bright warm color to contrast with the blue chosen previously.

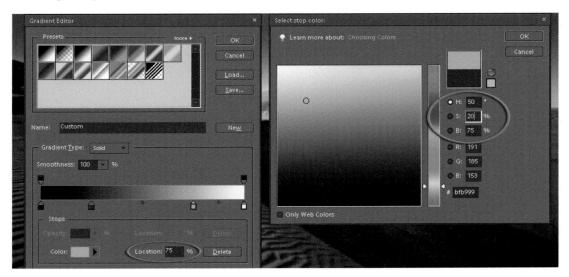

Drag these color sliders and observe the changes that occur in your image. Create bright highlights with detail and deep shadows with detail for maximum tonal impact. Be careful not to move the color stops too close together as banding or 'posterization' will occur in the image. Choose desaturated colors from the Color Picker (less than 40%) to keep the effects reasonably subtle. Once you have created the perfect gradient you can give it a name and save it by clicking on the New button. This gradient will now appear in the gradient presets for quick access.

PERFORMANCE TIP

The gradient map used in this toning project uses a midtone color stop and can be downloaded from the supporting DVD and loaded directly from the Gradient Editor dialog box or by using the Preset Manager (go to 'Edit > Preset Manager > Gradients > Load'). Then browse to the Maximum_Performance.grd preset and select OK. Quick split-tone effects can be accessed via the Maximum Performance split-tone actions available on the DVD.

Experiment with lowering the opacity of the Gradient Map layer to allow some of the underlying color to blend with the colors introduced with the Gradient Map toning technique.

Project 5

Character Portrait

It is often possible to unleash the hidden potential of an image without going to the hassle of making fiddly selections. This project demonstrates how the tonality of an image can be enriched using duplicated layers, blend modes and a couple of filters to shape and sharpen. Dust off your trophy shelf - I feel an award coming on!

The beauty of these techniques is that we can let Photoshop Elements do all of the hard work and extract an image that has all of the hallmarks of a professionally lit studio-quality portrait from an image illuminated with nothing more than ambient light. The secret to success, if you plan to reuse this recipe on one of your own images, is to start with a razor-sharp image illuminated by soft directional light (diffused window light is ideal).

Preparing the image

Before we start our culinary masterpiece we should prepare the main ingredient - the image. This should include optimizing the histogram via a manual or auto Levels adjustment (if you have the luxury of accessing a 16 Bit/Channel file via a Raw capture or a 48-bit scan your histogram will appreciate the Levels adjustment prior to hitting the '8 Bits/Channel' option in the Image > Mode submenu). Start the project by removing any distractions in the image so that the viewer's focus will not wander from the *pièce de résistance* - the face containing the character and majesty of our sitter. Keeping it simple is a key to clean and effective design.

1. You can either paint directly on to the background layer or duplicate the layer if you want to preserve the background layer unadjusted. Remember you have the option to undo any brush stroke that is not absolutely effective. In fact Elements allows you to undo 50 steps by default. Check the preferences and adjust the number to suit your own workflow if required. I think 50 is overly generous and this can consume excessive portions of the computer's available RAM that would be best served being made available for the more memory-intensive editing tasks we are about to engage in. There is no need to restart the computer if you decide to lower the number of 'History States' to 20.

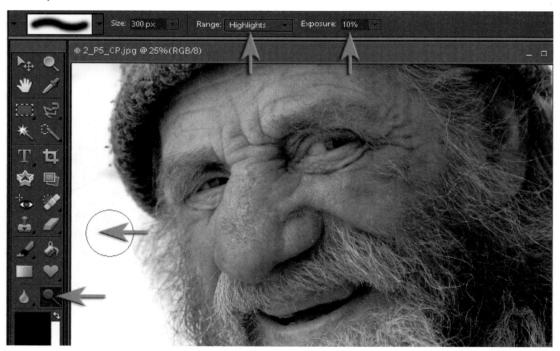

Dodge tool > Use a soft-edged brush and paint with the Dodge tool set to 'Highlights'. Reduce the opacity to around 20–30% to ensure that you lighten the background in the top left-hand corner without unduly affecting the sitter's hat. Lower the opacity to 10% to lighten the rest of the background on this side (around the beard). The following steps will ensure that this backdrop will look like something from a studio (rather than the bus shelter where this image was captured).

Burn tool > Use a similar soft-edged brush and paint with the Burn tool set to 'Midtones' to reduce the distracting pattern of the clothing. You are not aiming to remove the texture - just subdue it.

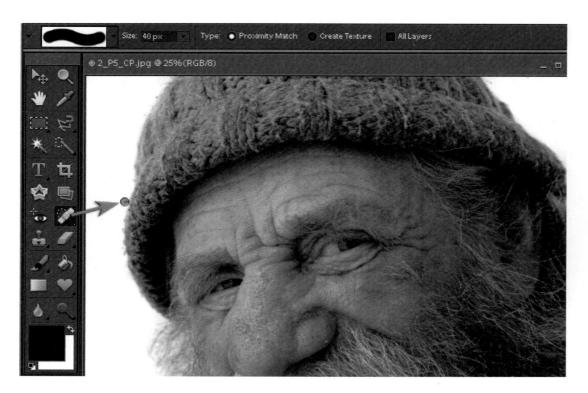

Spot Healing Brush > The Healing Brush tool is the best tool for removing distracting details or dust marks. Use a hard-edged Healing Brush when working in areas of large tonal difference, e.g. removing the dark woollen bobbles that are surrounded by the white background. This will ensure the healing area is not contaminated with the adjacent tones of the nearby hat.

Part 2: Enhance

2. To start working on the tonality we need to separate the 'luminance' or brightness values from the color component of the image. Start the process by dragging the background layer to the New Layer icon in the Tools palette to duplicate it (alternatively use the keyboard shortcut Ctrl + J). From the Enhance menu choose the Remove Color command from the Adjust Color submenu. This will create a desaturated layer sitting above the colored background layer.

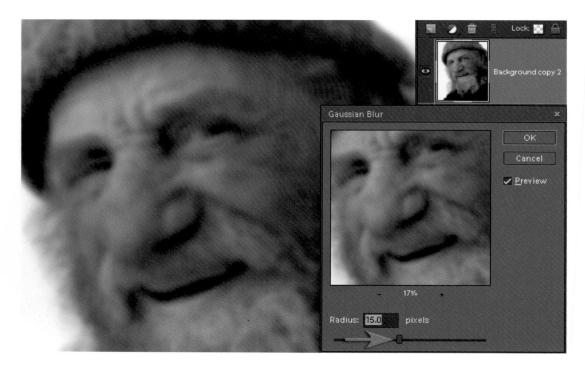

3. The fine detail of this portrait is going to be more pronounced if we create some smooth underlying tones. These smooth tones will also help to increase the three-dimensional quality of the portrait. Duplicate the desaturated layer using the keyboard shortcut Ctrl + J and then go to the Filter menu and choose 'Gaussian Blur' from the Blur submenu. Choose a generous Radius value - one where the skin tones are very smooth but the facial features can still be made out. When the 'Blur Radius' is selected choose OK.

4. Switch the blend mode of the blurred layer to 'Multiply'. The Multiply mode blends the blurred tones back into the sharp detail underneath but renders the image temporarily dark. The shadow information, although very dark, is not lost or 'clipped' by this blending technique. The overall brightness of this image will be restored in the next step so that we can appreciate how effective this technique has been.

Multiply mode > The 'Multiply' blend mode is one of the most useful blend modes for creative editing of digital images. The 'Multiply' blend mode belongs to the 'Darken' family grouping. The brightness values of the pixels on the blend layer and underlying layer are multiplied to create darker tones. Only values that are multiplied with white (level 255) stay the same.

5. To restore the majority of the brightness values to this image simply create a new Levels adjustment layer and switch the blend mode to 'Screen'. The action of first multiplying and then dividing (screening) has, however, incorporated the blur layer into the pixel stew and the visual outcome is altogether different from the start image.

Screen mode > The 'Screen' mode belongs to the 'Lighten' family grouping and has the opposite effect to the 'Multiply' blend mode.

PERFORMANCE TIP - BEFORE AND AFTER

When working on a long project it is often necessary, or reassuring, to perform a quick taste test, i.e. gain a quick reminder of how life started out for this image and whether the techniques you are using are creating positive or negative visual outcomes. Rather than clicking on each Eye icon, on each individual layer, to switch the visibility off (one by one) you can simplify the process by simply holding down the Alt key and clicking only the Eye icon on the background layer. This action switches all of the other layers off in a single click, enabling you to see how life for this image started out. Alt + Click a second time to switch all of the layers back on. Looking good? Then let's proceed.

PERFORMANCE TIP - STAMP VISIBLE

One of the really essential techniques for multilayered image editing is the ability to take all of the combined elements from the visible layers and stamp them to a single new layer. It is so important that Adobe have decided to keep the shortcut a secret. The long way to achieve this stamping process involves choosing 'Select All' from the Select menu, choosing 'Copy Merged' from the Edit menu and then choosing 'Paste', again from the Edit menu.

Stamp Visible - the mother of all keyboard shortcuts

The shortcut is long, very long, but will save you considerable time as this technique is used over and over again in this style of editing. It will also impress the socks off image editors who are self-taught and who are most unlikely to have come across this permutation, as it involves holding down nearly all of the left side of the keyboard! Hold down the Ctrl, Alt and Shift modifier keys and then (whilst still holding down the modifier keys) press the letter E. If your new layer is not on top of the layers stack, click and drag it to the top of the Layers palette.

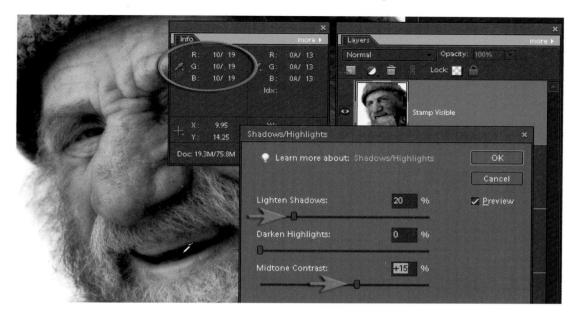

6. Sometimes tones need to be rescued if they are getting too close to 0 or 255. As the shadows are starting to make friends with level 0 and getting a little too close for comfort we must instigate a rescue attempt. We will need to stamp all of the visible elements to a new layer (see previous performance tip) if we are to utilize our good friend and ally - Shadows/Highlights. Choose Enhance > Adjust Lighting > Shadows/Highlights. Move the Lighten Shadows and Midtone Contrast sliders to values that will raise the darkest shadows above level 15.

The Shadows/Highlights adjustment feature is an excellent tool for targeting shadow or highlight tones that need to be massaged in isolation and brought back into the range of tones that can be comfortably printed using an inkjet printer. Although the 'Screen' blend mode did an excellent job of moving the midtones and highlight tones back to their former glory, the shadows of this image are still struggling to emerge above a level where they are likely to print with detail (between level 10 and level 20 depending on the type of paper, ink and printer being used). The adjustment feature can be accessed via the Enhance > Lighting menu. Before accessing the adjustment feature it is probably worth having either the Histogram palette or the Info palette open so that you can gauge when the shadows have been restored to a value that will print on your trusty inkjet printer. Raising the Midtone Contrast slider can also inject some life and drama into the tonality of the image. You may need to do a balancing act between the two sliders whilst observing the numerical or visual effects to your tonal range if you intend to make use of the Midtone Contrast slider.

PERFORMANCE TIP - SHADOWS/HIGHLIGHTS

Shadows/ Highlights > The Shadows/ Highlights adjustment feature is the most sophisticated tool for lowering excessive contrast in Adobe Elements. The tool made a very welcome appearance in Elements 3.0 and forms part of the sophisticated armory of adjustment features that can enable users to edit the tonal qualities of an image with control and confidence in a non-destructive way.

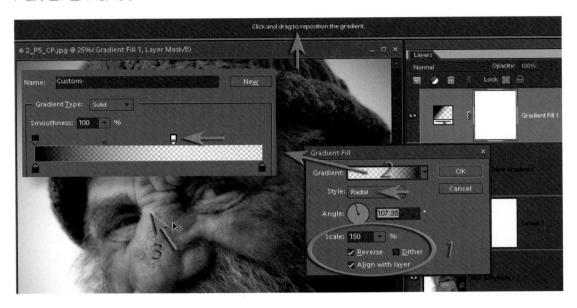

7. The next step involves getting rid of the distracting white background and replacing it with something a little more dramatic. Before creating a gradient make sure that black is the foreground color in the Tools palette (type D on the keyboard to return the color swatches to their default setting). From the Create adjustment layer menu in the Layers palette choose 'Gradient'. The creation of a radial gradient or 'vignette' involves fours steps. First choose the 'Radial' and 'Reverse' options in the Gradient Fill dialog box and enter a value of 150% in the 'Scale' field, and then choose an appropriate angle (I have followed the angle of the face). The second step involves clicking on the gradient to open the Gradient Editor. Choose the 'Foreground to Transparent' preset and move the opacity stop on the far right of the gradient ramp to the left to clear the face of any tone, thereby pushing the starting point of the gradient to the edge of the face. For the third step select OK to close the Gradient Editor and then drag inside the image window to move the center of the gradient to the perfect position. Finally (step 4) select OK and adjust the opacity of the layer to balance the background tone with the portrait.

PERFORMANCE TIP

Gradient layers > One feature short of a full load

Although gradient layers represent an important and powerful editing tool, the good people at Adobe overlooked a very important aspect in this adjustment layer feature. Gradients have a nasty habit of 'banding', either in the screen view and/or in the printed image, giving the tonal transition a posterized appearance that is not at all in keeping with the rich tonal qualities of advanced image-editing techniques. The banding can only partly be reduced by selecting the 'Dither' option (not a default option for the gradients). To ensure this banding does not raise its ugly head the user must add noise to any areas of smooth tone after any gradients have been applied. Gradient layers unfortunately do not contain pixels to which noise can be added, so this can become especially problematic and requires an additional noise layer to resolve the problem.

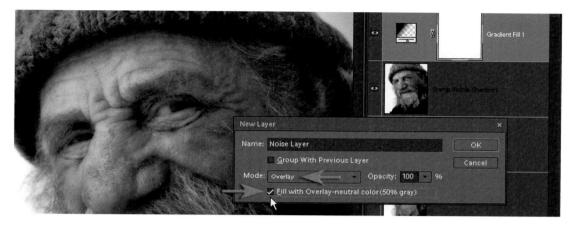

8. Adding noise rather than reducing noise may sound strange. One has to remember, however, that the gradient is completely artificial and completely noiseless - something that cannot be matched even with a low-noise image captured on a digital camera using a low ISO setting. By adding noise we are merely trying to match the noise present in the rest of the image and at the same time eliminate or reduce the problem of banding. You can add noise directly to the Gradient Fill layer but you will have more flexibility and control if the noise is added to a seperate layer. To create a Noise layer hold down the Alt key and click on the New Layer icon in the Layers palette. In the New Layer dialog box choose 'Overlay' as the mode and click on the 'Fill with Overlay-neutral color (50% gray)' checkbox.

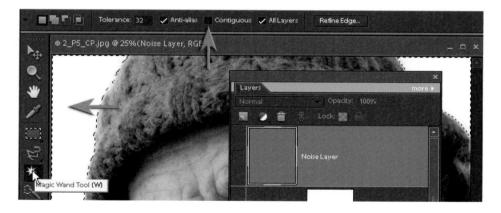

Select OK and then switch off the visibility of the Gradient layer so that we can see the original white background. Only one selection is used in this project and it is used to isolate the background for the noise treatment. Select the 'Magic Wand' from the Tools palette and select the 'Sample All Layers' option in the Options bar. Deselect the 'Contiguous' box and lower the tolerance to 20 to ensure that the selection is painless - a single click should do the trick. You will need to add a generous amount of feather (100 pixels or more) to this mask to create a gradual transition between noise and no noise (Select > Feather). After feathering the selection switch the visibility of the gray overlay layer back on. Zoom in to 100 or 200% (avoid magnifications that do not give an accurate screen view, e.g. 133% etc.).

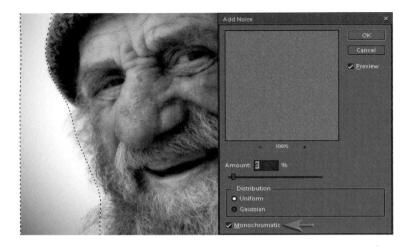

9. With the selection still active select the Add Noise filter from the Filter > Noise submenu. Select the 'Monochromatic' option and choose an amount that will create a noise level that is consistent with the rest of the image file. To check that the noise level is OK hold down the Spacebar to enable you to drag the image between the gradient (with added noise) and the face (with no added noise). When the texture is consistent select OK.

Note > Adding noise is an essential component of using gradients. Think gradient - think noise.

10. The localized contrast is already vastly improved from the original file, but if you want to see how far you can take this tonal manipulation you may like to try the following technique that can add depth and volume to a seemingly lifeless and flat image. Stamp the visible elements yet again to another new layer (Ctrl + Alt + Shift and then type E) and then switch the blend mode to 'Overlay'. From the Filter menu go to the Other submenu and choose the High Pass filter. When this filter is used as an alternative to the Unsharp Mask filter a small radius of between 1 and 5 is usually selected, depending on the resolution of the image file and the output medium, but in this case the Radius slider can be moved to a much higher radius whilst observing the effects to the image file. At the moment the effects may appear a little excessive, but lowering the opacity of the layer and/or switching the blend mode of the layer to 'Soft Light' can refine the overall effect.

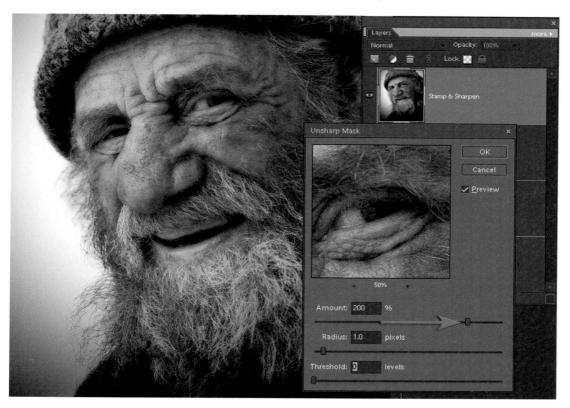

1 1. The rich tonality will now serve as an excellent canvas for the fine detail that we are about to sharpen. Sharpening should always be done late in the editing process to avoid exaggerating any image artifacts or non-image data. If you are to have maximum control over the sharpening process and the flexibility to adjust the level of sharpening after making a test print (images tend to look a little softer when compared to their screen counterpart - especially when using LCD displays), you need to apply the Unsharp Mask to a Copy Merged layer. You know the drill by now - stamp visible to a new layer. When this has been done you should set the blend mode to 'Luminosity'. Switching the layer to the 'Luminosity' blend mode will have zero effect on the visual outcome of the image at this stage. The advantage of this mode change is when the color is switched back on in the next and final step of the project. If you are used to applying conservative values in the Unsharp Mask filter this is not the time to exercise constraint. Be generous - very generous - with the Amount slider (200 in this project) but keep the Radius slider to the usual amount (no more than 1.5). The Threshold slider, which is usually raised to avoid sharpening minor details, can either be left at 0 so that all of the image information comes under the global sharpening umbrella or raised to around 5 so that the image noise levels are not excessively sharpened. You will need to print a test strip to your favorite paper surface before you can assess whether the amount of sharpening for this image is correct. If the sharpening seems a little excessive simply lower the opacity of the sharpening layer until you find the perfect setting for your paper.

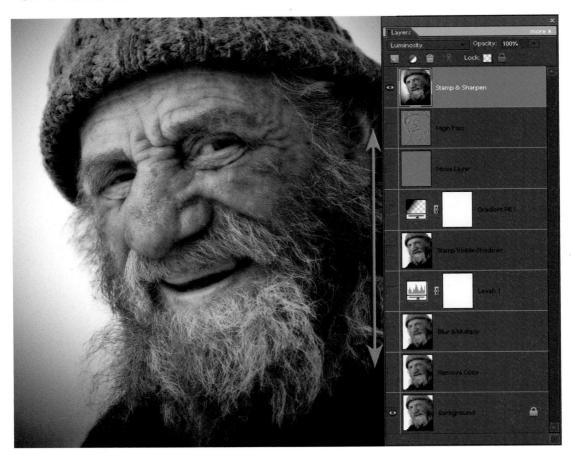

12. You might be so impressed with the tonal qualities of your monochrome masterpiece that the thought of switching the color back on gives you the shivers. It is important, however, to the learning curve of this project to discover how the luminance values of an image file can be edited independently of the color before being reunited. Color can be a major distraction when editing tonality. Switching off the visibility of the three monochrome or desaturated layers sitting directly above the background layer will allow the top layer in Luminosity mode to merge with the color of the background layer. The blend modes are one of the most underutilized of the editing features to be found in Photoshop Elements. Perhaps it is because of their slightly abstract names and their mathematical approach to multilayered pixel editing, but their creative power and usefulness should not be underestimated. With the digitally remastered dish ready to serve up to your printer you may need to savor both monochrome and color versions over a period of time before your own personal preference helps you make the final decision. Enjoy!

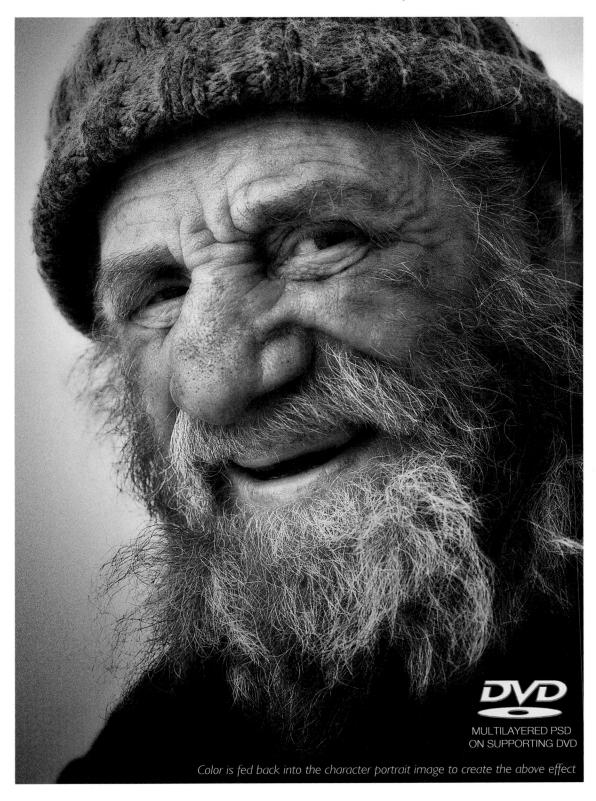

Project 6

Photograph by Jennifer Stephens

Use the soft focus action to achieve a lightening fast makeover (minus the heal and liquify steps)

Glamor Portrait

Cheaper (and more fun) than plastic surgery, we explore how pixel surgery can be used to craft perfect portraits that are bound to flatter the sitter every time.

The glamor portrait offers an excellent opportunity to test the effectiveness of a variety of image-editing skills. The portrait is an unforgiving canvas that will show any heavy-handed or poor technique that may be applied. We will start with a color portrait that has been captured using a soft diffused light source.

This project will aim to perfect various features and not to make such changes that the character of the sitter is lost to the technique. The techniques used do not excessively smooth or obliterate the skin texture that would, in turn, lead to an artificial or plastic appearance. The techniques used smooth imperfections without totally eliminating them.

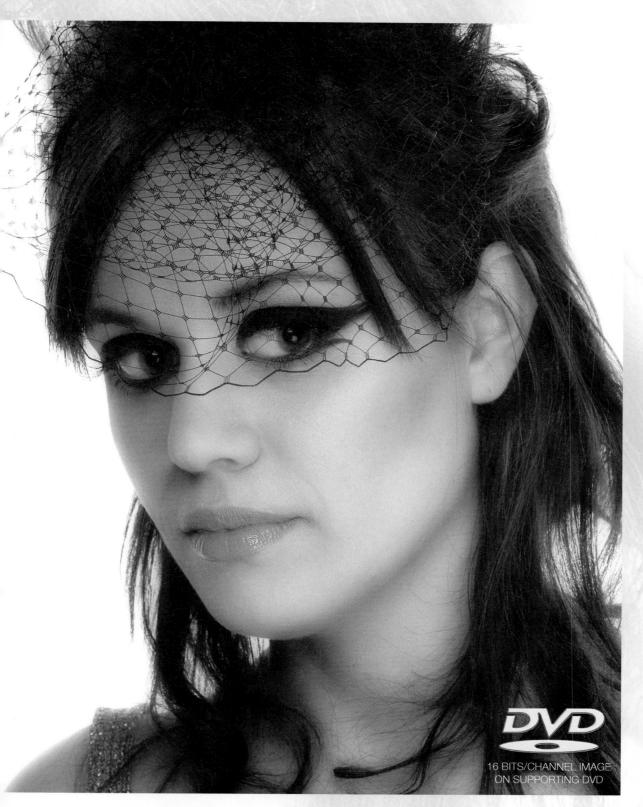

The 15-minute (after practice) makeover - techniques designed to flatter your model

PERFORMANCE TIP

Use window light or diffused flash to obtain a soft low-contrast light source to flatter the subject. Avoid direct flash unless it is diffused with a white umbrella. Stand back from your sitter and zoom in with your lens rather than coming in close and distorting the features of the face (the closer you stand - the bigger the nose of the sitter appears). A perfect white background is difficult to create if you don't have a studio backdrop and multiple lights but, with a little practice, it is possible to get a near white background by capturing the sitter in front of a white translucent curtain against a brightly illuminated window and with a single introduced light source.

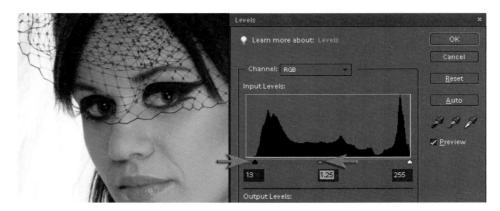

1. If you can capture using the Raw format then you will have the opportunity of perfecting the histogram and color balance in 16 Bits/Channel mode prior to starting the project. Choose Enhance > Adjust Lighting > Levels, then drag the Shadow and Highlight sliders in to meet the histogram or simply click the Auto button. Drop the bit depth once this has been done to 8-bit mode (Image > Mode > 8 Bits/Channel).

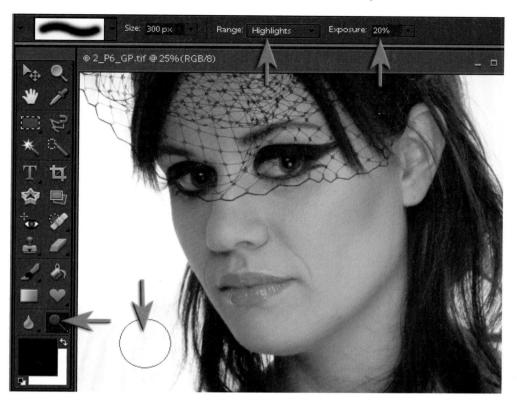

2. Select the 'Dodge tool' in the Tools palette and in the Options bar choose 'Highlights' and an exposure setting of around 20–30%. If you are a little nervous about using this tool on the background layer duplicate the background layer by dragging it to the New Layer icon in the Layers palette. Stroke the background with a large soft brush until any detail or tone present is rendered white. As the Dodge tool in Highlight mode only lightens the brightest tones on the layer, care only needs to be taken if the skin tones or hair next to the white background are also very bright.

3. As you move through this project it is worth saving consecutive versions. The Organizer in Elements can keep track of these versions and help name them if you click on the 'Save in Version Set with Original' option when you use the Save As command from the File menu.

Part 2: Enhance

4. Select the Healing Brush from the Tools palette to remove or reduce dark lines on the face. A time-saving technique when working with the Healing Brush tool is to either duplicate the background layer or create a new empty layer before starting the healing process. You can simply fade all of your work at the end of the process by dropping the opacity of the healing layer. If you choose to heal to an empty layer make sure that this is the layer that is selected in the Layers palette and the 'Sample All Layers' option is selected in the Options bar.

PERFORMANCE TIP

Care must be taken when selecting the size and hardness of the brush. If an overly large soft-edged brush is used near the eyes, lips or hair it can draw in color values that can contaminate the skin tones (a selection can be made prior to using the Healing Brush to isolate the healing area from different colors or tones). If the brush is too hard the edges of the healing area will be visible. Sometimes it is better to use a smaller brush and make several passes rather than trying to complete the section with a single pass. The Healing Brush tool, with its protection of surface texture, is a superior alternative to using the Rubber Stamp tool at a reduced opacity.

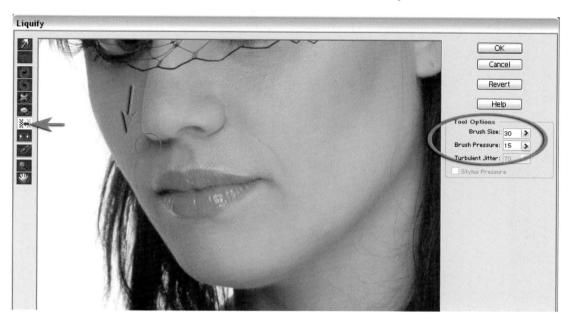

5. Next we're going to alter the facial features. Choose Filter > Distort > Liquify. The Liquify filter is another tool that works directly on your pixels so you may like to duplicate the background layer if you are feeling nervous about the pixel surgery that follows. The various tools in the Liquify filter dialog box can be used to modify the shape or size of the sitter's features. The Pucker tool and Bloat tool can be used to contract or expand various features, e.g. grow eyes or lips and shrink noses. Perhaps the most useful of the Liquify tools, however, is the Shift Pixels tool. This tool can be used to move pixels to the left when stroking down and to the right when stroking up. This tool is ideal for trimming off unsightly fat or reshaping features. In this project the brush pressure is dropped to 15% and an appropriate brush size is selected so that the side of the face is not moved along with the nose. If things start to get ugly just remember the keyboard shortcut Ctrl + Z (undo)!

Note > It is important to exercise great restraint when using the Liquify filter, as the face can quickly become a cartoon caricature of itself when taken too far. The filter also softens detail that becomes obvious when overdone.

PERFORMANCE TIP

It is possible to 'freeze' pixels to protect them from the actions of the Liquify filter. There is a freeze brush in the Liquify filter of the full version of Photoshop - but not so in Elements. To activate the freeze in Elements simply make a feathered selection prior to selecting the Liquify filter. Select the area to be modified, being careful to leave out sections of the face that should be protected from the pixel surgery. With the selection active open the Liquify dialog box. The areas outside of the selection are now frozen.

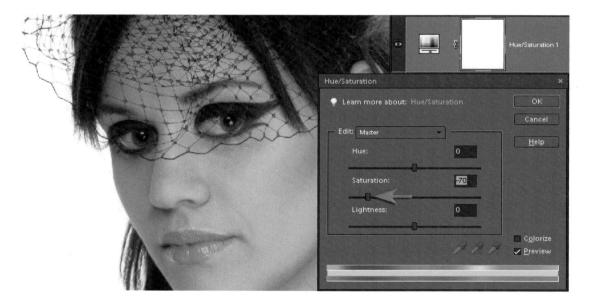

6. Create a Hue/Saturation adjustment layer. Focus your attention on the whites of the eyes and lower the saturation until any discoloring in the eyes is removed. Disregard the effects to the rest of the face for the time being. Select OK and then fill the layer mask with black to conceal the adjustment (Alt + Backspace if black is in the foreground color swatch or Ctrl + Backspace if black is in the background color swatch).

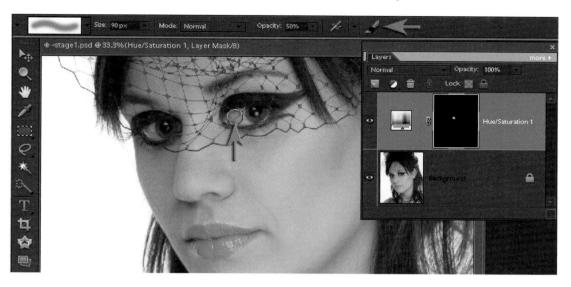

Select the 'Brush tool' from the Tools palette. Choose a soft-edged brush just a little smaller than the eye in the Options bar and lower the opacity to 50%. Choose white as the foreground color in the Tools palette. Stroke the whites of the eyes with the brush until they are appropriately drained of color.

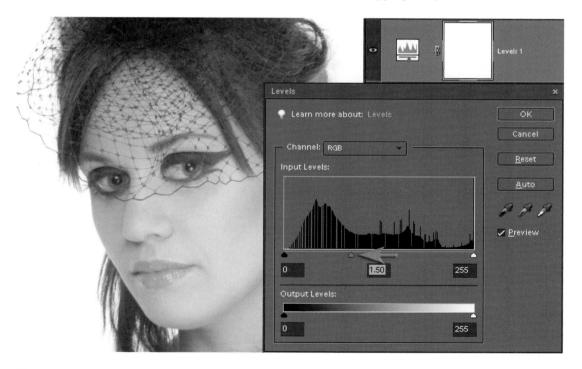

7. Create a Levels adjustment layer and move the Gamma slider to the left to brighten the whites of the eyes. As before, select OK and then fill the layer mask with black to conceal the adjustment once again.

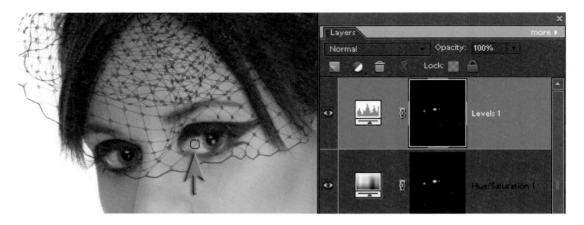

This time brighten the eyes by painting with white at 50% opacity. If you overdo it you can switch colors and paint with black or simply lower the opacity of the adjustment layer.

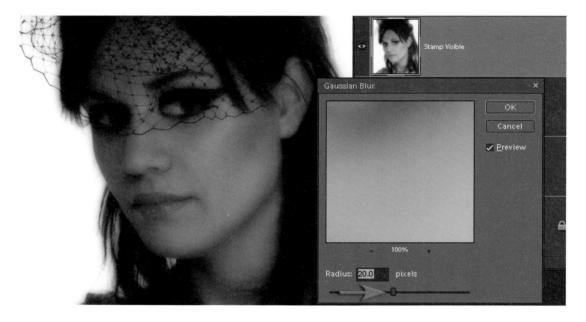

8. The technique to smooth the tones of the face is quick and very effective. The first step is to merge all of the visible elements of this image into a new layer on top of the layers stack (referred to as 'Stamp Visible'). Hold down all of the modifier keys (the Ctrl, Shift and Alt keys) and then type in the letter E. Make sure the resulting layer is on top of the layers stack and set the blend mode of this layer to 'Multiply'. Go to the Filter menu and choose 'Gaussian Blur' from the Blur submenu. Apply a 20-pixel Gaussian Blur.

Visual warning > Now it is going to look like someone turned out some of the lights until we carry out the next stage of the process, but if you use your imagination you can probably already see that the skin tones are now smooth and radiant - if just a tad dark.

PERFORMANCE TIP

The precise pixel radius of the Gaussian Blur filter will vary depending on the resolution of your image. The idea is to bleed the tones, but not so much as to lose the features of the face.

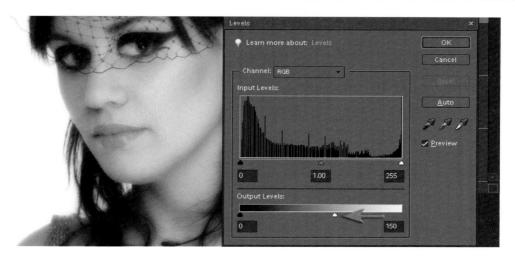

9. Create a Levels adjustment layer and set the blend mode to Screen to lighten the image. If the image is still not light enough drag this adjustment layer to the New Layer icon to duplicate it. The blend mode of this duplicate layer will also be in Screen mode. If this lightens the highlights too much drag the Output highlight slider towards the center of the histogram to restict the screening effect to the shadows and midtones only.

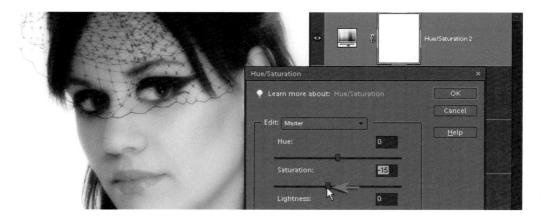

10. Create a Hue/Saturation layer above these screened layers and lower the saturation a little. The side effect to smoothing the skin tones using this technique is that saturation increases. Another problem that will need to be resolved is that the deepest shadow tones may be pushed too dark to print. These important shadow tones will need to be rescued in order to produce a professional result.

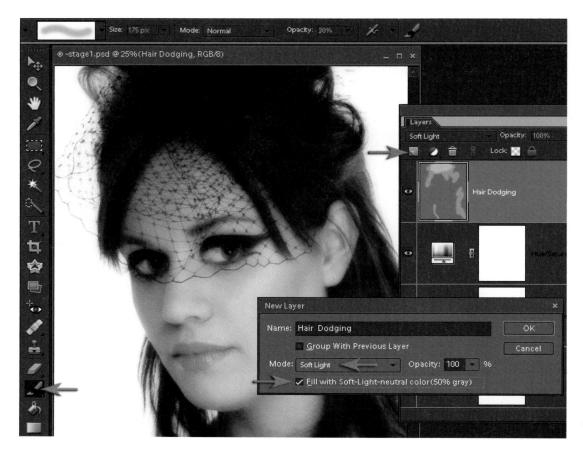

Fine-tuning the tonality

11. There are a number of different ways we can rescue the shadow tones of this image. The first technique uses the non-destructive dodge layer technique. Hold down the Alt key whilst you click on the New Layer icon in the Layers palette. Switch the mode to 'Soft Light' and check the 'Fill with Overlay-neutral color (50% gray)' box. Select OK. This 50% gray layer is invisible in 'Soft Light' mode but can be used to lighten or darken the underlying image. Select 'White' as the foreground color and use a soft-edged brush at 50% opacity to paint the darkest areas of the hair lighter. Several passes at a reduced opacity rather than a single pass at 100% opacity will render the dodging a subtle affair.

PERFORMANCE TIP

Try switching the blend mode of your dodge and burn layer to Overlay mode instead of Soft Light mode for alternative effects when dodging and burning.

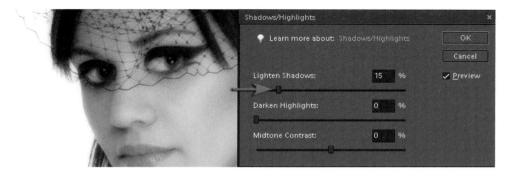

12. The Shadows/Highlights adjustment feature from the Enhance > Adjust Lighting submenu can also be used to target and rescue the darker tones of your image. Stamp Visible to a new layer before implementing the adjustment. When using a layer mask with the Shadows/Highlights adjustment command it is possible to pump up the level of lightening and midtone contrast without affecting the midtones or highlights in the image.

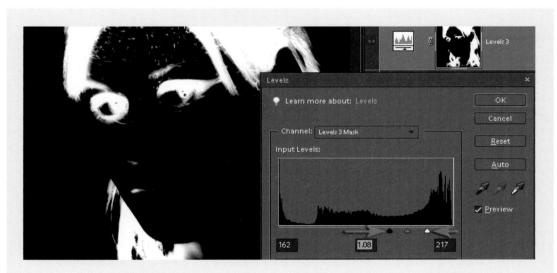

PERFORMANCE TIP

The Shadows/Highlights is a very powerful adjustment feature. Use a layer mask to further limit or restrict the effects of the Shadows/Highlights adjustment. Create a Levels adjustment layer without making any adjustment (simply click OK). Copy the image to the clipboard (Edit > Copy Merged) and paste it into the layer mask of this adjustment layer. In order to paste the image into the layer mask you must first Alt + Click the layer mask. When you Alt + Click an empty layer mask the image window will appear completely white. From the Edit menu choose 'Paste'. If this action is not taken the copied pixels will be pasted to a new layer. To restrict the adjustment to just the darkest tones of the image you must first invert the image in the layer mask (Ctrl + I) and then perform a Levels adjustment (Ctrl + L) to this layer mask. Move the Shadow slider to the right to restrict the lightening process to just the darkest shadows. Move the Highlight slider to the left to increase the effect of the Shadows adjustment.

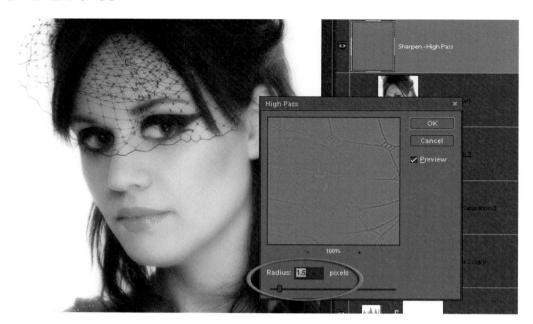

13. Smooth skin tones can be unduly sensitive to the application of the Unsharp Mask. It is usual to raise the Threshold slider sufficiently so that areas of smooth tonal gradation are left unaffected. Film grain, image sensor noise and minor skin defects all come in for the sharpening treatment if the threshold is left too low. If the sharpening process is proving problematic using the Unsharp Mask a selective sharpening technique should be considered. Stamp Visible to a new layer, set the blend mode to 'Overlay' and apply the High Pass filter (Filter > Other > High Pass). At this stage the sharpening is global but it can be restricted by using a layer mask borrowed from an adjustment layer or by painting directly into this High Pass layer using 50% gray to eliminate sharpening.

Click on a 50% gray swatch in the Swatches palette or click on the foreground color swatch in the Tools palette and set the HSB values to 0, 0 and 50. With 50% gray as your foreground color you can now proceed to paint the smoother areas of skin to ensure they escape the sharpening process.

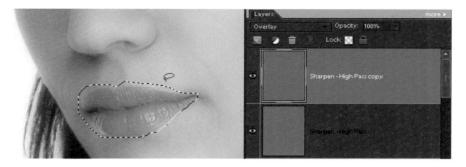

14. You can add a little lip-gloss (or extra sparkle to the eyes) by duplicating the High Pass layer and filling the rest of the image with 50% gray. Make selections of the lips and/or eyes and then invert the selection. Then choose 'Fill Selection' from the Edit menu and choose 50% gray. Switching the mode of the layer to 'Hard Light' will pump up the effect to maximum.

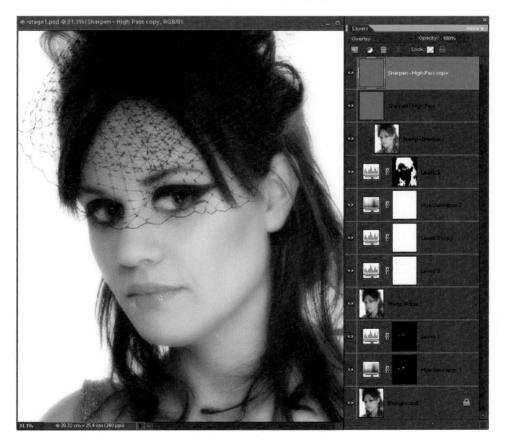

It might seem like a long road to the final result but this technique can be surprisingly quick when you get into the swing of things. It avoids excessive selections and fiddly work, and a lot of minor blemishes are nuked via the blurred layer set to Multiply mode. Of course the real reward will be the admiration of your photographic skills by the sitter - who will be eternally grateful.

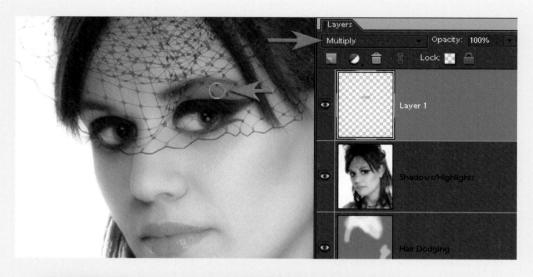

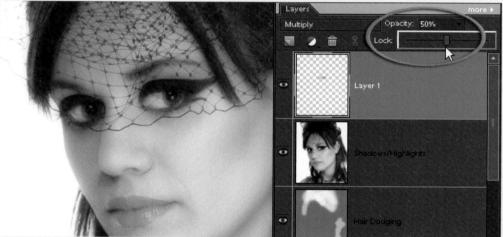

PERFORMANCE TIP

If you can't leave well enough alone, or would just like to explore different approaches to the make-up the model is using, then you can add your own make-up in post-production instead of pre-production. Add a new empty layer set to Multiply mode. Using a soft paint brush set to 50% opacity build up some eye shadow, rouge or lipstick and then lower the opacity of the layer until you create the right effect.

Try grouping a Hue/Saturation slider with the make-up layer and move the Hue and Saturation slider to explore alternative shades quickly and easily. If only getting ready to go out for the evening was this simple!

Carmen Martinez Banus (www.iStockphoto.com)

Before and after - the skin makeover can be applied to any subject requiring smoother tones

Project 7

CORVETTE

Motion Blur

If you have a need for speed and would like to 'move it, move it' this project shows you how to get some ooomph into your stationary wagon.

To get some motion magic happening we need to start with nothing more than a half decent parked car. The example used in this project may look like your professional car shoot but was in fact captured using a fixed lens digicam in a school car park. With little more than a selection, a couple of blur filters and a little know-how the static becomes dramatic.

A 1999 Corvette is polished and taken for a spin in this classic car makeover

The post-production editing or 'car makeover' is simplified when there are not too many reflections in the bodywork or chrome of the car that you capture. Busy reflections will either detract from the final quality or increase the time you spend removing the unwanted detail. In this tutorial you will learn how to smooth out the bodywork, streak the background and spin the wheels, and finally put the icing on the corporate cake by applying the logos to give the image that advertising look.

Stage 1 - Cleaning the paintwork

1. If you are not experienced using the Healing Brush tool and Clone Stamp tool I would recommend duplicating the background layer by dragging it to the New Layer icon in the Layers palette. This will give you the option of trashing the layer if all goes horribly wrong. Hold down the Alt key and click on an area of good paintwork and then paint over any scratches, blemishes or damaged areas. Vary both the size and the hardness of the brush to get the best results. If you are working in the middle of a panel the Healing Brush tool usually gives the best results. If you are working close to an edge you may want to try increasing the hardness of the brush in the Options bar or switching to the Clone Stamp tool. Double-click on the layer name in the Layers palette and name it 'Clean' to differentiate it from the background layer.

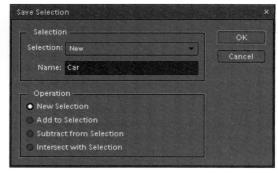

2. Make a selection of the car using one of the tools from the Lasso group (the edge contrast is a little too low for the Quick Selection tool). The Magnetic Lasso tool will do a good job of selecting most of the car. Select only the car, excluding its shadow. Click on an edge of the car with the Magnetic Lasso tool and move the tool slowly along the edge to start the process. You will notice that the tool lays down anchor points. When moving the tool over an edge with poor contrast you can help Photoshop along a little by pressing the Shift key and clicking to add an anchor point manually (Photoshop cannot see some edges due to the poor contrast). Alternatively you can fine-tune the sensitivity of the tool by experimenting with the settings in the Options bar. From the Select menu choose 'Save Selection', give your selection a name such as 'Car' and click OK.

3. The next part of the process involves separating the edges of the car from the broader areas of paintwork. This will allow us to smooth out the paintwork whilst retaining the definition and detail of the edges. Duplicate the layer you have just cleaned and healed (if you duplicated the background layer in the first step you will now have three layers in your Layers palette) and apply a 1-pixel Gaussian Blur (Filter > Blur > Gaussian Blur). This prepares the file for the filter used in the next step.

4. Choose the Find Edges filter found in the Stylize submenu (Filter > Stylize > Find Edges) to reduce this layer to the edges only. To increase the contrast and width of the edges we can apply the Threshold filter from the Adjustments submenu (Filter > Adjustments > Threshold). Drag the slider in the Threshold dialog box to the right until you have well-defined black lines and limited detail visible in the panels. Name the layer you have been working on to save any possible confusion later. I have called mine 'Find Edges'.

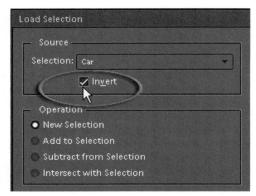

5. Select the 'Brush tool' in the Tools palette and 'White' as the foreground color (press the letter D on your keyboard to set the colors to their default settings and then press the letter X to switch the foreground and background colors). Paint to remove any detail in the paintwork that is not required, i.e. anything that is not the edge of a panel or important detail that needs to be pin sharp. Load the selection (Select > Load Selection) that you saved earlier in step 2. Check the Invert box and then select OK. The background should now be selected.

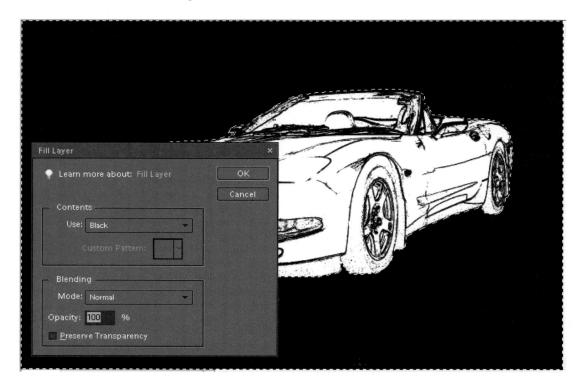

6. Choose 'Fill Selection' from the Edit menu and select 'Black' for the contents color. Select OK. Your image should now appear as a line drawing of the car with a black background. Choose 'Deselect' from the Select menu.

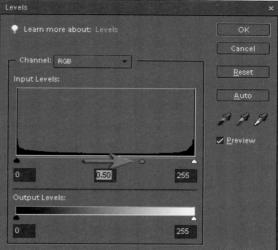

7. To soften the lines so that detail of the edges fades gradually into the smooth paintwork we must apply a small amount of Gaussian Blur to this layer. Although softening the edges the Gaussian Blur may also reduce the density of the lines, so follow the Gaussian Blur with a Levels adjustment (Enhance > Adjust Lighting > Levels). In the Levels dialog box move the central Gamma slider underneath the histogram to the right until the lines once again appear black. This is now the resource for our mask that we will use to protect the important detail when we smooth out the superfluous detail in the bodywork.

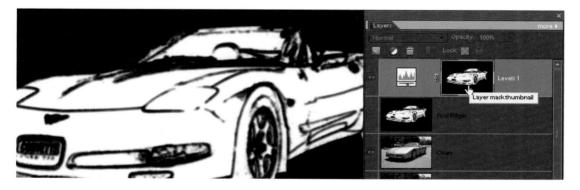

8. To transfer this layer to a mask we need to choose 'All' from the Select menu. Photoshop Elements cannot add a layer mask to a pixel layer so we will need to borrow a mask from an adjustment layer. Create a Levels adjustment layer and then select OK without making any adjustment. Hold down the Alt key and click on the layer mask of this adjustment layer in the Layers palette. The image window will appear white (you are now viewing the contents of the layer mask, and as yet there is nothing in there). Now choose 'Paste' from the Edit menu and the line drawing of your car should now appear. Alt-click the layer mask a second time and choose 'Deselect' from the Select menu. Although it appears you are still viewing the layer mask you are in fact viewing the layer beneath, which is identical.

9. Click on the Eye icon to hide the visibility of the mask resource layer I have called 'Find Edges' (the one below the adjustment layer) or discard it by dragging it to the Trashcan icon in the Layers palette. Create a duplicate of the layer that you cleaned in step 1 by holding down the Alt key and dragging it to the top of the layers stack. Group this layer with the adjustment layer supporting your layer mask by going to the Layer menu and choosing the command Group with Previous.

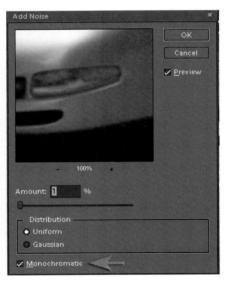

10. Apply a small amount of Gaussian Blur to this Clean Copy layer - 1 or 2 pixels is usually required if you are using a file from a fixed lens digital compact or prosumer camera. This step will create smooth paintwork by removing superfluous detail and image noise. The important detail such as the crisp edges to the bodywork and panels will not be affected due to the actions of the mask below. If you have used more than 1-pixel Gaussian Blur to smooth the paintwork you may need to add 1% noise to this layer to prevent possible tonal banding or posterization (visual steps of tone instead of a smooth transition of tone).

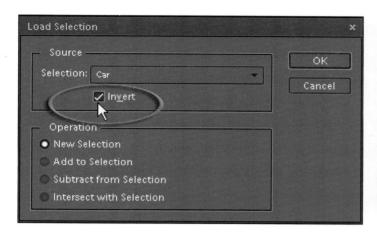

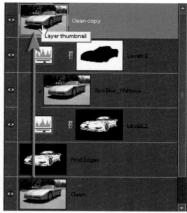

Stage 2 - Blurring the background

1. Now that the car looks brand new we can add the dramatic element in this project. Load the selection of your car, ensuring the Invert box is checked again (Select > Load Selection). Create another adjustment layer with the selection still active. There is no need to make any adjustment. We are again just using the adjustment layer to access its layer mask. The active selection will create its own layer mask. Again whilst holding down the Alt key, drag a copy of the clean layer to the top of the layers stack. You may want to rename your previous clean copy layer to save any possible confusion or to remember any settings you have used.

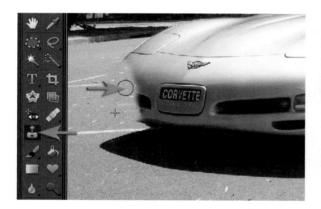

12. Before we apply the Motion Blur filter to this copy layer we must prepare the layer so that the car is not streaked into the background, thereby creating a ghost image of itself. Select the 'Clone Stamp tool' from the Tools palette. Choose a large soft-edged brush set to 100% opacity in the Options bar. Clone away the front and the rear of the car by setting a source point in the road in the lower right-hand corner of the image. To set the source point hold down the Alt key and click your mouse. Clone away the top of the car by moving the source point to the trees above the windscreen. There is no need to be overly precise with this work, as any imperfections will be hidden when the Motion Blur filter is applied in the next step.

Important > Do not clone away any of the shadow of the car.

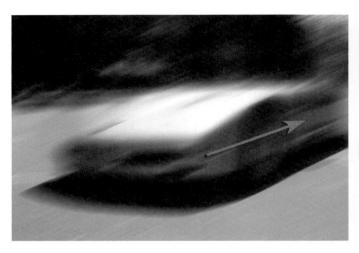

13. Go to the Filter menu and choose 'Motion Blur' from the Blur submenu. Drag the Distance slider to the right to increase the apparent speed of the car. Adjust the angle using the little wheel or by entering a figure in the field so that the streaked lines of the blurred background appear to line up with the angle of the car and then select OK. Group the motion blur layer with the adjustment layer beneath by choosing the Group with Previous command from the Layer menu. Although we now have an impressive result the image is not yet perfect.

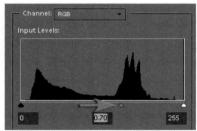

14. We must now turn our attentions to the shadows. The Motion Blur filter may drag lighter tones underneath where the wheels make contact with the ground. This will give the illusion that the car is floating above the road instead of in contact with it. To darken the road immediately next to the tires we can use an adjustment layer. To prevent the adjustment layer from lightening the entire image we simply need to add the adjustment layer to the group. Hold down the Alt key as you click on the Adjustment Layer icon in the Layers palette and select a Levels adjustment layer. When the New Layer dialog box opens check the Group With Previous Layer box and select OK. When the Levels dialog box opens move the central Gamma slider underneath the histogram to the right to darken the road. Pay particular attention to the road directly in front of the rear wheel. Select OK when the tones match. To restrict this darkening process to just a small area around the wheels we must fill the layer mask with black. Go to the Edit menu and choose 'Fill Layer'. Select 'Black' as the contents and select OK. The effects of the adjustment layer will momentarily disappear.

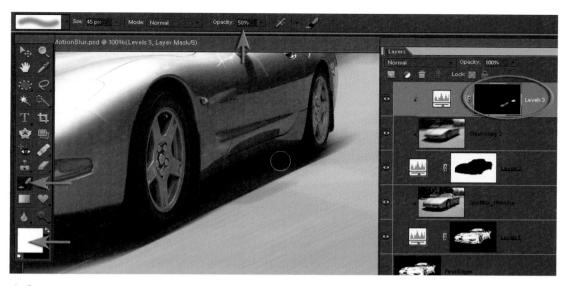

15. Now choose the 'Brush tool' in the Tools palette and select 'White' as the foreground color. Drop the opacity of the brush to 50% and paint where the road requires darkening. Make several strokes with the brush (letting go of the mouse button after each stroke) until the road is darkened sufficiently.

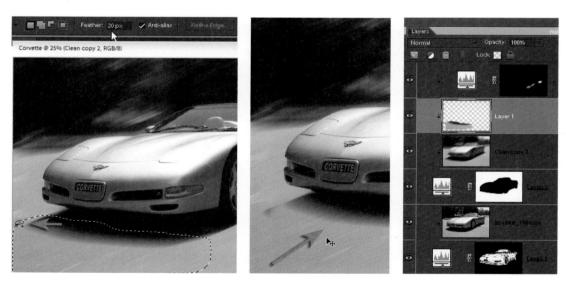

16. The act of adding motion blur to the shadow has made it too long in front of the car so we need to reposition it. Make a selection of the soft leading edge of the shadow using the Lasso tool with a 20-pixel feather selected in the Options bar. Select 'Copy' from the Edit menu and then select 'Paste' from the Edit menu. Group this layer with the Layer group underneath (Layer > Group with Previous). Select the 'Move tool' and drag the shadow back underneath the car. Ignore the original shadow that may appear to the left, as this will be removed in the next step.

17. To remove any evidence of the original shadow select the 'Clone Stamp tool' and check the Sample All Layers box in the Options bar. This option will allow you to select the pixels from the layer underneath without first selecting it. Choose a sample point by holding down the Alt key and clicking the mouse. Now the Motion Blur will be convincing and the car will look like it is neither floating nor parked.

Stage 3 - Spinning the wheels

If you examine the pin-sharp wheels of the car you will probably appreciate that there is still more work to do before we can hide the fact that this car is actually static. We must apply a small amount of Motion Blur to the wheels but this needs to be a radial instead of linear Motion Blur.

18. Make a selection with the Circular Marquee tool using a 5-pixel feather. If you need to move the selection before it is complete (letting go of the mouse button will complete the selection) you can press the Spacebar and slide the selection to a better position. Copy the wheel using the Copy Merged command from the Edit menu. The Copy Merged command will copy all of the visible pixels instead of the pixels on the currently selected layer. Choose 'Paste' from the Edit menu to paste a copy of the wheel to a new layer. From the Select menu choose Reselect.

Note > If the ellipse of the selection is slightly crooked when compared to the ellipse of the wheel that you are trying to select you can rotate the selection by using the Transform command (Image > Transform > Free Transform). You must, however, select an adjustment layer with an empty layer mask to ensure that no pixels are rotated when the elliptical selection is rotated. As none are currently available in this project you would have to create one.

Choose the Transform command (Image > Transform > Free Transform) and drag the side handle of the bounding box until the wheel appears as a circle instead of an ellipse. To get the best result from the Radial Blur filter we must present the wheel on the same plane to the one in which the filter works, i.e. front on.

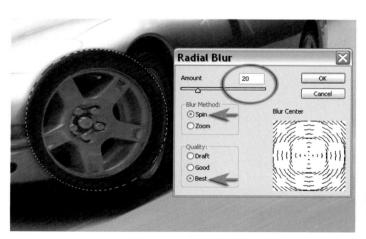

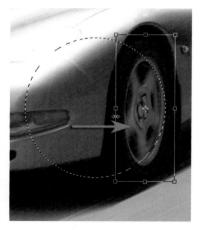

19. From the Blur group of Filters choose the Radial Blur filter. Check the radio buttons 'Spin' and 'Best' and start with a value of around 20 pixels before clicking OK. If the radial blur is excessive or insufficient choose 'Undo' from the Edit menu and then try the filter using an alternative amount. When you have applied the filter choose the Transform command again and return the wheel to its original elliptical shape. Repeat the process with the rear wheel.

Stage 4 - Adding the graphics

A classic car shot such as this would look great with a little window dressing. Rather than create the graphics from scratch a couple of extra close-up images were taken of the car model name and its distinctive logo of crossed flags.

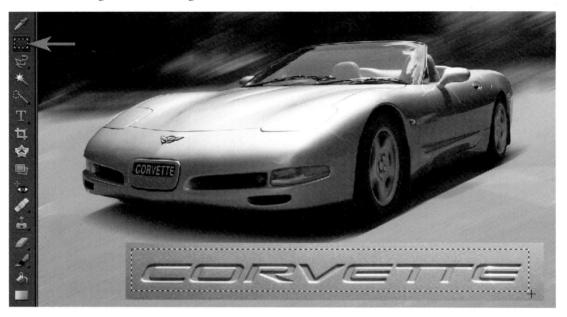

20. Open the image 'Logo1' and then click and drag the background layer thumbnail in the Layers palette from this new image file into the window of the car image. Use the Move tool to drag it into position below the car. Set the layer to Luminosity mode in the Layers palette so the background behind the text adopts the same color as the road. You can create a softer edge to the background by using the rectangular Marquee tool and making a feathered selection around the name. I have used a 30-pixel feather in this project.

21. Select the layer beneath the Logo1 layer and then create a Levels adjustment layer (no adjustment required). The active selection will create a mask that we can use to soften the edge of the logo. To make use of this mask select the logo layer and then choose 'Group with Previous' from the Layer menu. We can disguise the tonal difference of the background by grouping a Levels adjustment layer with the logo layer (hold down the Alt key and check the option in the New Layer dialog box as in step 14).

22. Move the Gamma slider until the left side of the logo's background appears the same tone as the road (ignore the fact that the right side is now lighter than the road) and then select OK.

23. Select the 'Gradient tool' in the Tools palette and choose the 'Black', 'White gradient' and 'Linear' options in the Options bar. Click and drag a straight line from the end of the logo to the start of the logo (hold down the Shift key whilst dragging your line to constrain the gradient to a straight line). This will shield the right side of the gradient from the excessive effects of the adjustment and create a tonal balance or uniformity along the width of the logo.

24. Open and drag in the second logo file. Use the Transform command to rescale the logo and move it into position. In the Effects palette choose the Layer Styles icon and the Bevels subcategory, and apply the Simple Pillow Emboss style by double-clicking its icon in the palette. This will ensure the logo matches the style of the embossed letters. Delete the background surrounding this second logo if you wish to emboss only the flags instead of the entire layer.

Stage 5 - Completing the image

At last we are on the home straight. All we have to do is add a vignette to focus the attention on the car and then, as always, an appropriate amount of sharpening just prior to printing.

25. Create a new layer and make sure it is positioned above all other layers in the Layers palette. Choose the 'Circular Marquee tool' and select a 200-pixel Radius in the Options bar. Drag from the top left-hand corner of the image to the bottom right-hand corner of the image. Choose 'Inverse' from the Select menu and sample some of the dark green foliage using the Eyedropper tool. Then choose 'Fill Selection' from the Edit menu and select 'Foreground Color' as the contents. Drop the opacity of the vignette layer to create the right effect and set the mode of this layer to Multiply.

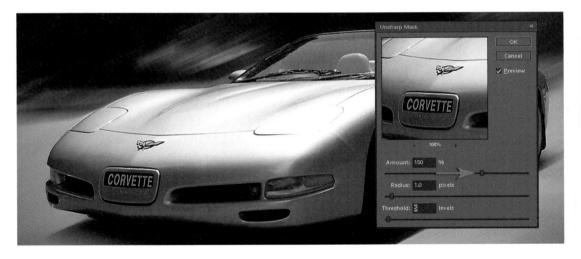

26. Complete the project by sharpening the image. Select the top layer in the Layers palette and then hold down the Ctrl + Alt + Shift keys and type the letter N followed by the letter E. This keyboard shortcut will copy all of the visible layers and paste them to a new layer. Use a generous amount of sharpening (150 to 200) but keep the radius low (0.8 to 1.5). Threshold can be raised slightly (3 to 6) when using files from a digital compact rather than a digital SLR. Print the image to assess the appropriate amount of sharpening. If the sharpening is excessive lower the opacity of the unsharp mask layer. Perfection on a plate – well almost. For even more realism don't forget to add that quintessential ingredient that I missed in this project – the driver!

PERFORMANCE TIP

When the movement is towards the camera the illusion of movement can be created by using the Radial Blur filter instead of the Motion Blur filter. To reduce the effects of the blur in the distance the filter can first be applied to a duplicate layer and this duplicate layer can then be grouped with an adjustment layer that contains a radial gradient. The sky was also masked using a linear gradient in Multiply mode.

The car in this illustration came from a separate image and was masked using techniques outlined in Project 1 of the Montage section (Part 3) in this book. The original shadow was preserved using the techniques outlined in Project 6 of the Montage section. The images used in this Performance Tip are courtesy of iStockphoto (www.iStockphoto.com) and are available for download from the supporting DVD.

Project 8

Low Key

A low-key image is where the dark tones dominate the photograph. Small brighhighlights punctuate the shadow areas, creating the characteristic mood of a low-key image. The position of the light source for a typical low-key image is behind the subject or behind and off to one side so that deep shadows are created. In the olden (pre-digital) days the appropriate exposure usually centered around how father photographer could reduce the exposure before the highlights appeared dull. In the digital age this approach to exposure at the time of capture should be avoided at all costs, especially when black velvet-like tones are your benchmark for quality.

The classic low-key image - redefining exposure for a digital age

Exposure for low-key images

For those digital photographers interested in the dark side, an old SLR loaded with a fine-grain black and white film is a hard act to follow. The liquid smooth transitions and black velvet-like quality of dark low-key prints of yesteryear is something that digital capture is hard pressed to match. The sad reality of digital capture is that underexposure in low light produces noise and banding (steps rather than smooth transitions of tone) in abundance. The answer, however, is surprisingly simple for those who have access to a DSLR and have selected the Raw format from the Quality menu settings in their camera. The next step is to be generous with your exposure to the point of clipping or overexposing your highlights and only attempt to lower the exposure of the shadows in Adobe Camera Raw.

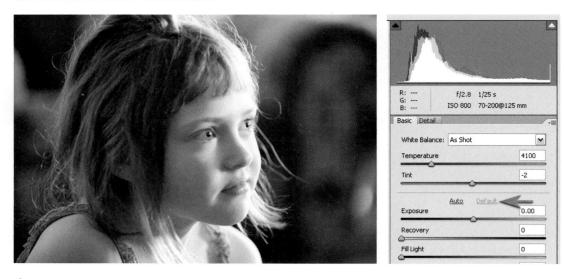

1. The first step is the most difficult to master for those who are used to using Auto or Program exposure modes. Although the final outcome may require deep shadow tones, the aim in digital low-key exposure is to first get the shadow tones away from the left-hand wall of the histogram by increasing and NOT decreasing the exposure. It is vitally important, however, not to increase the exposure so far that you lose or clip highlight detail. The original exposure of the image used in this project reveals that the shadow tones (visible as the highest peaks in the histogram) have had a generous exposure in-camera so that noise and banding have been avoided (the tones have moved well to the right in the histogram). The highlights, however, look as though they have become clipped or overexposed. The feedback from the histogram on the camera's LCD would have confirmed the clipping at the time of exposure (the tall peak on the extreme right-hand side of the histogram) and if you had your camera set to warn you of overexposure the highlights would have been merrily flashing at you to ridicule you of your sad attempts to expose this image. The typical DSLR camera is, however, a pessimist when it comes to clipped highlights and ignorant of what is possible in Adobe Camera Raw. Adobe Camera Raw can recover at least one stop of extra highlight information when the Exposure slider is dragged to the left (so long as the photographer has used a DSLR camera that has a broader dynamic range than your typical fixed lens compact digicam).

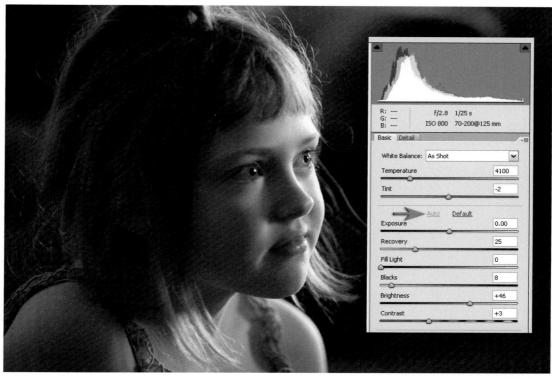

Adobe Camera Raw rescues the highlights - sometimes automatically

'Exposing right'

When the Auto checkbox in the Exposure slider is checked Adobe Camera Raw often attempts to rescue overexposed highlights automatically. With a little knowledge and some attention to the histogram during the capture stage you can master the art of pushing your highlights to the edge. So if your model is not in a hurry (mine is watching a half-hour TV show) you can take an initial exposure on Auto and then check your camera for overexposure. Increase the exposure using the exposure compensation dial on the camera until you see the flashing highlights. When the flashing highlights start to appear you can still add around one extra stop to the exposure before the highlights can no longer be recovered in Adobe Camera Raw. The popular term for this peculiar behavior is called 'exposing right'.

PERFORMANCE TIP

If the highlights are merrily flashing and the shadows are still banked up against the left-hand wall of the histogram the solution is to increase the amount of fill light, i.e. reduce the difference in brightness between the main light source and the fill light. If using flash as the source of your fill light it would be important to drop the power of the flash by at least two stops and choose the 'Slow-Sync' setting (a camera flash setting that balances both the ambient light exposure and flash exposure) so that the flash light does not overpower the main light source positioned behind your subject.

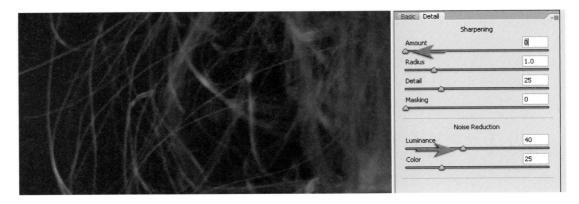

2. Before we massage the tones to create our low-key image we must first check that our tones are smooth and free from color and luminance noise. Zoom in to 100% magnification for an accurate preview and look for any problems in the smooth dark-toned areas. Setting both the Luminance Smoothing and Color Noise Reduction sliders to 25 (found in the Detail tab) removes the noise in this image. I would also recommend that the Sharpness slider be set to 0 at this point. Selective sharpening in the main editing space may help to keep the tones as smooth as possible rather than committing to global sharpening using the Adobe Camera Raw dialog box.

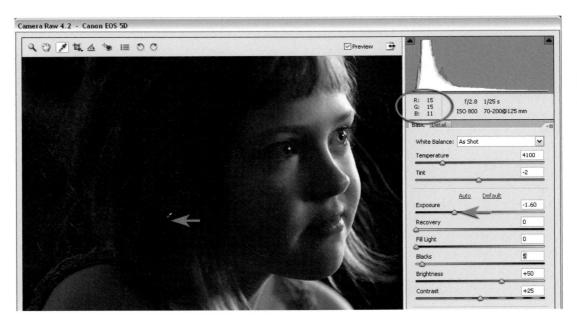

3. Create the low-key look by dropping the Exposure and/or the Brightness sliders in the Adjust tab. You can continue to drop these sliders until the highlights start to move away from the right-hand wall of the histogram. Select the 'White Balance tool' and move your mouse cursor over the deeper shadows - this will give you an idea of the RGB values you are likely to get when this image is opened into the editing space. Once you approach an average of 15 to 20 in all three channels the low-key look should have been achieved.

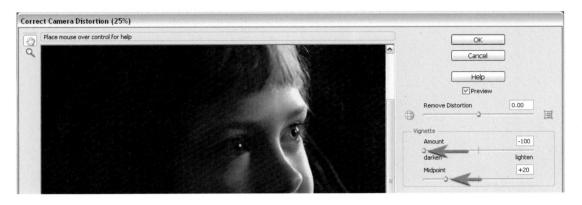

4. To enhance this image further a vignette has been added. This can be achieved in the Adobe Camera Raw dialog box in the full version of Photoshop but in Photoshop Elements the vignette has to be added in the main editing space. In Photoshop Elements 6 the Correct Camera Distortion filter can be used to add the vignette. Just drag the Amount slider to the left to darken the corners. Dragging the Midpoint slider to the left will slowly move the darkening effect towards the center of the image.

Note > If you are in 8 Bits/Channel mode and you want to add a vignette using layers, first create a new layer in Multiply mode and fill this layer with white. Hold down the Alt key as you click on the New Layer icon in the Layers palette to access the New Layer dialog box to give you these options.

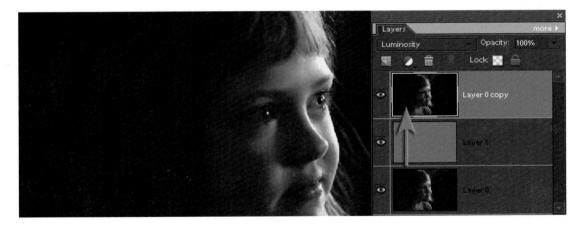

5. To drop the RGB to Black and White I have used a technique that extracts the luminance values from the RGB file. I usually find that this gives a superior result to lowering the saturation or choosing the Remove Color command. Simply click the New Layer icon in the Layers palette and from the Fill Layer dialog box choose '50% Gray' as the contents color (Edit > Fill Layer > 50% Gray). Create a duplicate of the background layer (or merge the contents if you have placed the vignette on a separate layer) and then move this duplicate background layer to the top of the layers stack. Switch the mode of the background copy layer to 'Luminosity' to create a black and white image from the Luminance values. Choose 'Flatten Image' from either the Layers palette's fly-out menu or the Layer menu itself if the original Color values are no longer required.

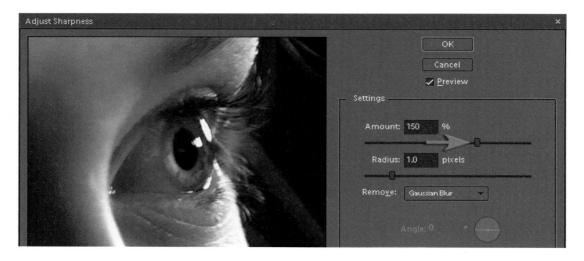

6. To complete the project the file should be sharpened for printing. Photoshop Elements now has an alternative to the Unsharp Mask. Adjust Sharpness (Enhance > Adjust Sharpness) is an excellent alternative for sharpening images that have little to no noise. To ensure the image does not appear over-sharpened be sure to restrict the Radius to nothing higher than 1.5. The image preview in this dialog will appear in color as the layer itself has not been dropped to black and white.

Note > If the Adjust Sharpness is making the smoother soft-focus tones appear anything but liquid smooth then consider a localized sharpening technique as described below.

- 7. Duplicate the layer you wish to sharpen by dragging it to the New Layer icon in the Layers palette. Apply a generous amount of sharpening using either Unsharp Mask or Adjust Sharpenss (be generous with the Amount slider but restrict the Radius slider to nothing greater than 1.5).
- 8. Click on the background layer, beneath the layer you have just sharpened, to make this the active layer. Then click on the Create Adjustment Layer icon in the Layers palette and choose a Levels adjustment layer from the pull-down menu. When the Levels dialog box opens make no adjustment just click OK. Make sure this adjustment layer is below the duplicate layer. Click and drag it into position if it needs to move.

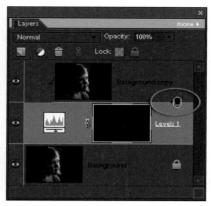

- 9. Fill the adjustment layer mask with black (Edit > Fill Layer > Black).
- 10. Click on the duplicate layer to make this the active layer. From the Layer menu choose 'Group with Previous'.

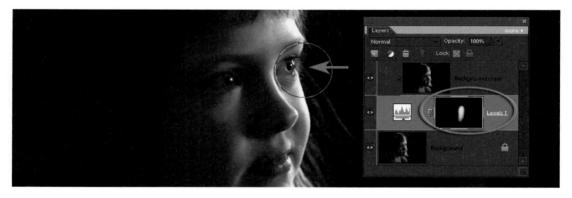

- 11. Select the Brush tool from the Tools palette. Select 'White' as the foreground color. Choose a soft brush from the Options bar and drop the opacity of the brush to 50%.
- 12. Click on the layer mask in the Layers palette to make this active and then move your attention to the main image window. Zoom the image to either 50% or Actual Pixels (100%). Paint in the areas where you would like to increase the sharpness of the image. Painting several times in the same region will slowly build up the sharpness of the image.

PERFORMANCE TIP - A FINAL WORD OF WARNING

To extract the maximum quality from your low-key image you will need to print this image on premium quality photo paper or have the image printed at a professional quality print service provider. All the work will be for nothing if the printer or surface quality of the paper cannot handle all of these smooth dark tones. If printed well the print will stand up to close - really close - scrutiny at close range.

Channels

You can spend a long time making pointless selections when all Elements needs is to be shown the differences between 'that which must be changed' and the pixels that need to be left alone based on hue, saturation or brightness. I have learnt to resist the temptation to jump in early with the lasso or tragic wand tool and instead learn to utilize and exploit the differences that may be lurking beneath the RGE surface of the image. The differences that Photoshop thrives on for selection-free editing can usually be found in the component channels of the RGB image.

The Apostles - The finished image together with the start image and the red and blue channels. The red channel is employed to enhance the sky whilst using the blue channel to mask its effects.

The red channel in this seascape image is information rich in the sky, whilst the blue channel has excellent contrast that could be utilized for the creation of a mask to control localized adjustments. Users of the full version of Photoshop have this information available in the Channels palette. The Photoshop Elements user must find another way, as the Channels palette is out of bounds. Although Photoshop Elements uses the three primary color channels to create the RGB image, Adobe feels that the Photoshop Elements user does not need to see the component information. Just because you can't see the channels doesn't mean you can't use them.

Part 2: Enhance

Part 1 - Extracting the red channel

1. To start the ball rolling duplicate the background layer by dragging it to the New Layer icon in the Layers palette and then add a Solid Color adjustment layer from the Create Adjustment Layers menu in the Layers palette. Select Red in the Color Picker (255 Red, 0 Green, 0 Blue).

2. Set the blending mode for the layer to Multiply and then choose Merge Down from the Layer menu. It will probably come as no surprise, but your image has just turned bright red.

3. Duplicate the Red layer (background copy) by dragging it to the New Layer icon and from the Enhance menu choose 'Adjust Hue/Saturation' from the Adjust Color submenu (Enhance > Adjust Color > Adjust Hue/Saturation, or use the keyboard shortcut Ctrl + U. Move the Hue slider to +120. Your 'Background copy 2' layer is now bright green.

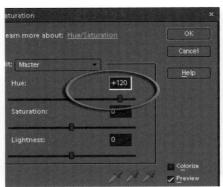

4. Change the blend mode of this green layer (Background copy 2) to Screen (this will turn the main image yellow as the filtering process begins to take place) and then drag the green Background copy 2 layer to the New Layer icon to copy it. Use the Hue/Saturation adjustment again to change the hue to blue by dragging the Hue slider to +120. The image in your main image window should now appear as a black and white image - these are not just any shades of gray but the gray values that are only present in the red channel of your image. It is a bit too early for the round of applause as we are currently using three layers to achieve this effect.

5. Select all three colored layers by holding down the Ctrl key and click on each layer in turn so that all three colored layers are highlighted. From the Layer menu choose Merge Layers. This red layer (dropped to grayscale values) is a useful way to create dramatic black and white images, due to the fact that red filtration of a full color scene makes blue skies darker without darkening any clouds that may be present in the sky. We will, however, take this a few steps further if you are able to stay along for the ride.

Part 2 - Using the red channel layer to darken the sky

6. I have named the background copy layer as the Red Channel (really a layer) by clicking on its name in the Layers palette (just so things don't get too confusing). Duplicate the Red Channel layer by dragging it to the New Layer icon and change the blend mode to Multiply. This step is designed to darken the sky and create a lot more drama. Choose 'Merge Down' from the Layer menu to create a single darkened red channel layer. Now click on the background layer in the Layers palette to select it and then from the Create Adjustment Layer icon in the Layers palette choose 'Levels'. Don't make any adjustment - just click 'OK' in the Levels dialog box. We will use the adjustment layer mask on this adjustment layer to mask or hide everything in the Red Channel layer except the sky, which we will leave visible in order to darken the sky below.

/. Click on the Red Channel layer to make it active and then from the Layer menu choose 'Group with Previous'. Change the blend mode of the Red Channel layer to Luminosity. The Luminosity blend mode will allow all of the color from the background layer to become visible but retain the brightness or 'luminance' values of the Red Channel layer. The mask beneath can hide any of the luminance values that are not required. Adjust the opacity of the Red Channel layer if the drama needs to be lowered a little. Now you could just paint in the mask to hide the unwanted luminance values but the idea behind this tutorial is to let Photoshop do all of the work - we are just providing the brains. My brain cells tell me that a mask for those rocks probably already exists in the blue channel of this RGB file. We will typically find that the sky is very light in the blue channel and everything that has no blue component will be dark, i.e. the rocks and foreground beach.

Part 3 - Channel masking

8. Switch off the visibility of the top two layers by clicking on the eye icon next to the layer thumbnail. Using the same technique as in Part 1 of this tutorial create a blue channel layer. Instead of selecting Red as the Solid Color in step 1 choose 255 Blue (the other two channels should be set to 0 in the Color Picker). The rest of the procedure is identical (hallelujah!) using the same +120 Hue value in the Hue/Saturation dialog box each time and the same sequence of blend modes (first apply the Multiply mode to the blue solid color adjustment layer, apply the Screen mode to the subsequent color layers and then Merge Layers).

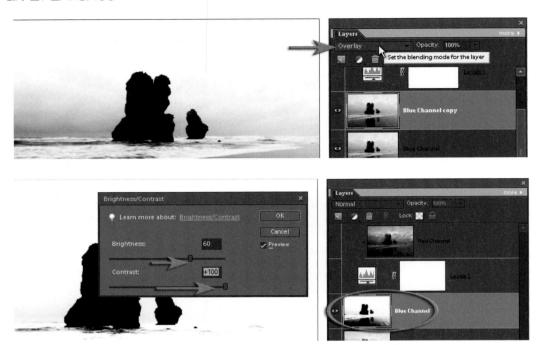

9. After merging the three color layers to create a Blue Channel layer you should see that the rocks in the sea are very dark against the bright sky (the basis of a really effective mask) - the contrast, however, is not quite high enough to act as a layer mask just yet. The aim is to render all of the sky white and the rocks black. To increase the contrast duplicate the Blue Channel layer and then set the duplicate layer to Overlay mode. Then choose Merge Down from the Layers menu. Apply the Brightness/Contrast adjustment feature (Enhance > Adjust Lighting > Brightness/Contrast) to render the sky mostly white and the rocks mostly black.

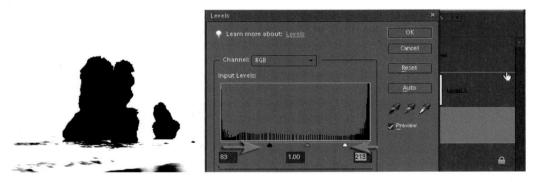

10. Apply a Levels adjustment to this layer (Enhance > Adjust Lighting > Levels) and drag the white slider underneath the histogram to the left until no traces of gray sky are left. Drag the black slider underneath the histogram to the right until the rocks are solid black. Click OK to apply the changes and create your mask - the only problem now is that it needs to be in the layer mask above and not in its own layer.

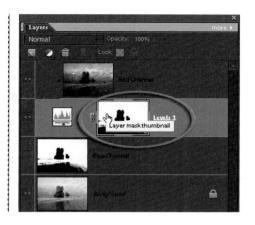

11. To transfer this high-contrast Blue Channel layer to the layer mask above select 'All' from the Select menu and then choose 'Copy' from the Edit menu. Hold down the Alt key and click on the adjustment layer mask thumbnail on the Levels 1 layer. The main image window should momentarily appear white, as you are now viewing the empty contents of this layer mask. Choose 'Paste' from the Edit menu to paste the contents of the clipboard into this layer mask. Hold down the Alt key again and click on the layer mask thumbnail one more time to switch off the layer mask view. Nothing will have appeared to have changed until you then switch off the visibility of the Blue Channel layer by clicking on the eye icon next to the layer thumbnail. Don't expect perfection just yet as the water and the reflections on the beach will appear slightly weird at this point in time.

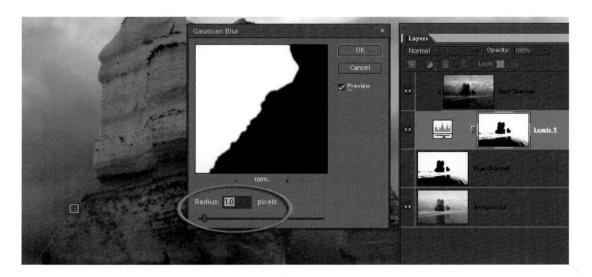

12. Apart from some strange tones in the water and on the beach you will probably also notice a halo, or white line, appearing around the rocks where the sky has not been darkened. To remove this halo, first apply a 1- or 2-pixel Gaussian Blur filter to the layer mask to soften the edge (Filter > Blur > Gaussian Blur). This step serves to soften the edge whilst the next step will attempt to realign the edge.

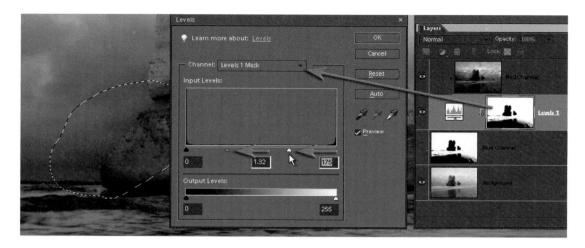

13. Make a selection with the Lasso tool around any edges that have a thin white halo around them. Apply a Levels adjustment to the mask. Moving the central Gamma slider underneath the histogram in the Levels dialog box to the left and moving the white Highlight slider to the left should remove the halo.

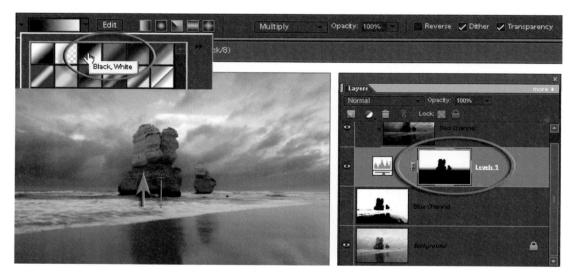

14. To finish off this edit we must hide the foreground pixels in the Red Channel, in order to return normal viewing to both the water and the reflections on the beach. Select the Gradient tool in the Tools palette and choose the 'Black, White' gradient in the Options bar and set the Opacity to 100%. Make sure the Linear gradient option is also selected and change the blend mode to Multiply. Move your mouse cursor into the main image window (this is the only painting tool used in the entire edit) and click just around the base of the central rock and drag a short stroke to a point around halfway up the rock. Let go of the mouse clicker to apply the gradient to the layer mask. As the blend mode of the Gradient tool is set to Multiply this gradient will be added to the existing mask rather than replacing it.

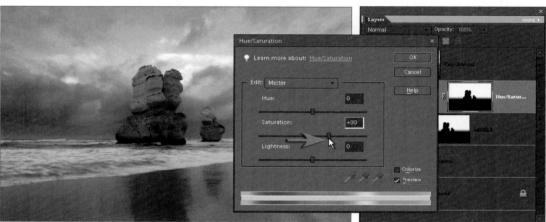

15. The last step of this edit is to replace some of the saturation in the sky that was upset when we changed the Red Channel layer to Luminosity mode. It is a really painless process to pick up the selection from the layer mask we have just crafted. Hold down the Ctrl key and click on the layer mask thumbnail. This will load the mask as a selection. With the active selection simply select a Hue/Saturation adjustment layer from the Create Adjustment Layer menu in the Layers palette and increase the intensity of the color to taste.

Not convinced

You may be thinking that this is a very long process to simply darken the sky of this image. I have, however, learnt all the keyboard shortcuts for every step of this process (including all of the blend modes and merge commands) and I reckon most people would only be halfway around the first rock with their Lasso tool before I had completed this entire editing procedure (all 15 steps). This image edit would normally only take you three or four minutes when you know where you are going. If this is not fast enough be sure to check out the action with this book. Remember - just one click and you have all three channels as layers installed in the Layers palette. A little more brains and a little less playing with your tools now will pay dividends in the amount of time you save later.

part

montage

Project 1

Creative Montage

Masks can be used to control which pixels are concealed or revealed on any image layer except the background layer. If the mask layer that has been used to conceal pixels is then discarded the original pixels reappear. This approach to montage work is termed 'non-destructive'. In the full version of Photoshop the mask can be applied to any layer. In Photoshop Elements layer masks are only available on adjustment layers, but these can be used to mask the pixels on the layer, or layers, above.

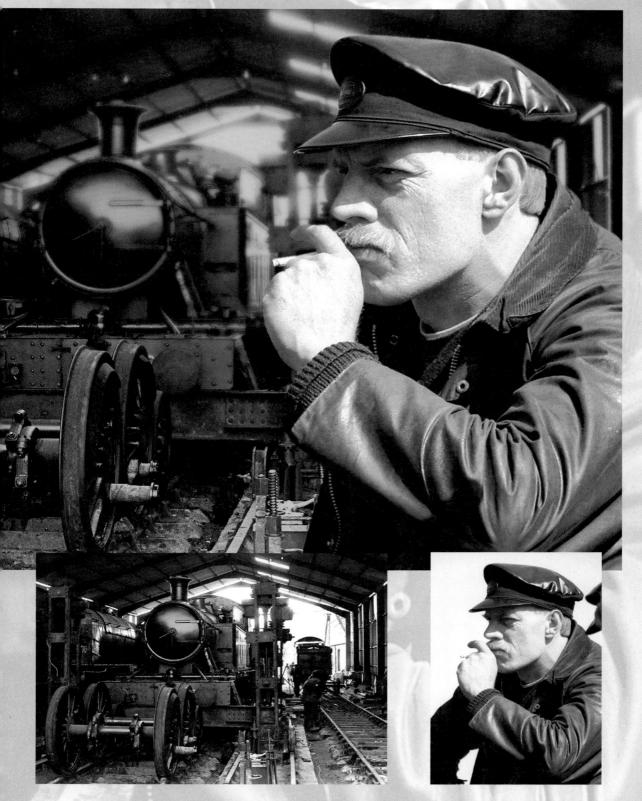

Forget cutting and pasting - learn the craft of professional montage using advanced masking techniques

- 1. Open the resource images and drag the layer thumbnail of the train driver image into the image window of the train to create a file with two layers. Use the Move tool to position the second layer. Select 'Free Transform' (Image > Transform > Free Transform) to scale and move the image into position (the train driver should be on the tright side of the image and be the same height as the background layer).
- 2. Select the majority of the sky on Layer 1 by using either the Quick Selection tool or Magic Wand tool. Use the 'Add to selection' and 'Subtract from selection' icons in the Options bar to modify the selection.

3. Holding down the Option key when making a selection with the Quick Selection tool will allow you to drag over any parts of the image you would like to exclude. Remove the arm on the left of the image and also the second hat in the top right-hand corner. You may need to reduce the brush size, zoom in and carefully stroke the tip of the sleeve to add this to the selection.

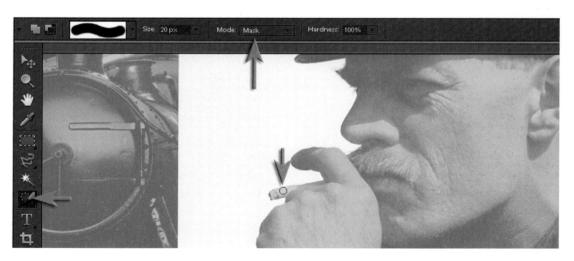

4. Use the Selection Brush tool in Mask mode to fine-tune the selection work. Pressing the Alt key when painting with the Selection Brush tool will remove rather than add to the selection or mask. Keep the feather set to 0 and the hardness of the Selection Brush tool set to maximum to match the quality of the Quick Selection tool or Magic Wand tool. Switch the mode in the Options bar back to 'Selection' and from the Select menu choose 'Inverse'.

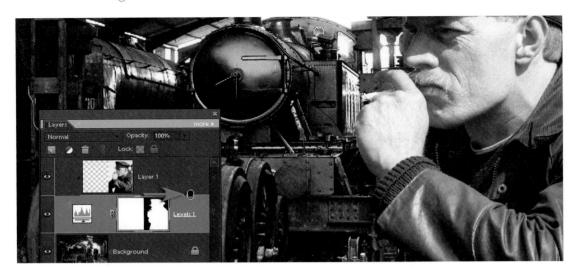

5. Select the background layer in the Layers palette and create a Levels adjustment layer. Select OK without making any adjustment. The selection has now become a mask that can be used to conceal the background pixels of the train driver. Click on Layer 1 at the top of the layers stack to select it and then choose 'Group with Previous' (Ctrl + G) from the Layer menu or hold down the Alt key as you move your mouse cursor over the dividing line between the train driver layer and the Levels adjustment layer and then click your mouse. The pixels are concealed rather than being deleted and can be retrieved if required to create the perfect edge.

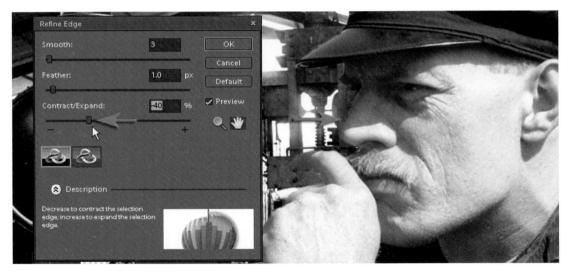

6. The mask will require some modifications before the edge is subtle and believable. Click on the layer mask thumbnail to select it and select Refine Edge from the Select menu. Choose Selection from the View menu to hide the marching ants at the edge of your selection. Set the Smooth slider to 3, the Feather slider to 1.0 and slide the Contract/Expand slider to the left to conceal the white edge that surrounds your subject.

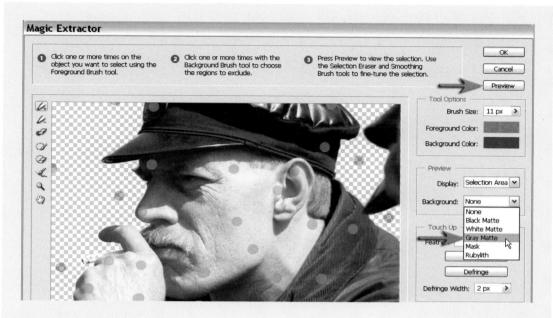

PERFORMANCE TIP

The fact of life is that some extractions can be as painful as pulling teeth! With this in mind Adobe offers you even more magic - the Magic Extractor (Image > Magic Extractor). This is yet another alternative for getting rid of problematic backgrounds. This tool takes a little more time than the Quick Selection tool and is destructive in nature (it deletes the pixels you select with the Background Brush tool) so I would advise duplicating this layer before proceeding. You make little marks or squiggles to advise Photoshop which regions of the image you would like to keep and which regions you would like to delete. Click on the Preview button to see how Photoshop does the hard maths to extract your subject from the background. From the Preview menu choose a matte color to view your extracted subject (choose a different tone to the original background or one that is similar to the new background).

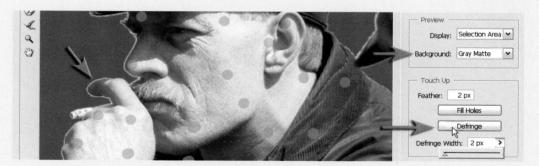

In the Touch Up section of the dialog box select a Feather value (usually 1 or 2 pixels) and then choose a 'Defringe Width' to remove any of the remaining background. Not a bad job - if you don't mind losing the background pixels.

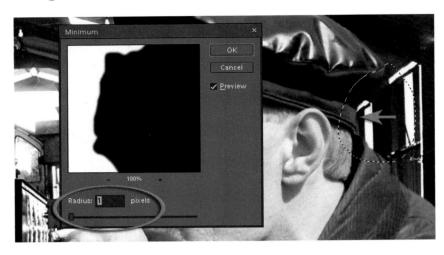

7. View the entire edge around the subject, looking for any remaining halos. If this is the case make a selection to isolate that edge for individual attention. To remove any small halo from around the subject go to the Filter menu and select 'Other > Maximum'. Select a pixel Radius amount that is just enough to shrink the mask so that the fringe of old background pixels disappears.

Note > Any small traces of old background (especially in corners or areas of fine detail) can be removed with a soft-edged brush. Paint with white at a reduced opacity (approximately 50%) and erase some of the mask in the localized area that is causing the problem.

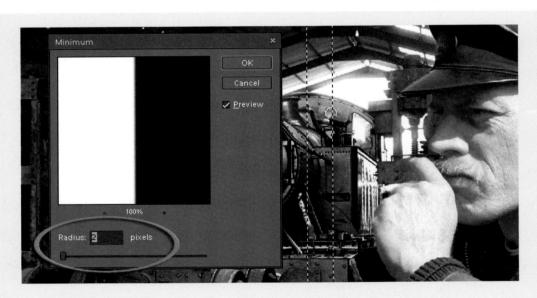

PERFORMANCE TIP

If the edge of the train driver file is still visible as a thin white line either brush it out in the mask or make a selection around the line using the Rectangular Marquee tool and then select the Minimum filter (Filter > Other > Minimum). A Radius setting of 2 pixels should remove the white line.

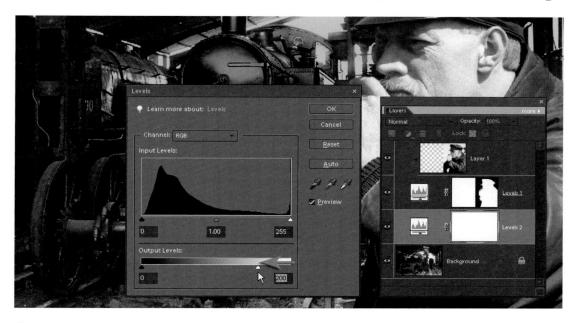

8. Select the background layer and create a Levels adjustment layer. Drag the Output Levels slider to a value of 200 to reduce the brightness of the distracting highlights in the background.

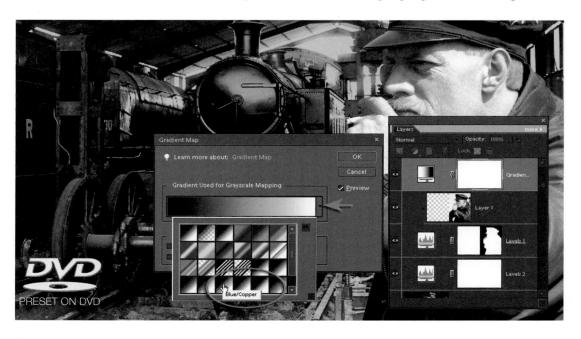

9. Select the train driver layer at the top of the Layers palette and then select 'Gradient Map' by clicking on the Create Adjustment Layer icon. Choose the "Blue/Copper' gradient preset that can be loaded from the supporting DVD or click on the gradient to edit an existing gradient map. *See* Part 2, Project 4: Toning (page 120) for more information on this technique.

10. Duplicate the background layer, and from the Filters menu choose 'Blur > Gaussian Blur'. Select a pixel Radius that reduces the focus sufficiently to separate the portrait from the background layer.

11. Create a Levels adjustment layer above the background layer and group the background copy with it (Ctrl + G). Select the 'Gradient tool' with the 'Foreground (black) to Transparent' and 'Linear' options. Select the layer mask thumbnail and drag the Gradient tool in the main image window to follow the perspective line of the train. This gradient mask will conceal the front of the blurred train layer to create a simple depth of field effect.

Note > More elaborate 'depth masks' can be created using the selection tools. See Part 2, Project 1: Depth of Field (page 92).

12. Use the Clone Stamp set to 50% opacity to 'tone down' the distracting highlights on the background copy and/or background layer (top left side of the image). This action makes way for the insertion of the wheels image in the top left-hand corner. Drag the layer thumbnail of the wheels image into the train image to add it to the composition.

13. Choose Free Transform (Image > Transform > Free Transform) and scale the new image to a suitable size. Place the mouse cursor inside the Free Transform bounding box and drag the image into position in the top left-hand cormer. Commit the transformation by clicking on the green check icon.

14. Select the 'Circular Marquee tool' and draw a feathered circle around the wheel. With the active selection create a new Levels adjustment layer. Select OK without making any adjustment. With the Levels adjustment layer mask active choose 'Fill Layer' from the Edit menu. Choose Black as the Contents and select OK.

15. Place the Levels adjustment layer below the wheels layer and group the wheels layer with the adjustment layer (Layer > Group with Previous). The mask can be further softened to create a smoother transition by applying the Gaussian Blur filter (Filter > Blur > Gaussian Blur) or sharpened (if the original feather was too great) by applying a Brightness/Contrast adjustment. The size of the mask can be modified by going to Image > Transform > Free Transform.

16. Use the Text tool to add a line of type ('Age of Steam') below the wheel. I have selected white as the font color and chosen 30 pt as the type size. From the Options bar select the 'Create warped text' option. From the Style menu choose the Arc option and set the bend to a negative value (approximately -65%) by dragging the slider to the left.

17. Once the relationship between the wheels, the mask and the text layer is correct these combined elements can be moved as one by first selecting all three layers in the Layers palette. Click on each layer in turn while holding down the Ctrl key. Then select the Move tool and move into the best position within your composition to complete the project.

Replacing a Sky

For people who seem to find themselves in the right place at the wrong time! Have you ever traveled long and far to get to a scenic vista only to find that the lighting is useless and the sky is a little short of inspiring? Do you make camp and wait for the weather to change or reluctantly and humiliatingly buy the postcard? Before you hit the Delete button or assign these 'almost rans' to a never-to-be-opened-again folder to collect digital dust, consider the post-production alternatives Photoshop Elements lets you revisit these uninspired digital vistas to inject the mood that you were looking for when you first whipped the camera from its case.

The Road to Morocco - change the sky to change the weather

I think every photographer can relate to the intrepid explorers of the Australian Outback who, after scaling the highest peak in the area with great expectations, decided to call it Mount Disappointment! One can only conclude that they were expecting to see something that was simply not there. This something extra could be made real so that all of your landscapes live up to your high expectations - with just a little digital help.

Check out the supporting DVD to access an extensive stock library of royalty-free skies

Part 3: Montage

This tutorial requires a little something you prepared earlier - a sky. It is worth making a little photographic collection of interesting skies for projects such as this one. A whole library of interesting skies can be found in the stock library on the supporting DVD.

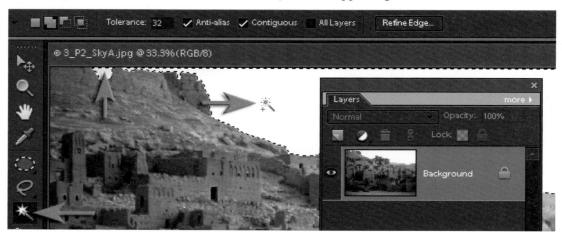

1. Open the resource image and use the Magic Wand tool to select the sky. Select the Add to Selection icon in the Options bar to add additional areas of sky. Increasing the tolerance in the Options bar from the default setting will increase the amount of sky that is selected the first time. Clicking off the 'Contiguous' option in the Options bar will allow the Magic Wand tool to select areas of sky that may not be connected to the original area of sky you clicked on. This may, however, cause highlights present in the image to be included in the selection. If this happens select the 'Lasso tool' with the 'Subtract from Selection' option and then encircle the areas you wish to remove from the overall selection.

2. Click on the Refine Edge button in the Options bar to open the Refine Edge dialog box. This dialog box will allow you to perfect the selection.

3. When the Refine Edge dialog box opens click on the Custom Overlay Color icon to see the area that is not selected masked with a color (the opacity and hue of which can be changed by double-clicking on the icon). Click on the Default button to reset the sliders to their default setting. Move the Contract/Expand slider to the right to expand the selection. You may notice the color overlay shrink a little as you move the slider. This will ensure there is no unsightly line between the new sky and the foreground when this project is completed.

4. It is advisable to save any important selections that you have made to prevent your selection being accidentally lost. Go to 'Select > Save Selection' and name your selection with an original name such as 'Sky'. After saving a selection you will be able to impress your friends by loading a selection with the words 'here is something I prepared earlier'. Save the changes to the edited file so the selection can be loaded even after the image has been closed and then reopened.

5. Open the image with the sky you wish to import. Click and drag the sky thumbnail in the Layers palette into the Morocco image window. The sky should have similar pixel dimensions to that of the host image. If the images do not precisely match you can, however, use the Free Transform command (Image >Transform > Free Transform) to resize your sky to fit.

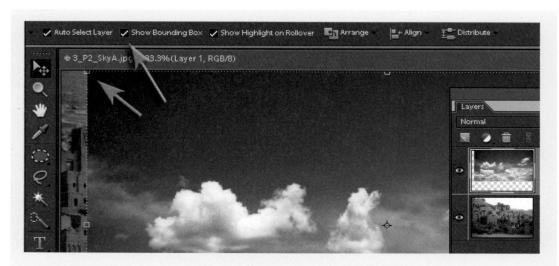

PERFORMANCE TIP

You can also transform a layer by selecting the Move tool and checking the Show Bounding Box checkbox. Dragging any of the bounding box handles will then increase or decrease the size of the image on this layer.

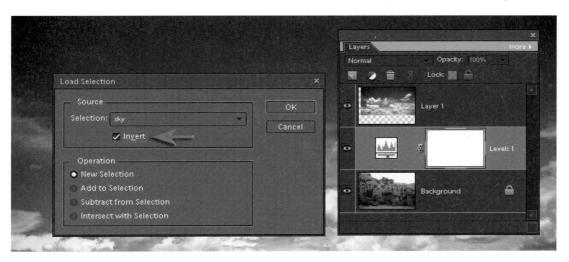

6. Click on the background layer in the Layers palette to make it the active layer and then add a Levels adjustment layer. Select OK without making any adjustment (we only need the layer mask and not the adjustment itself). To restrict or limit the visibility of the new sky to the correct area we need to load the selection that we saved earlier. Go to the Select menu and choose 'Load Selection'. Choose your named selection, check the 'Invert' option and click OK.

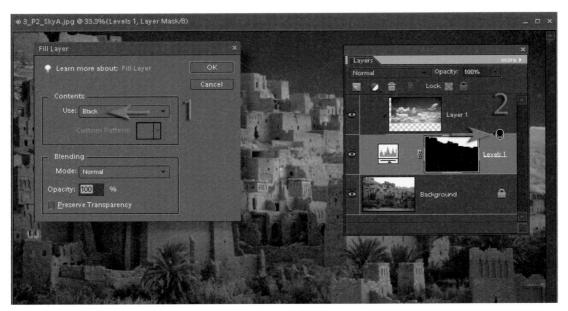

7. With your active selection and the layer mask of the Levels adjustment layer selected choose the 'Fill Selection' option from the Edit menu and choose 'Black' from the Contents menu. Select the sky layer and from the Layer menu choose 'Group with Previous' (Ctrl + G) or hold down the Alt key and click on the dividing line between the two layers in the Layers palette.

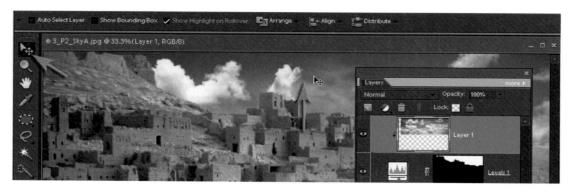

8. Select the 'Move tool' and choose the best position for the new sky by dragging it in the main image window. It is not going to look perfect just yet as most skies get progressively lighter as they near the horizon. If the sky you are importing does not have this quality it can easily be fixed in a two-step process.

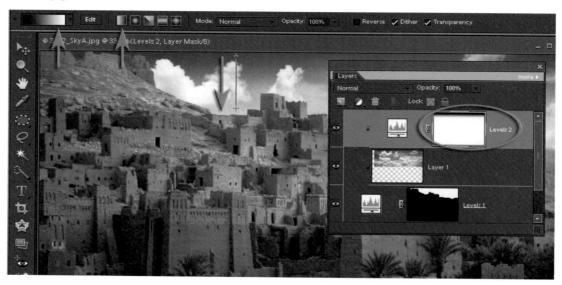

9. Hold down the Alt key and create another Levels adjustment layer. The Layers dialog box that opens gives you the option to 'Group' this adjustment layer with the previous layer. This will restrict the adjustments we are about to make to only the sky component of the image. Click OK and when the Levels dialog box opens make the entire sky much lighter by dragging the Gamma slider most of the way to the left. Select OK to close the Levels dialog box.

To fade or lighten the sky progressively towards the top of the hills start by selecting the default 'Foreground' and 'Background' colors in the Tools palette. You may need to switch the colors to ensure black is the foreground color. Select the 'Gradient tool' with the 'Foreground to Background' and 'Linear Gradient' options from the Options bar. Drag a gradient from the top of the frame to just above the top of the hills. If the effect is anything other than 'cool', hit the 'Edit > Undo', check the settings and try again.

10. Zoom in to 100% Actual pixels or 200% and use the Spacebar to drag the image along the seam between the host image and its new sky. If you detect any white haloes or loss of fine detail along this edge we can adjust the position of the edge to create a perfect match. Select the 'layer mask' at the base of the clipping group and from the Select menu choose 'Refine Edge'. Set the Smooth and Feather sliders to zero and then move the Contract/Expand slider either to the left or to the right to refine the visual appearance.

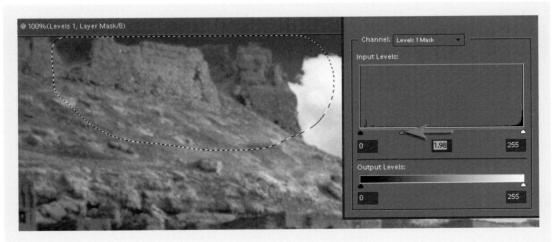

PERFORMANCE TIP

If an initial adjustment to the layer mask fixes the majority of the edge accuracy, but leaves an inaccurate section, you should proceed to make a feathered selection of the offending area (use the Lasso tool or a Marquee tool with a 3- to 5-pixel Feather Radius), then reapply a Levels adjustment. The resulting modification will be restricted to the selected area only.

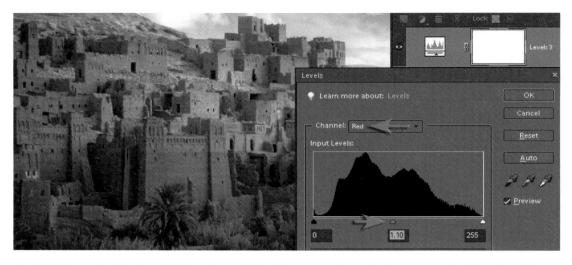

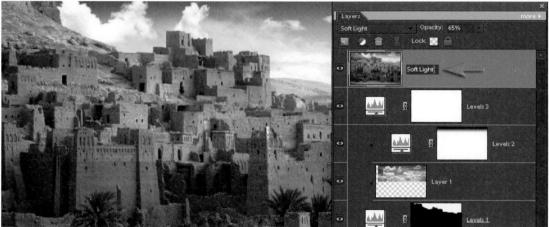

11. When replacing a sky you can aim to match the light quality found in the host image with that likely to be provided by the new, but more interesting, sky. There are examples of skies on the supporting DVD that would provide soft, filtered, sunny, warm or cool lighting to any scene. If, however, the new sky looks altogether more sunny than the one you have replaced, you may need to warm up the scene you are working on and increase the contrast to suit.

In this image the entire image is made warmer and brighter using a Levels adjustment layer. Drag the central Gamma slider to the right in the red channel and to the left in the blue channel to increase the warmth in this image. A neat trick to add saturation and contrast is to stamp the visible elements to a new layer (Ctrl + Alt + Shift and then type E) and set the blend mode to 'Soft Light'. Reduce the Opacity of this layer if required.

Now that you have spread a little sunshine around you may like to consider the words of an old pop song, 'Everywhere you go, always take the weather with you'. With Photoshop Elements rendering the world with an altogether sunnier outlook, alternative realities are always a possibility. May your landscapes always bask in beautiful/interesting weather!

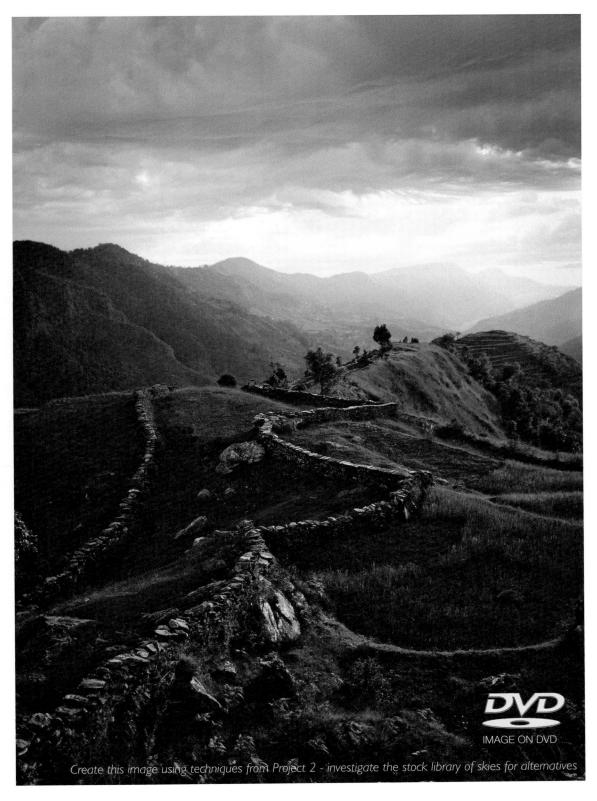

High Dynamic Range

Contrary to popular opinion, what you see is not always what you get. You may be able to see the detail in those dark shadows and bright highlights when the sun is shining - but can your image sensor? Contrast in a scene is often a photographer's worst enemy. Contrast is a sneak thief that steals away the detail in the highlights or shadows (sometimes both).

Contrast no problem - discover the secrets to limitless dynamic range

Wedding photographers will deal with the problem of contrast by using fill flash to lower the subject contrast; commercial photographers diffuse their own light source or use additional fill lighting and check for missing detail using the Histogram or a Polaroid. Landscape photographers, however, have drawn the short straw when it comes to solving the contrast problem. For the landscape photographer there is no 'quick fix'. A reflector that can fill the shadows of the Grand Canyon has yet to be made and diffusing the sun's light is only going to happen if the clouds are prepared to play ball.

Method 1 - using a single Camera Raw file

The first technique the photographer can use to combat extreme subject contrast utilizes the flexibility of the Camera Raw format (an image format that can be selected in most high-end digicams and all DSLR cameras). If you are able to capture in Raw mode you will be able to exploit the full dynamic range that your image sensor is capable of. Choosing the JPEG format in your camera when photographing high-contrast subjects may result in the loss of shadow and highlight detail (*see* Part 1, Project 3: Camera Raw, page 22). Part 2 of this project offers an option for merging two separate exposures to restore highlight and shadow detail.

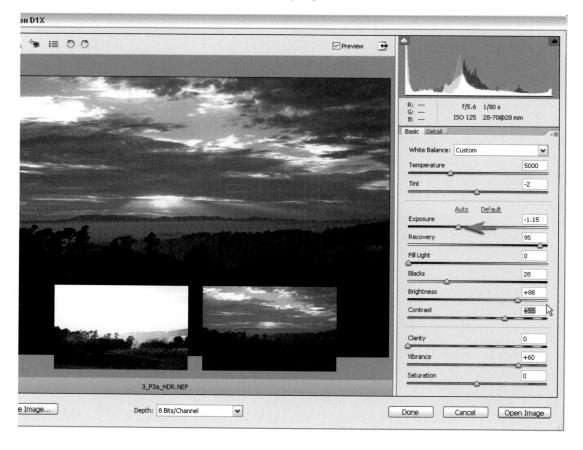

When the Raw file is opened in Photoshop Elements moving the Exposure slider allows you to take advantage of the extra information in the Camera Raw file to simulate an increase or decrease of exposure in the camera. This allows the photographer to access either increased highlight information or increased shadow information after the image has been captured. It is possible to open multiple versions of the same Raw file and combine them in the main editing space of Photoshop Elements.

Note > When the Raw information is processed the preview and thumbnail of the Raw file reflects these preferences but the Raw data cannot itself be modified. Raw files can be processed multiple times using different settings for exposure, color, sharpness, etc.

To achieve the optimum dynamic range that is possible from the information recorded by the image sensor (increased shadow detail AND increased highlight detail) we can open two images from the same Raw file, each file being optimized for a different end of the exposure range. In Photoshop Elements we can then simply merge the two exposures together. Some would call this manipulation when in reality all we are doing is restoring the tonality back to how our human vision first saw the scene rather than how the camera interpreted it.

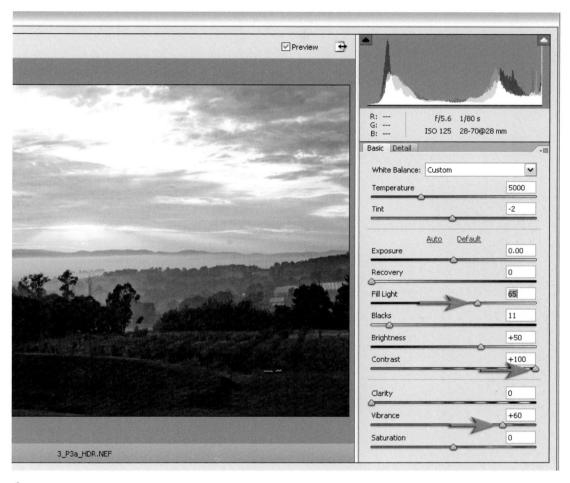

1. Open your Camera Raw file in the Adobe Camera Raw dialog box. Move the Exposure slider or Fill Light slider to the right until the shadow detail has opened up and the detail is clearly visible. Pay no attention to the highlights that may now appear overexposed. Notice how the tall peaks on the left-hand side of the histogram move away from the left side as you move the Exposure or Fill Light sliders to the right. If the shadows are rich in detail but appear flat and gray you can compensate for these by raising both the Contrast and Vibrance sliders. Zoom in to 100% and check the shadows for excessive noise. If noise is a problem proceed to the Detail tab and raise the Luminance Smoothing and Color Noise Reduction sliders to the right until the noise is sufficiently suppressed. Set the 'Depth' in the bottom of the dialog box to 8 Bits/Channel and select 'Open Image'.

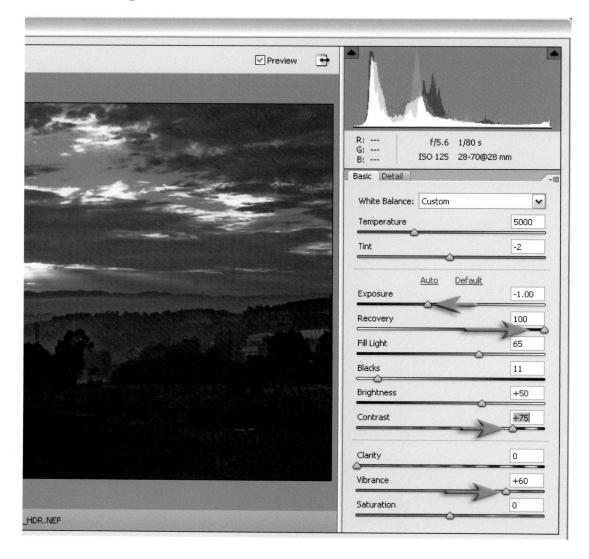

2. Go to File > Place and browse to the same Raw file that you have just opened. Open the file into the Raw dialog box for the second time and now move the Exposure slider to the left to optimize the image for the highlight detail. Drag the Recovery slider all the way to the right and then choose appropriate settings for the Contrast and Vibrance sliders and select the OK button. This second 'interpretation' from the Raw data will be placed on a layer above the first. Commit the transform bounding box without altering the size so that both layers will align perfectly.

PERFORMANCE TIP

In the example some of the highlights are only just recoverable. If you are presented with a landscape with even more contrast the only way of achieving additional information in the highlights or shadows is to bracket the exposures (covered in the next part of this project).

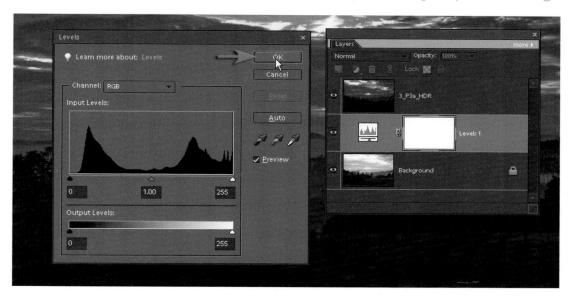

3. The next step involves adding a layer mask that will be used to conceal the darker features of the top layer. To create an adjustment layer for this purpose first select the background layer in the Layers palette and then click on the Create Adjustment Layer icon and choose 'Levels'. Do not make any adjustment in this dialog box but simply select OK.

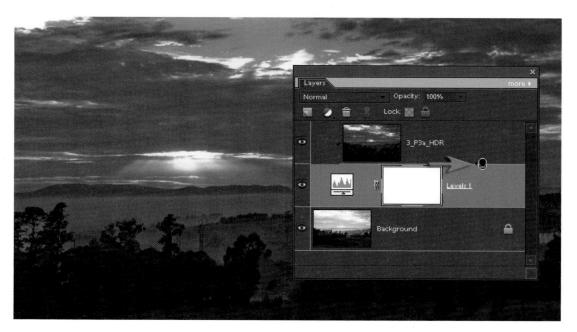

4. Group the top layer with this adjustment layer to link the layer mask to this image layer. Click on the top layer to make this the active layer and then from the Layer menu choose 'Group with Previous'.

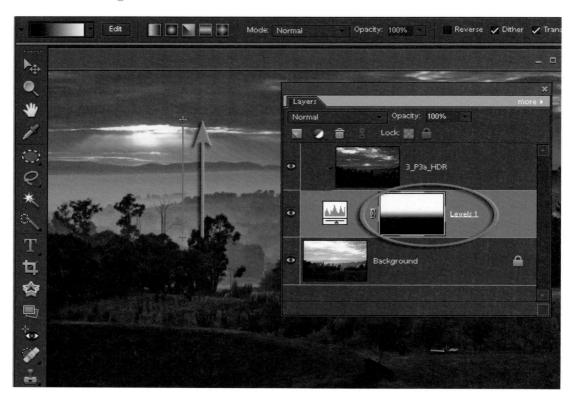

5. In the Tools palette choose the 'Gradient tool' and from the Options bar choose the 'Black, White' gradient, 'Linear' option with an opacity of 100%. Click on the layer mask to make this the active component of the layer. Move the cursor into the image window and click just below the horizon line. Hold down the Shift key and drag the gradient to a position just above the sun and then let go of the mouse button. This action will add a gradient to the layer mask and will act to hide the darker foreground pixels in the top layer. We will now be able to view the sky from the image with the decreased exposure, and the foreground from the image with the increased exposure.

PERFORMANCE TIP

A more complex mask is often called for when the subject is not so clearly defined as a bright sky and a dark foreground. If this is the case you can paint directly into the mask using a soft-edged brush with the foreground color set to 'Black' and the opacity dropped to 50%.

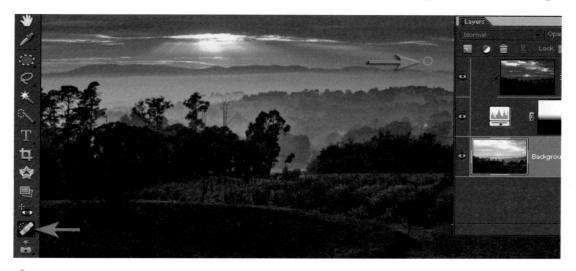

6. The camera used to capture this image has a dust mark on the sensor. It is visible in the sky on the right side of the image, just above the distant hills. Select the Spot Healing Brush Tool and then, with a small soft-edged brush, click in the sky to repair the damage. You may need to perform this task on both the top layer and the background layer depending on where you have drawn your gradient.

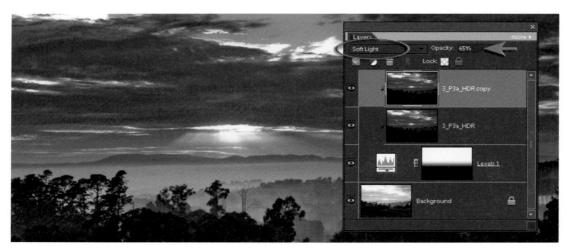

7. To create the right balance between the foreground and background it may be necessary to fine-tune the image. We could have increased the contrast and saturation of the decreased exposure in the Raw dialog box but it was difficult to gain an idea of what the two images would look like when combined at this stage of the process. In this project it was decided to duplicate the top layer (drag the layer to the New Layer icon in the Layers palette) and then switch the mode to 'Soft Light'. You will notice that the duplicated layer is still part of the group and so the mask shields this layer as well as the layer beneath. The 'Soft Light' blend mode has the effect of increasing both the contrast and the saturation of the sky. The effect is that the image now looks like how I remembered the scene when I first raised the camera to my eye.

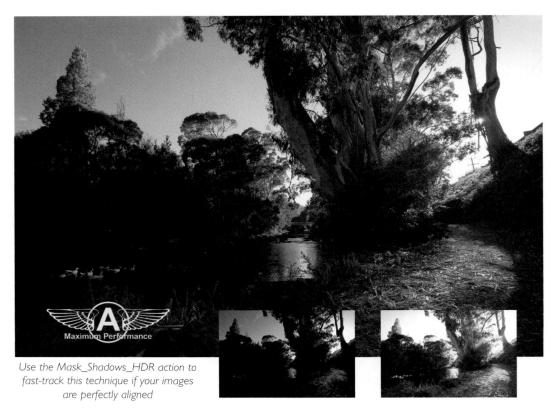

Method 2 - bracketing exposures

1. If we can't fit all the goodies in one exposure, then we'll just have to take two or more. The idea is to montage, or blend, the best of both worlds (the light and dark sides of the camera's not quite all seeing eye). To make the post-production easier we need to take a little care in the pre-production, i.e. mount the camera securely on a sturdy tripod. Take two exposures - one overexposing from the auto reading and the other underexposing from the auto reading. One or two stops either side of the meter-indicated exposure should cover most high-contrast situations.

PERFORMANCE TIP

Setting your camera to 'auto bracket exposure mode' means that you don't have to touch the camera between the two exposures, thereby ensuring the first and second exposures can be exactly aligned with the minimum of fuss. Unfortunately for me, the little Fuji FinePix s7000 I was using for this image has auto bracket exposure but it is not operational in Raw capture mode - the only respectable format for self-respecting landscape photographers. This is where you dig out your infrared remote or trusty cable release (if you have somewhere to screw it into). The only other movement to be aware of is something beyond your control. If there is a gale blowing (or even a moderate gust) you are not going to get the leaves on the trees to align perfectly in post-production. This also goes for fast-moving clouds and anything else that is likely to be zooming around in the fraction of a second between the first and second exposures.

2. Click on the dark underexposed image to make it the active image window and then drag the layer thumbnail (in the Layers palette) into the window of the lighter overexposed image. Holding down the Shift key as you let go of the image will align the two layers (but not necessarily the two images).

3. In the Layers palette set the blend mode of the top layer to 'Difference' to check the alignment of the two images. If they align no white edges will be apparent (usually the case if the tripod was sturdy and the two exposures were made via an auto feature or cable release). If you had to resort to a friend's right shoulder you will now spend the time you thought you had saved earlier. To make a perfect alignment you need to select 'Free Transform' from the Image > Transform menu. Nudge the left side into alignment and then move the reference point location in the Options bar to the left-hand side of the square. Highlight the numbers in the rotation field in the Options bar and then rotate the image into final alignment by pressing the up or down arrow keys on the keyboard.

4. Add a Levels adjustment layer above the background layer. Make no adjustments as only the mask is required. Group the top layer with this adjustment layer (hold down the Alt key as you click on the dividing line between the two layers). Click on the background layer and choose 'All' from the Select menu (Ctrl + A). Copy to the clipboard and then Alt + Click the adjustment layer thumbnail. The image window should appear white as the layer mask is empty. Now choose 'Paste' from the edit menu (Ctrl + V). Apply a small amount of Gaussian Blur to this mask before Alt + Clicking once again to return to the normal view.

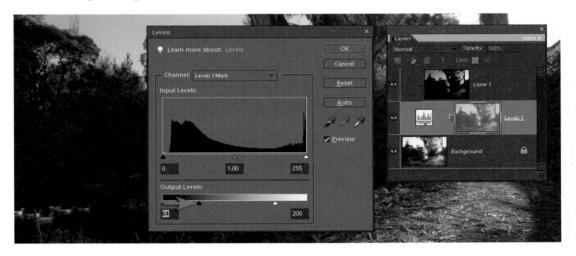

5. It is important to recreate the expanded contrast of the original scene, otherwise the image will look slightly surreal if the overall contrast is low. The first technique to expand the contrast is to apply a Levels adjustment to this layer mask (Ctrl + L). Drag in the Output sliders (directly beneath the Shadow and Highlight sliders) until the final contrast appears high but not clipped (lowering the contrast of the mask increases the contrast of the final image).

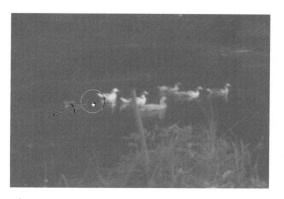

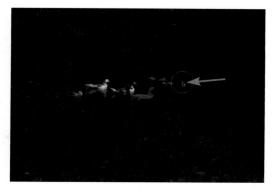

6. The observant amongst us will have noticed the ducks have been breeding. The ghost images can be removed by painting or cloning them out on both the top layer and the layer mask beneath. If using a soft-edged brush to paint them out you should first sample an adjacent color by holding down the Alt key and clicking on the surrounding tone. Alt + click the layer mask to get a clear idea of what you are doing.

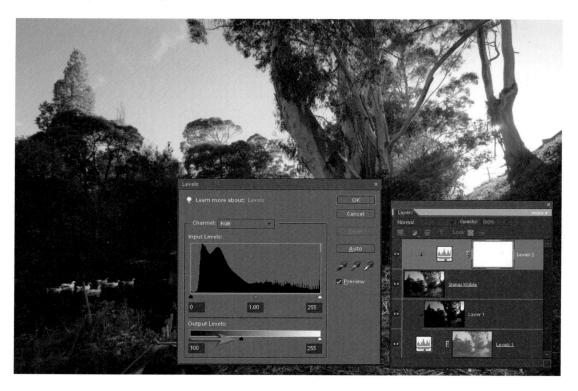

7. In order to achieve the final contrast setting for this image, stamp the visible elements to a new layer (Ctrl + Alt + Shift then type the letter E) and place this new layer in Overlay or Soft Light mode. Adjust the opacity of this layer until the required effect is created. If the shadow tones are rendered too dark by this process, a Levels adjustment layer can be grouped with this layer and the Shadows Output slider raised to restrict the increase in contrast to just the midtones and highlight tones.

In the full version of Photoshop the user has access to the 'Advanced Blending Options'. In this dialog box it is possible to reduce the opacity of the shadow tones on the top layer to reveal the shadow tones beneath. The effect can be faded in gradually, creating a blend of the optimum highlights from the top layer and the optimum shadow tones of the background layer. The advanced blending options are only available to users of the full version of Photoshop, but the same results can be achieved using a layer style preset loaded into the presets folder in Elements. The layer styles provided on the supporting DVD give the Elements user the option of partial transparency based on tonality.

Photoshop Elements users can access the Transparency Layer style by first loading the styles and metadata available on the supporting DVD into the Layer Styles folders (<C:\Documents and Settings\All Users\ApplicationData\Adobe\Photoshop Elements\6.0\Locale\<installed locale>\Photo Creations). The styles and metadata were created in the full version of Photoshop but can be read by Photoshop Elements. The software may have to be restarted after loading the styles and metadata into the folder before Photoshop Elements will load the new content.

Note > Vista users will find the Adobe folder in the C:\Program Data folder.

Select the top layer in the Layers palette and then click on each of the four presets in turn (now located in the Effects palette) and choose the one that renders the best tonality.

To improve the midtone contrast proceed to stamp the visible elements of both the dark and light layers into a single layer (hold down the Ctrl + Shift + Alt keys and then type the letter E). Set the blend mode of this Stamp Visible layer to Soft Light and adjust the opacity of the layer if required.

Project 4

Creative Type

Photoshop Elements may be a couple of tools short of a six-pack when it comes to working with vector shapes and paths, the principal tools of the trade for graphic designers, but creative typography is one area where Photoshop Elements users do not have to bow down their heads in shame. We can be subtle and sophisticated, using conservative and delicate fonts with carefully color-matched hues or, for those of you who believe typography does not always have to whisper here are a couple of major techniques we can employ to get our message across loud and clear.

Master the techniques for working creatively with text layers and images to create stunning graphics

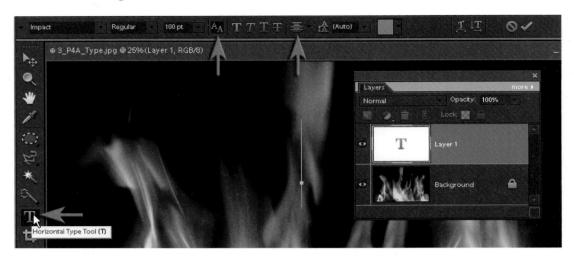

1. Open the Fire image from the supporting DVD. Select the 'Type tool' in the Tools palette and then specify the font style, size and select the anti-aliased and align center options for the text.

Note > The anti-aliased option when highlighted will ensure smooth-edged type. Color is not important for this project as the type will be filled with another image.

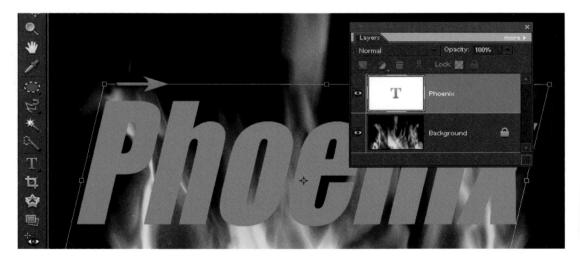

2. Stretch or distort the type layer by applying the Free Transform command (Ctrl + T). The type in the example is stretched vertically by dragging the top-center handle upwards and then skewed to the right. Press the Enter key to apply the transformation.

PERFORMANCE TIP

'Transform' alters the shape and/or size of the subject matter on a single selected layer. Holding the Shift key down whilst dragging a corner handle will constrain the proportions. Holding down the Ctrl key whilst dragging a handle will allow you to skew the text.

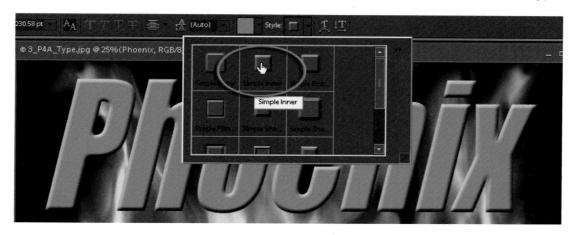

3. Apply an effect or layer style to this text layer. Click on the Style icon in the Options bar, then click on the fly-out menu and choose Bevels. Then select the Simple Inner thumbnail.

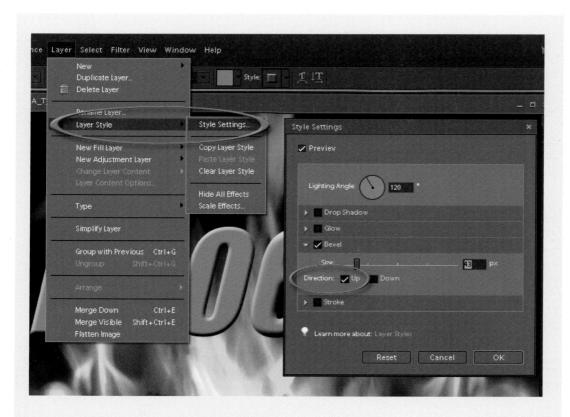

PERFORMANCE TIP

The appearance of the bevel can be fine-tuned by going to 'Layer > Layer Style > Style Settings'. The Style Settings dialog box can also be accessed by double-clicking on the Layer Style icon on the layer in the Layers palette.

4. Open the image containing the texture you wish to paste into the text. For maximum quality check that the pixel dimensions of the texture image are the same or greater than the image containing the text. The size can be modified later using the Free Transform command but the digital photographer must be careful not to increase the size of any image excessively ('interpolation' has a tendency to lower the overall quality). Drag the thumbnail of the drops in the Layers palette into the image window containing the fire and text. The texture will be placed on a layer above the other layers, completely concealing both the text and the background.

5. A clipping group is required in order to fill the text with the image of the raindrops. Go to 'Layer > Group with Previous' or move the mouse cursor to the line that divides the two layers in the Layers palette. By holding down the Alt key the Clipping icon should appear (two overlapping circles). Clicking whilst holding down the Alt key will group the layers together. The layer thumbnail is indented, the name of the base layer in the group is underlined, and the text acts as a mask.

6. Switch off the visibility of the background layer by clicking on the eye in the Layers palette. Stamp the visible elements to a new layer (hold down the Ctrl, Alt and Shift keys whilst typing the letter E on the keyboard). The text will appear on its own layer filled with raindrops. You can now switch on the visibility of the background layer. The visibility of the text layer directly above the background layer can now be switched off as it has served its purpose.

7. Select 'Layer 1' in the Layers palette (the raindrops layer) and then create a Levels adjustment layer. As we only require the adjustment layer mask we can simply click OK without making any adjustments. Group Layer 2 with this adjustment layer (Layer > Group with Previous).

Note > When the Phoenix layer is grouped with the adjustment layer no visible change occurs at this stage as the adjustment layer mask is empty.

8. Set the default foreground and background colors in the Tools palette and then type the letter X on the keyboard to switch the colors to black in the foreground and white in the background. Select the 'Gradient tool' in the Tools palette. Select the 'Linear gradient', 'Foreground to Background' or 'Black, White' options and 100% opacity. Move the cursor to the bottom of the typography in the main image window. Click and drag the gradient cursor from the base of the letters to the top of the letters. A linear gradient will appear in the layer mask and the typography should be half hidden behind this layer mask. Experiment with dragging shorter and longer gradients.

9. The graphic is now constructed from three layers. Each component can be moved separately to alter the visual outcome or they can all be moved together. The layer mask can be moved to hide or reveal the text by selecting the 'Move tool' and dragging inside the main image window. To move the text instead of the mask you must first click on the layer above the adjustment layer. To move the layer mask and the typography at the same time you must first link the layers. Hold down the Shift key and click on both of the layers in the group to select them, then click on the Link Layers icon in the Layers palette. The mask and the text can now be moved together.

To adjust the color of the text (now that it is not controlled by the font color) you can add an adjustment layer to the existing group. Hold down the Alt key as you select an adjustment layer to open the New Layer options dialog box. Select the Group With Previous Layer box to ensure the adjustment affects only the text and not the background layer.

10. Select the 'Horizontal Type tool' again and click beneath the word you have just created. Select a smaller point size and type the words 'rises from the ashes'. Adjust the size and position of the text so that it is exactly the same width as the word 'Phoenix' (see step 2).

Note > Holding down the Shift key as you click with the text cursor ensures you always create a new text layer rather than editing the existing text layer. This is not a problem in this step as the visibility of the original text layer is off.

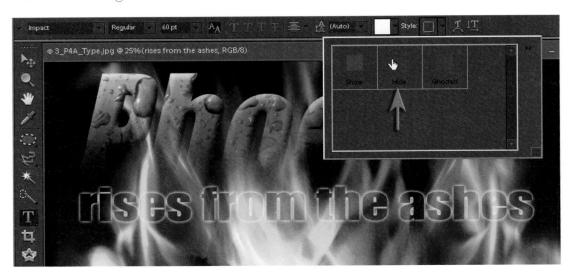

11. Click the Layer Styles icon to open the fly-out menu, choose Outer Glow, then pick Simple Glow. Return to the Style menu and choose Visibility from the fly-out menu, then choose the Hide style. This action hides the text color but leaves the layer style at 100% opacity. Adjust the Outer Glow size using the Style Settings palette (see the Performance Tip in step 3).

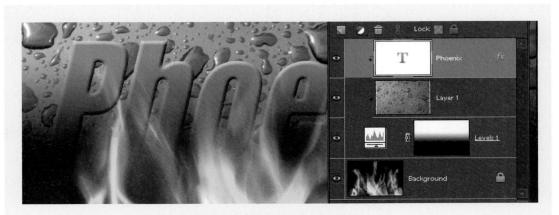

PERFORMANCE TIP - AN ALTERNATIVE APPROACH

An alternative approach to masking the text and texture is possible. The advantage of this approach is that the text remains editable as the text is not rasterized (converted from a text layer into a pixel layer). The disadvantage of this approach is that a more sophisticated mask is required to mask both the texture and the text, and this can take a little longer to perfect.

Ungroup all of the layers you have created so far. Place the Levels adjustment layer above the background layer. Drag the water droplets layer above the adjustment layer and the text layer above the water droplets layer. The text and texture are grouped with the adjustment layer mask containing the linear gradient.

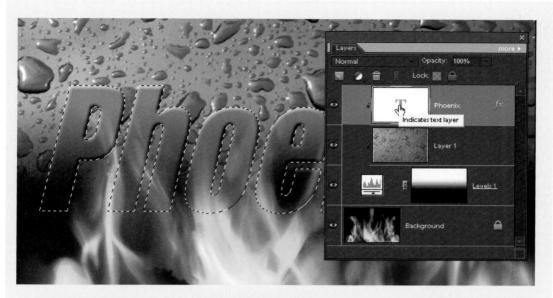

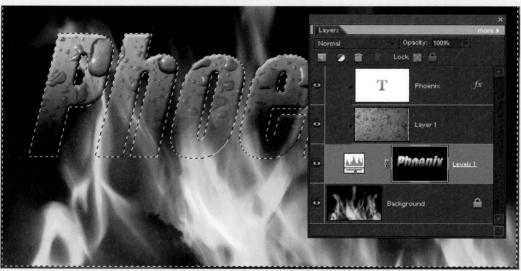

Ctrl + Click the text layer to load the outline of the text as a selection. Invert the selection (Shift + Ctrl + I) and then select the layer mask thumbnail and fill the selection with black (Alt + Backspace if black is the foreground color). Use the Maximum or Minimum filters, if required, to perfect the mask. Click the Layer Styles icon and choose Visibility from the flyout menu, then choose the Hide style. The Hide layer style is applied to the text layer to hide the text color and reveal the water droplets on the layer below. If the text layer is modified in any way (spelling, font style or size) then a new mask will need to be created.

Creative text styles can be accessed via the Effects palette. Text styles can be found in the Layer Styles section. Filters can also be applied to text but this requires the user to 'simplify' the layer (convert the text to pixels), which will prevent you from editing the text later on.

When applying a layer style to your text layer be sure to double-click the Layer Styles icon on the layer to open the Style Settings dialog box. These styles can be dramatically altered by changing the settings or switching off component aspects of the layer style.

The styles available in your Photoshop Elements software are just the tip of the iceberg when it comes to creative possibilities. If you want your type to look like wood, metal, plastic, rock or even tree bark then there is a free style waiting for you online at Adobe Studio Exchange.

HTTP://SHARE.STUDIO.ADOBE.COM

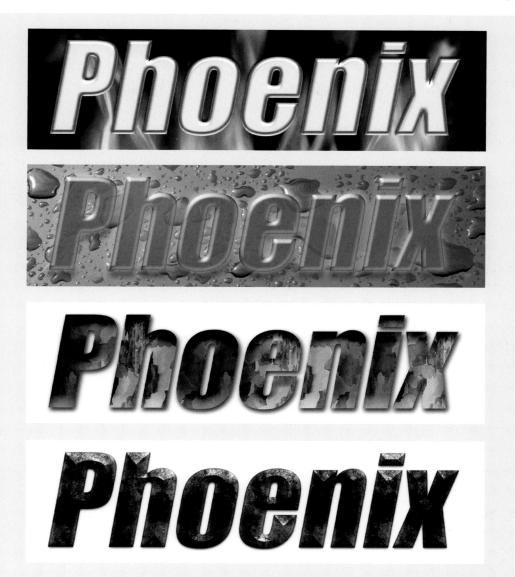

Above are just a few examples of the possibilities that layer styles can afford the creative individual. A Maximum Performance Text Styles folder is available on the DVD that accompanies this book. Just place the folder in the Styles folder (6.0\Locale\<Installed Locale>\Photo Creations\Layer Styles) and use the same procedure outlined in the previous project and the introductory section of the book to load the styles into your Special Effects library. The last two examples were downloaded from the Adobe Studio Exchange website and are from the Australian Bush series by BSeen and the Stonemason series by CSP.

Note > If installing styles without an accompanying XML file they will appear in the All category after you restart Photoshop Elements.

Project 5

Displacement

Create a showpiece montage by elevating an old Jag into a classic motor with a little spit and polish and some delectable digital deeds. Wickedly good stuff. The car's paintwork was enhanced before starting the project by increasing the overall saturation of the image and the scratches were removed using the Healing Brush. The tires were made to look like new by using the Burn tool set to 20%. It only it was this easy in real life!

Liquid pixels - a displacement, masking and layer style 'combo'

Stage 1 - Creating a backdrop using the Displacement filter

The layer blend modes are an effective way of merging or blending a pattern or graphic with a three-dimensional form. By using the blend modes the flag in this project can be modified to respect the color and tonality of the undulating silk beneath it. The highlights and shadows that give the silk its shape can, however, be further utilized to wrap or bend the flag so that it obeys the material's shape and sense of volume. This can be achieved by using the Displace filter in conjunction with a 'displacement map'. The 'map' defines the contours to which the flag must conform. The final effect can be likened to 'shrink-wrapping' the flag to the 3-D form of the undulating silk.

How it works: The brightness level of each pixel in the map directs the filter to shift the corresponding pixel of the selected layer in a horizontal or vertical plane. The principle on which this technique works is that of 'mountains and valleys'. Dark pixels in the map shift the graphic pixels down into the shaded valleys of the 3-D form whilst the light pixels of the map raise the graphic pixels onto the illuminated peaks of the 3-D form.

1. A silk dressing gown was photographed using the available light. For this image to act as an effective displacement map the contrast must, however, be expanded. An effective way of expanding contrast in Photoshop Elements is to duplicate the layer and set the top layer to 'Overlay' blend mode. Note the changes to the histogram by viewing the histogram in the Histogram palette.

Note > Duplicate the silk image resource file to ensure the original file is retained as a master and not lost by this manipulation. Either copy the image file before you start the project or go to 'File > Duplicate' before you proceed to step 2.

2. Go to the Image menu and from the Mode submenu select 'Grayscale'. Choose the option 'Flatten' when the Warning dialog box appears.

Note > The displacement map must be in Grayscale otherwise the color channels will upset the appropriate displacement effect.

3. To further improve the effectiveness of the displacement map we must blur the image slightly. This effect of blurring the map will smooth out the lines of the flag as it wraps around the contours of the silk. Too much blur and the undulations will be lost, too little and the lines of the flag will appear jagged as it is upset by any minor differences in tone. Go to 'Filter > Blur > Gaussian Blur' and start by selecting a Radius of around 10 pixels. Increase or decrease this radius when working with images of a different resolution.

4. Save the image (displacement map) as a Photoshop (PSD) file. Close the blurred Grayscale file as the map is now complete. You will need to choose this file when the Displacement filter asks for the location of your map, so make a note of where it has been saved to on your computer.

5. Open or select the RGB silk file that has not been blurred. Also open the flag image. With the flag image as the active window, choose 'All' from the Select menu and then choose 'Copy' from the File menu. Now make the silk image the active window and choose 'Paste' from the File menu. Alternatively you can just drag the thumbnail of the flag image in the Layers palette into the image window of the silk image if you can see both image windows on your desktop.

Set the blend mode of the flag layer to 'Multiply'. If you are intending to displace a graphic or a texture it is worth ensuring that you have some elbow room (when we displace the flag it will come away from, and reveal, the edges of the background layer if they are the same size). Use the Free Transform command to enlarge the flag layer so that it is a little larger than the background layer.

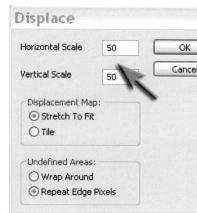

6. Go to 'Filter > Distort > Displace'. Enter in the amount of displacement in the Horizontal and Vertical fields of the Displace dialog box. The size of the displacement is dependent on the resolution of the image you are working on. Choose amounts of 40 for both fields for the Flag.jpg used in this project. Increasing the amount greater than 60 for either the Horizontal or Vertical scale will increase the amount of distortion in this project image, but will also start to break off islands of color from the design of the flag, indicating that the limit of the effect has been exceeded. Select OK in the Displace dialog box and in the 'Choose a displacement map' dialog box browse to the diaplacement map you saved. Select Open and your flag should now miraculously conform to the contours of the silk. If you are not entirely happy with the results go to the Edit menu and choose 'Undo'. Repeat the process choosing smaller or greater amounts in the Displace dialog box.

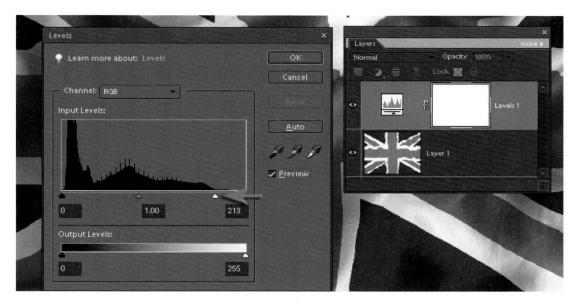

7. Add an adjustment layer and drag the Highlight slider to the start of the histogram to extend the dynamic range and make the highlights and midtones appear brighter. Your dramatic and colorful background is now complete.

Stage 2 - Creating a montage using masks

The following montage techniques are used for professional results. The techniques covered allow precise control over the alignment and quality of the edge (soft/hard) to ensure that no haloes from the old background are visible (even when using crude selection tools such as the Magic Wand).

Note > Download the completed flag file from the supporting DVD if you would like to start the project at this point.

8. Open the image of the Jaguar car and add this as a layer above the adjustment layer and flag in the master project file (see step 5 for a guide on combining two images). I have made the background behind the car white in order to make it easier for you to remove it from view in this project.

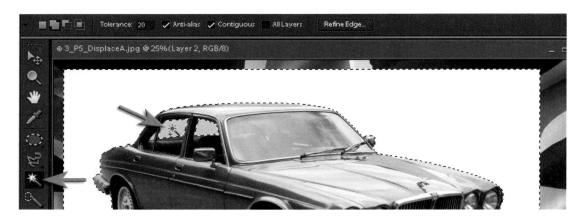

Select the 'Magic Wand tool' in the Tools palette. Select the Add To icon in the Options bar and set the tolerance in the Options bar to 20. Click on the white background surrounding the car and then click on the rear window behind the back seat to add these sections to the selection. You do not need to delete the white background in order to conceal it (deleting pixels is considered destructive editing and can restrict the control over the edge quality later).

Note > The TIFF image on the supporting DVD has a saved selection of the car.

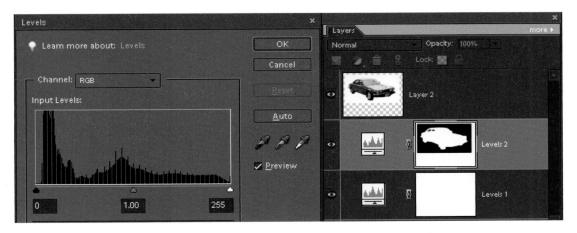

9. Go to the Select menu and choose 'Inverse Selection'. Then proceed to select an adjustment layer from the Layers palette. It does not matter which adjustment layer you choose as we will only be borrowing its layer mask and not using it to make any adjustments to the layers beneath. Just select OK without making any adjustment. Click on the car layer above the adjustment layer and choose 'Group' from the Layer menu.

Note > The background will now have been removed but the edge still needs to be refined to improve its appearance.

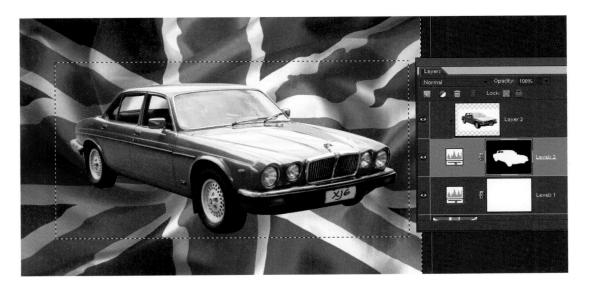

10. The resulting mask is likely to have a 1-pixel white line visible around the edge of the old background. To remove this thin white line paint with black directly into the layer mask of the adjustment layer. Alternatively a quicker option (if you know your shortcuts) is to make a rectangular selection around the car using the Marquee tool (M), invert the selection (Ctrl + Shift + I) and fill this selection with black (Alt + Backspace if black is in the foreground swatch).

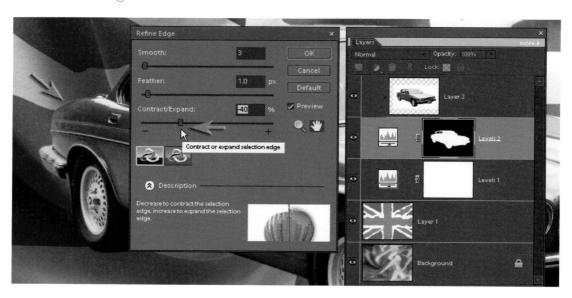

11. The edge of the mask needs to be softened and moved to conceal the remnants of the old white background. From the Select menu choose 'Refine Edge'. Use a Smooth value of 3 and a feather value of 1.0 pixel to smooth and soften the edge of the outline of the car. Slide the Contract/Expand slider to the left to hide any white edges from around the car. Select OK to apply the changes to the mask.

12. Now we're going to create a shadow. Select the adjustment layer below the mask layer and then click on the New Layer icon in the Layers palette. Select the 'Selection Brush tool' in the Tools palette and then paint a selection that extends just in front of the tires and underneath the car. Extend some way over the edge of the car as this will be needed later (blurring the shadow will reduce its opacity at the edges). From the Edit menu choose the Fill command, select 'Black' as the color and click OK.

13. Apply a Gaussian Blur filter to this layer and then refine the shadow by setting the blend mode to 'Multiply' and lowering the opacity to around 70%.

Note > A second shadow layer could be added to create some smaller shadows just underneath the wheels and further underneath the car. This refinement will help create the illusion that the car is in contact with the flag.

14. The image just needs a few finishing touches to complete the project. Add the leaping Jaguar and make a selection of the white background surrounding the Jaguar using the Magic Wand tool. Click on the layer below and then add an adjustment layer. Select OK without making any adjustments. Group the two layers (Layer > Group with Previous) and then use the Refine Edge command (Select > Refine Edge) to perfect the new addition.

15. As the Jaguar does not need to appear to be in contact with the flag we can simply add a drop shadow to this layer rather than create a shadow by hand. Go to the Effects palette and click on a Drop Shadow style. This can be modified or perfected by going to the Layers menu and choosing 'Style Settings'. The angle and distance of the shadow from the object can be controlled from this dialog box or the user can simply click inside the image window and drag the shadow to a different position to obtain the best effect.

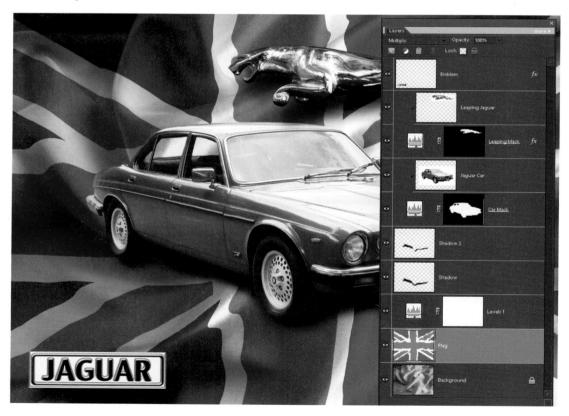

16. Complete the image by adding the image of the badge in the lower left-hand corner. Add a drop shadow to this layer and the project is complete.

Car photograph courtesy of www.iStockphoto.com

An American flag and Dodge Viper GTS classic car (2000 vintage) are also available on the DVD. The steps to creating a USA classic car and flag are pretty much the same as for the British car. A non-destructive dodge and burn layer was, however, grouped with the car layer to darken the tires and edge of windshield. Select the color of the car using the Eyedropper tool and paint in Darken mode at 20% in a new layer grouped with the car layer to darken the paint further.

Preserving Shadows

The flower for this project was photographed (using a digital compact) on a cold winter's morning in the temperate hills of Victoria, Australia whilst the sand (shot on Kodachrome film) hails from the Great Indian Desert in Rajasthan. Unlikely bedfellows, but with a little craft the two can lie together comfortably within the same frame - but only if the shadow (created by a not-so-subtle 75 watt globe and a couple of pieces of white paper) is captured with all of its subtlety and delicately transplanted to its new home in the desert.

The 'shadow catcher' technique - designed to preserve the natural shadows of a subject

Capture your subject against a plain white backdrop. For bigger subjects you just need a bigger backdrop. Professional studio photographers photographing full length models use a curved backdrop that extends from beneath the model's feet to the far wall in one continuous arc. If the white backdrop is to appear white then the backdrop has to be lit as well as the model. The surface should be smooth so the texture of the backdrop is not transplanted along with the shape of the shadow. In this project the white backdrop (a few sheets of printing paper) is separated from the subject using a mask and then placed in the 'Multiply' blend mode to make it invisible. The shadow which is not white blends with the new background.

Botanical Health Warning: The delicate petals of the flower can be cooked, frazzled or fried by the heat of a tungsten lamp in just a few minutes. Be prepared to work quickly or use soft window light as a low-temperature alternative.

1. Open the two project images. Place the flower above the sand and then duplicate the flower layer. Add a Levels adjustment layer between the two flower layers and 'Group' the top flower layer with this adjustment layer (Layer > Group with Previous). Create an accurate mask that hides the background of the top layer. Switching off the layer directly above the background may make this task easier.

Use any combination of the selection techniques outlined in the previous projects or for really tricky selections consider investing in a graphics tablet, such as those made by Wacom. This allows you to paint using a pen instead of your mouse with the Selection Brush tool.

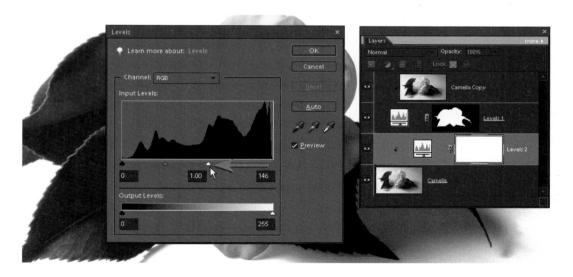

2. Group a Levels adjustment layer, this time above the bottom flower layer. Now move the Highlight slider to the left to clip (or render white) all of the levels that are not part of the shadow on the right side of the image. Ignore the left side of the image for the time being as it will render the shadows too bright on this side.

Holding down the Alt key as you move the White slider in the Levels dialog box will give you an accurate idea of when the backdrop becomes 255 white.

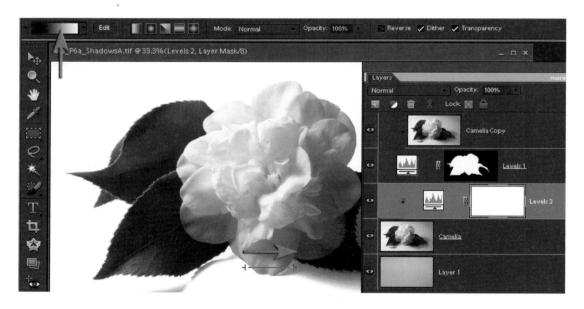

3. The Levels adjustment that has been applied will clip some of the delicate shadows on the left side of the image. To restore these delicate shadows you will need to mask this side of the image from this overly aggressive Levels adjustment. Click on the layer mask and use the Gradient tool with the 'Linear' and 'Black, White' or 'Foreground to Transparent' options (if black is the foreground color) to draw a short gradient in the center of the image from left to right.

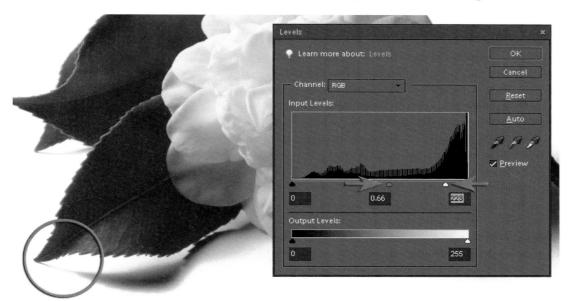

4. Create another Levels adjustment layer and group it with the previous adjustment layer and bottom flower layer. Concentrate on making the background on the left side of the image white while leaving the shadows intact (ignore the right side of the image). Be careful not to clip the really subtle shadows just beneath the tip of the leaf. When this has been achieved draw a gradient in the opposite direction to prevent the right side of the image being adjusted a second time.

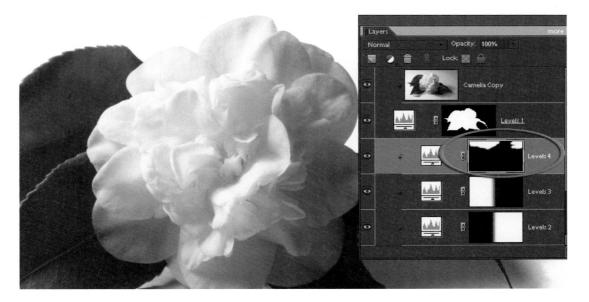

5. A third adjustment layer can be used if neccessary to render any remaining gray areas of the backdrop white. Fill the adjustment layer with black and then paint with white to clean the backdrop selectively.

6. Any details that cannot be clipped using the Levels adjustment layers can be removed by painting them white on the base layer of the clipping group. Although this is considered destructive editing it should be remembered that this layer has also been duplicated and these pixels could be retrieved if necessary from the top layer.

7. Switch the blend mode of all three adjustment layers to 'Luminosity' mode to remove any color that may have been introduced into the shadows and then switch the blend mode of the base layer of the clipping group to 'Multiply' mode. The white will now be rendered transparent whilst the shadows will be blended into the underlying background hue, color and brightness.

8. Use the Minimum/Maximum filters or a Levels adjustment on the layer mask if a white halo is visible around the subject. If a halo is present only in a localized area make a feathered selection around the offending area prior to moving the edge.

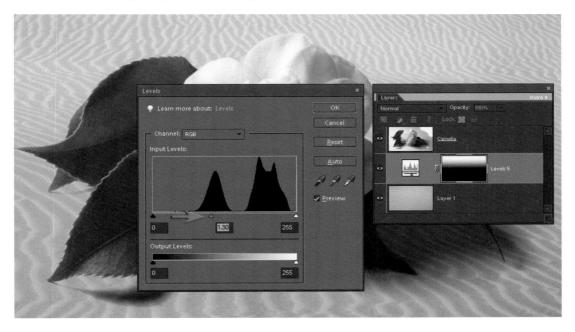

9. To complete this project add a Levels adjustment layer above the new background. Move the Gamma slider to the left to brighten the midtones in the background image. Add a Linear gradient (black, white) to the layer mask to shield the foreground from the adjustment. This step gives a little more sense of perspective to the finished result as color and tone fade into the distance.

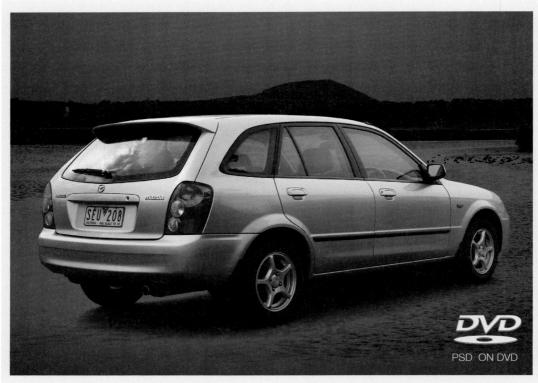

Original images and concept by Jakub Kazmierczak

This technique for preserving shadows does not have to be restricted to small objects sitting on paper. The technique is just as effective when isolating the shadow of a much larger object captured in its natural surroundings. If, however, the subject has been captured on a textured or rough surface this surface quality will be transferred to the new background when using this technique. A surface quality mismatch can occur that can make the shadow look unnatural.

To ensure a shadow with a rough surface texture does not look out of place against the smooth surface of a new background you can apply a small amount of Gaussian Blur to soften the quality of the shadow. In the illustration on this page a colored Linear gradient in Overlay mode has also been used to warm up the cool colors evident in the panels of the car. The detail in the car windows has also been softened using a Gaussian Blur. These measures ensure the car is perfectly at home in its new surroundings - even if it is balancing on water!

PERFORMANCE TIP

If it is not possible to preserve the original shadow, try to capture a second image from the direction of the light source. This second image will allow you to create a more accurate shadow than simply using the outline of the subject as seen from the camera angle instead of the direction of the light source.

This process would include the following steps:

- Make a mask of your subject and place it on a layer above a background.
- Import the second image captured from the direction of the light source and position it between the subject layer and the background layer.
- Make a selection of the subject in this second image (your shadow resource).
- Create a new empty layer that sits below the actual subject and above the background layer, and then fill this selection with black.
- Hide or delete the layer that the selection was made from.
- Place your new shadow layer in Multiply mode.
- Lower the opacity of your shadow layer and apply the Gaussian Blur filter.
- Use the Free Transform command to distort and move the shadow into position.

Project 7

Photomerge

Explore the greatly improved Photomerge feature in Photoshop Elements 6. Photomerge is now capable of aligning and blending images without any signs of banding in smooth areas of transition. The feature first made its appearance with Photoshop CS3 but the maths have got even better with the release of Photoshop Elements 6 and the stitching is so clever it will really have you amazed at the quality that can be achieved.

Spot the joins - upgrade from 10 to 30 megapixels with seamless stitching

The quality will be even better if you capture the component images with a 50% overlap, use manual exposure, focus and white balance setting (or processed the images identically in Camera Raw). The results are now truly seamless - an excellent way of widening your horizons or turning your humble compact camera into a 30 megapixel blockbuster.

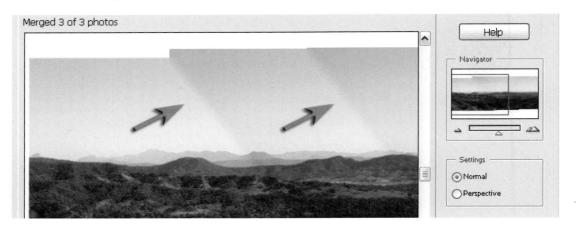

The Photomerge feature in previous versions of Photoshop Elements and the full version of Photoshop left a lot to be desired. All of the flaws and weakenesses of this feature are now gone with the release of Photoshop Elements 6.

Now the only limitation you may run up against is Photoshop's ability to align and blend strong geometric lines that come close to the camera lens. If the camera is hand-held to capture the component images (you have not used a specialized tripod head designed for professional panoramic stitching work) then the problem of aligning both foreground and distant subject matter is a big problem for any software (Photoshop handles it better than the rest). The camera should ideally be rotated around the nodal point of the lens to avoid something called parallax error. You will probably not encounter any problems with the new Photomerge feature unless you are working with strong lines in the immediate foreground. Notice how the curved lines in the image above are slightly crooked due to the fact that these images were shot with an 18 mm focal length and these lines are very close to the lens. Still pretty good - but not perfect.

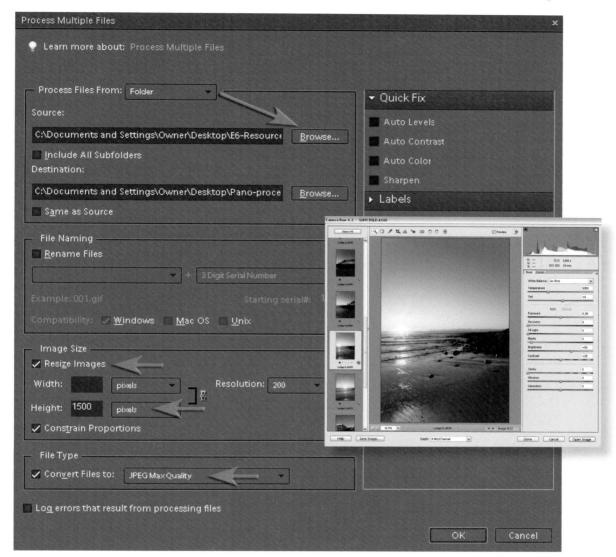

1. The images for this project are available as Camera Raw files but it is strongly recommended when using an older computer or a computer with less than 1 GB of RAM to downsample the images before attempting this project. To efficiently downsample multiple images go to 'File > Process Multiple Files'. Select the 'Source' folder of raw images (hit the Browse button) and then select a destination folder of where you would like your processed files to be saved. Check 'Resize Images' and select a height of 1500 pixels. Check 'Convert Files to:' and choose the JPEG Max Quality option. Select OK to process the images.

Note > If you wish to make a monster panorama (there are 12×10 megapixel images used in this project) select all of the Camera Raw files and open them in Adobe Camera Raw. Choose the Select All option in the top left-hand corner of the dialog box and select OK. The default settings in Adobe Camera Raw are OK for the images used in this project.

2. Select all of the images from the destination folder you created in the Process Multiple Files dialog box. Open the processed images in Photoshop Elements. From the File > New menu choose Photomerge Panorama.

Note > The observant amongst you will notice there are two images for every section of the panorama. There are twelve images in total using two different exposure settings. The camera first captured a set of images with an exposure that was perfect for the rising sun in this scene (the brighter side of the panaorama). A second set of six images was then created with an exposure that was optimized for the right side of the panorama (the dark side). Having the extra exposures helps in the creation of a higher quality result. Photomerge will choose the best exposure for each aspect of the scene and blend them all seamlessly.

3. In the Photomerge dialog box click on the Add Open Files button and select the 'Auto' radio button in the Layout options. Select OK and let Photoshop Elements do all of the work - and what a lot of work it has to do aligning and blending all of these images and even juggling which is the best exposure to use for any given location.

PERFORMANCE TIP

The 'Auto' layout setting gets it right pretty much most of the time. Occasionally you may need to select either the 'Perspective' or 'Cylindrical' options for very wide panoramas. The Interactive Layout can be selected when Photoshop Elements is having trouble deciding where one or two of the component images should be placed. This can occur when there is little detail in the image to align, e.g. a panorama of a beach scene where the only obvious line in the image is the horizon line. When this occurs you will need to drag the problem file into the best location in the Interactive Layout dialog box.

4. In previous articles I have written I would have been rattling on for another six steps of manual techniques to circumnavigate the shortcomings of Photomerge - but as you can see from the results in this project we just about have perfection handed to us on a plate. Fantabulous (I know that's not in the dictionary but neither is Photomerge - yet)! If you have used the full resolution images you probably had to go and make a cup of coffee while Photoshop Elements put this one together (all 120 megapixels) and will now be considering downsampling your file - but wait, we have one small glitch.

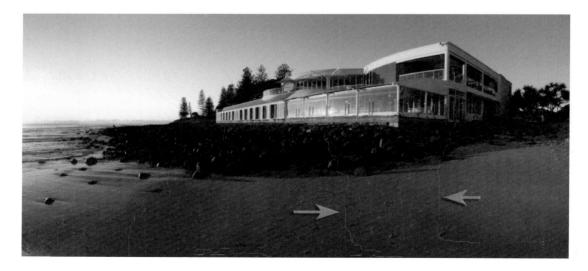

If you downsample before you flatten your file you will probably encounter hairline cracks appearing in your image after reducing the image size. The solution to this problem is to either flatten the file or stamp the visible content to a new layer (Ctrl + Shift + Alt and then type the letter E) before you reduce the size of the image.

5. This is not really a step, more of an observation (you can see I am struggling to find things for you to do so you feel you have earned your medal on this project); if you hold down the Alt key and click on each layer mask in turn you will notice that Elements has done a great job of working out the optimum exposure for each part of this panorama. Photomerge in Photoshop Elements does an even better job than Photomerge in Photoshop CS3 on this particular project.

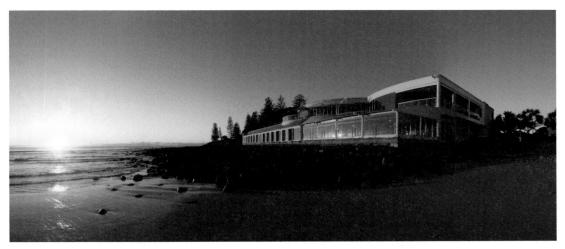

If you don't believe that the humble Photoshop Elements can do a better job than Photoshop CS3 - take a look at the the same files aligned and blended in the premium software package. It's chosen good exposures for the sunrise and the right side of the building but has chosen to include darker sections of the component images for the sky over the building and the building itself. When I completed this project in Photoshop CS3 I had to montage the two sets of panoramas manually to overcome this problem. In the 6 months between the release of Photoshop CS3 and Photoshop Elements 6 the new Photomerge engine has obviously been further refined.

6. If you crop away 'that which is surplus to requirements' before flattening the file, be sure to select the 'No Restriction' option in the Options bar and leave the width and height fields blank. This is a big image (especially if you used the full resolution files), so don't be surprised if things are a little slower in computer land right now.

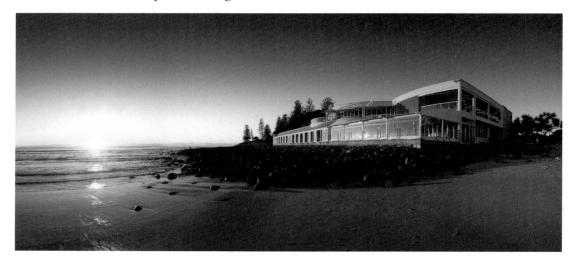

7. Sharpen the image and apply a linear gradient to darken the sky and the project is complete. It is important to note that the view of this particular building could not be captured any other way to achieve the same result. If I had moved back to encompass the entire view and then cropped down I would be left with less than 5 megapixels of data and the skyline above the building would be very busy as the buildings behind this beach house came into view. The dramatic sense of perspective would also be lost the further I moved away from the building.

PERFORMANCE TIP

Photomerge also has a 'Group Shot' option. This allows you to merge the best aspects of several images into the same image - especially useful when someone in a group has blinked or looked away. In this group shot (if you can call one boy and his dog a group) it has been decided to combine two images (captured hand-held) so both the boy and his dog are looking at the camera. In the Group Shot dialog box you just scribble over the part of the 'source' image you would like to merge with the 'final' image. Although Photomerge will align and blend the component images with the same skill as the Panorama option the user will be presented with an additional flattened file when Group Shot has finished weaving its magic.

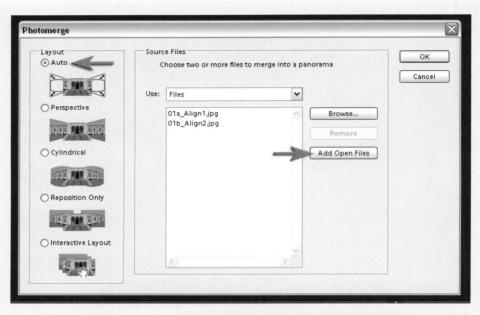

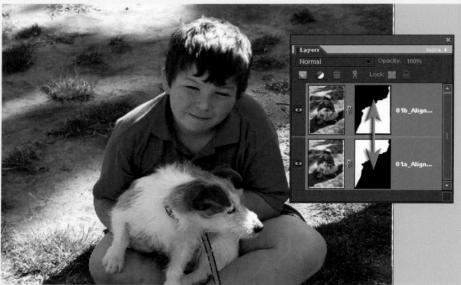

For those users who are still amazed at the results that can be achieved using Photomerge, but who mourn the loss of layers when using Group Shot, they can continue to use the Panorama option - even for group images. This is, however, only recommended for those photographers who use manual white balance rather than auto white balance in camera. When the Panorama option has finished aligning the images it will have no idea of the 'best bits' it should include in the final result. In the image above it has decided that neither the boy nor the dog need to be looking at the camera. Note how the layer masks, yes layer masks, are concealing the best bits of each image. Fear not, for we can modify these layer masks so we do get the bits that we want.

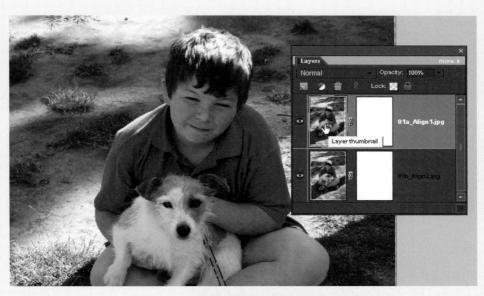

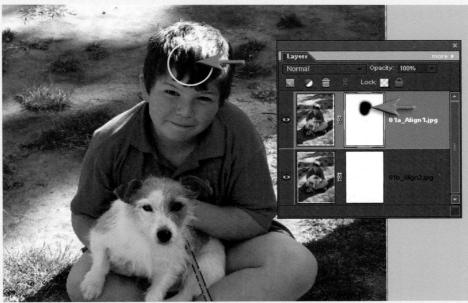

Clear both of the layer masks by clicking on each one in turn and then filling them with white. If white is the foreground color hold down the Alt key while pressing the Backspace key. Then choose the Brush tool and paint with black into the mask to shield any of the pixels you do not want to see on this layer. This may seem like a novel approach to montage as we are now enjoying layer masks without having to hijack one on an adjustment layer. You will need to crop the image to finish your project. If you can see the value of this technique then you will quickly realize that taking multiple shots the next time you are presented with a group (or even just one man and his best friend) ensures the decisive moment is history (sorry Henri).

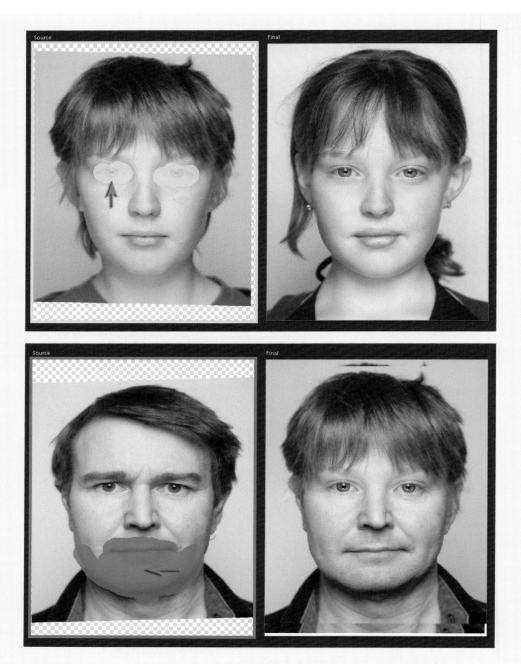

There is a third automated feature in the Photomerge bag of tricks called Photomerge Faces. The results are often delightfully random, even though you are supposed to define the bits you want merged. In the example above the boy's eyes have been merged seamlessly into the girl's face whilst in the lower of the two examples Photomerge has happily lifted the nose and lower portion of the ears in the source image in order to achieve a seamless stitch. Great fun (if slightly distrurbing) - absolutely no commercial value - but will keep the kids amused for hours!

Project 8

Photograph by Daniel Stainsby

Use the Mask Hair Against White action to fast-track this technique

Hair Transplant

One of the most challenging montage or masking jobs in the profession of post-production editing is the hair lift. When the model has long flowing hair and the subject needs to change location many post-production artists call in sick. Get it wrong and, just like a bad wig, it shows. Extract filters, Magic Erasers and Tragic Extractors don't even get us close. The first secret step must be completed before you even press the shutter on the camera. Your number one essential step for success is to first shoot your model against a white backdrop, sufficiently illuminated so that it is captured as white rather than gray. This important aspect of the initial image capture ensures that the resulting hair transplant is seamless and undetectable. The post-production is the easy bit - simply apply the correct sequence of editing steps and the magic is all yours. This is not brain surgery but follow these simple steps and you will join the elite ranks of Photoshop gurus around the world. Celebrity status is just a few clicks away.

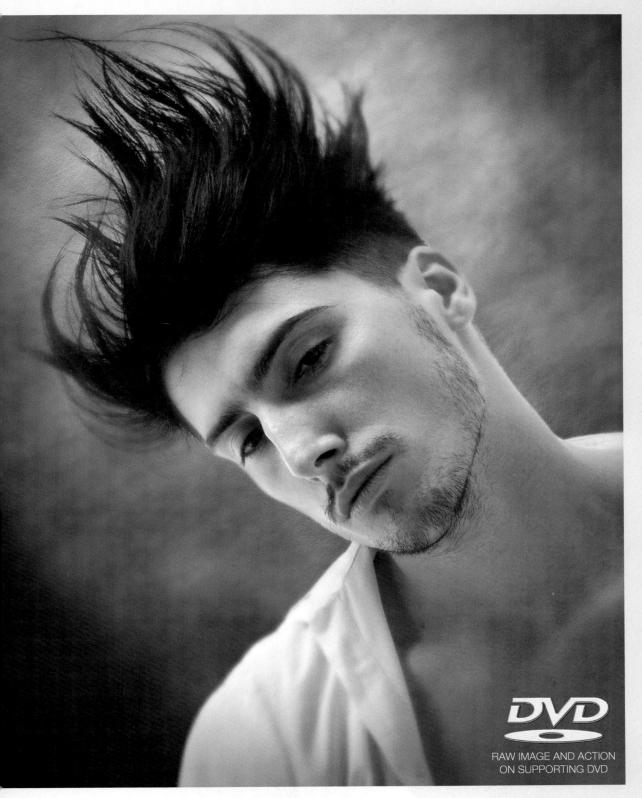

Hair extraction - not as painful as pulling teeth

Stage 1: Masking hair - tips for tremendous transplants

1. The initial steps of this tutorial are concerned with creating a mask that can be used in the final montage. Start by dragging the background layer to the New Layer icon to duplicate it. Choose 'Remove Color' from the Adjust Color submenu found in the Enhance menu (Enhance > Adjust Color > Remove Color). Drag this desaturated/monochrome layer to the New Layer icon in the Layers palette to duplicate it. Set the blend mode of this new layer (now on top of the layers stack) to 'Overlay' mode.

2. From the Layer menu choose 'Merge Down' to create a single high-contrast monochrome layer. Select 'Black' as the foreground color and the 'Brush tool' from the Tools palette. Choose a large hard-edged brush and 100% opacity from the Options bar and set the mode to 'Overlay' (also in the Options bar). Painting in Overlay mode will preserve the white background and darken the rest of the pixels. Accuracy whilst painting in Overlay mode is not a concern when the background is white or is significantly lighter than the subject. Avoid going anywhere near the tips of the hair at this stage.

3. Even the bright tones of the white shirt can be rendered black by repeatedly clicking the mouse whilst using a large brush in Overlay mode. Again it is important to avoid going anywhere near the hair.

4. Darken the body of the hair near the scalp but avoid the locks of hair that have white background showing through. Painting these individual strands of hair will thicken the hair and may lead to subsequent haloes appearing later in the montage process.

PERFORMANCE TIP

Switch the blend mode of the brush in the Options bar to 'Normal' mode when painting away from the edge of the subject. This will ensure a speedy conclusion to the mask-making process. The mask is now ready to use in the montage.

Note > If any of the background has been darkened in the process of creating a black and white mask switch the foreground color to 'White' and choose 'Overlay' in the Options bar. Paint to render any areas of gray background white. It is again important to avoid painting near the edges containing delicate hair detail.

5. With the Remove Color layer selected add a Levels adjustment layer. Without making any adjustment simply select OK. This Levels adjustment layer has a layer mask that we can use to house the mask that we have created in the previous step.

6. The next step relocates the mask you have just created into the layer mask of the adjustment layer. From the Select menu choose 'All' and from the Edit menu choose 'Copy Merged'. Hold down the Alt key and click on the layer mask thumbnail in the Layers palette. The image window will momentarily appear white as you view the empty contents of the layer mask. From the Edit menu choose 'Paste' to transfer the contents of the clipboard to this layer mask. Click on the layer below to select it and then click on the Visibility icon of this layer to switch it off. This mask layer serves no purpose now that it has been successfully transferred to the adjustment layer mask.

7. The new background is placed on its own layer above the figure and mask layers. Open the background image and drag the thumbnail of this new file into the image window of your project file from the layer thumbnail in the Layers palette. Group this new background layer with the adjustment layer beneath (Layer > Group with Previous). Alternatively you can hold down the Alt key and click on the dividing line between the two layers to group them.

8. Grouping the new background with the adjustment layer will mask the background in the region of the figure but the quality will not yet be acceptable. Setting the blend mode of the adjustment layer to 'Multiply' will bring back all of the fine detail in the hair. The background will not be darkened by applying the 'Multiply' blend mode as white is a neutral color. The subtle details in the fine strands of hair will, however, be preserved in all their glory.

9. The accuracy and quality of the edge of the mask will usually require some attention in order for the subject to achieve a seamless quality with the new background. Go to the Select menu and choose 'Refine Edge'. Choose the default values for the Smooth and Feather sliders (3 and 1.0) and then move the Contract/Expand slider to the right to hide any white edges from around the body and shirt.

10. In most instances the hair is already looking pretty fabulous but to modify and perfect the hair even further you will need to make a selection of just the hair with the Lasso tool. Choose 'Levels' once again and move the central Gamma slider to the left to increase the density of the hair and eliminate any white haloes that may be present. Moving the White slider to the left a little may help the process of achieving a perfect blend between subject and background. Select OK and choose 'Deselect' from the Select menu.

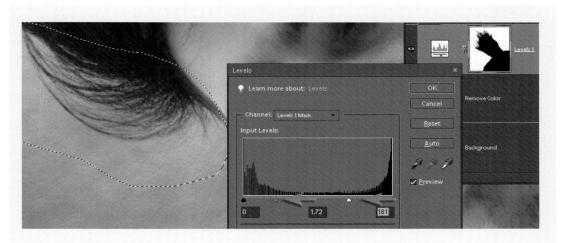

PERFORMANCE TIP

Make a selection of any portion of the edge that requires a localized adjustment with the Lasso tool with a small amount of feather entered in the Options bar. Use a Levels adjustment (Enhance > Adjust Lighting > Levels) to optimize this portion of the edge.

PERFORMANCE TIP

Any localized refinement of the mask can also be achieved manually by painting with a small soft-edged brush directly into the layer mask. Paint with white at a reduced opacity (10-20%) to remove any fine haloes present in localized areas. Several brush strokes will slowly erase the halo from the image.

11. The true test of an accurate mask for a subject that was photographed against a white background is when you place the subject against a very dark background. Grouping a Levels adjustment layer with the new background layer can darken the background image used in this project. Hold down the Alt key when you select a Levels adjustment layer from the Layers palette. Click on the Group with Previous box in the New Layer dialog box and then select OK to open the Levels dialog box. Move the Gamma slider to the right in order to preview your subject against a darker background in the image window.

Stage 2: Split tone styling and depth of field tweaking

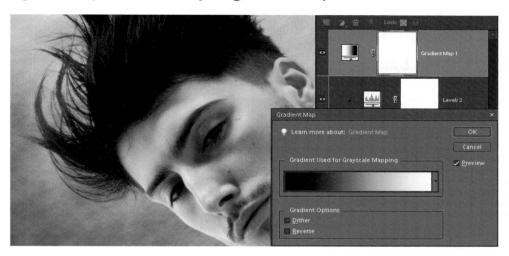

12. Now that the hair transplant is complete the styling can commence. Select the top layer in the Layers palette and then click on the Create Adjustment Layer icon and choose 'Gradient Map'. I have applied one of the split tone presets that is available on the supporting DVD. See the Toning project in Part 2 of this book. A split tone that has a cool shadow tone and warm highlight tone has been used to achieve the split tone effect for this project. The opacity of the Gradient Map layer is then lowered.

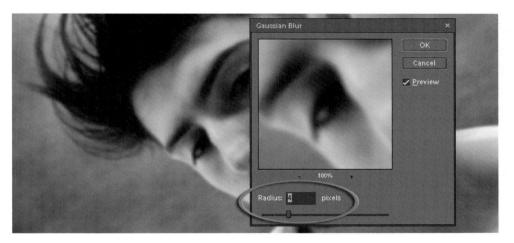

13. A shallow depth of field can be achieved by first merging the contents of all of the layers to a new layer. With the top layer in the Layers palette selected choose 'All' from the Select menu and then choose 'Copy Merged' from the Edit menu. Click on the New Layer icon in the Layers palette and then choose 'Paste' from the Edit menu. The keyboard shortcut for the last sequence of commands is to hold down the Ctrl, Shift and Alt keys whilst pressing the letter E on the keyboard (users of Elements 3.0 must type the letter N followed by the letter E). Apply a 4-pixel Gaussian Blur to this layer (Filter > Blur > Gaussian Blur).

14. Click on the layer beneath the merged layer (the one you have just blurred) and then create a Levels adjustment layer. Select OK without making any adjustment. Group the layer above with this adjustment layer and then click on the adjustment layer mask to select it. Select the 'Gradient tool' from the Tools palette and choose 'Reflected Gradient' and the 'Black, White' options from the Options bar. Click in the central part of the model's face and drag outwards to a position just beyond the ear. The sharp focus should now be restored to the central portion of the face only.

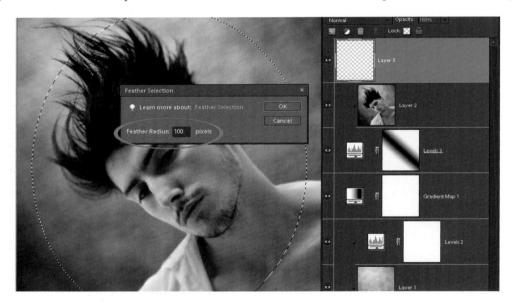

15. Create a vignette for this image. Hold down the Alt key and click on the Create a New Layer icon. In the New Layer dialog box set the mode to Multiply and choose the 'Fill with Multiplyneutral color (white)' option. A selection is then made using the Elliptical Marquee tool, feathered by 100 pixels (Select > Feather) and then in the Fill Layer dialog box, in the Contents section, choose 'Use Black' (Edit > Fill Selection). The vignette is then subdued by lowering the opacity of the layer.

Note > A small amount of noise must be added if you are creating a vignette in a very smooth-toned background in order to prevent any tonal banding (Filter > Noise > Add Noise).

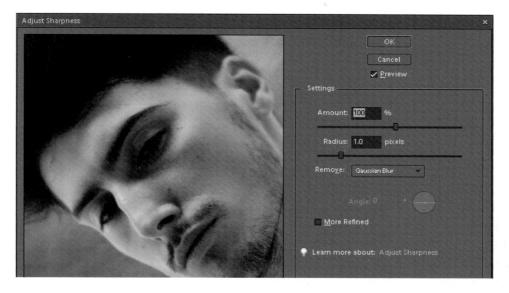

16. Create a merged copy of all of the layers (hold down the Ctrl + Shift + Alt keys and type the letter E as in step 13) and apply the Unsharp Mask (Enhance > Unsharp Mask) to complete the project.

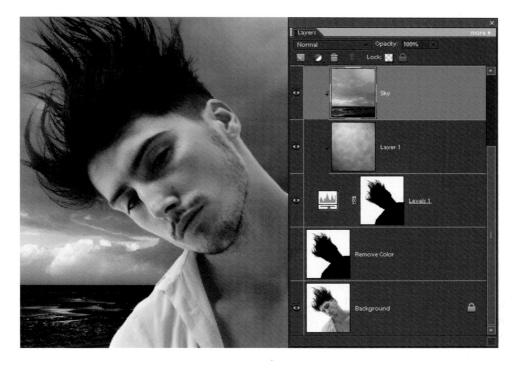

To change the scenery (background) simply trash the sharpened and blurred layers and cut and paste a new image into the layer that was clipped with your adjustment layer mask. One face, lots of hair - a million locations. Now you don't have to put a hat on to go traveling.

MAXIMUM PERFORMANCE

When masking hair that was shot against a black background, setting the Levels adjustment layer (the one holding the mask) to the Screen Blend mode is the secret to success. Note the difference between Normal mode and Screen Blend mode in the illustrations above.

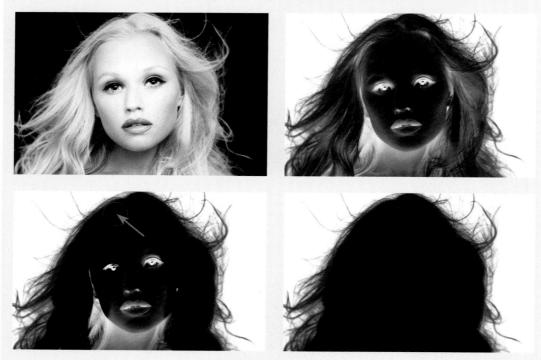

You will need to invert the layer mask when using a model shot against a black background (Filter > Adjustments > Invert). Paint in Overlay mode as in steps 2 to 4 of the Hair Transplant project. Apply a Levels adjustment to the layer mask and fine-tune the brightness of the hair against the background by moving the Gamma slider.

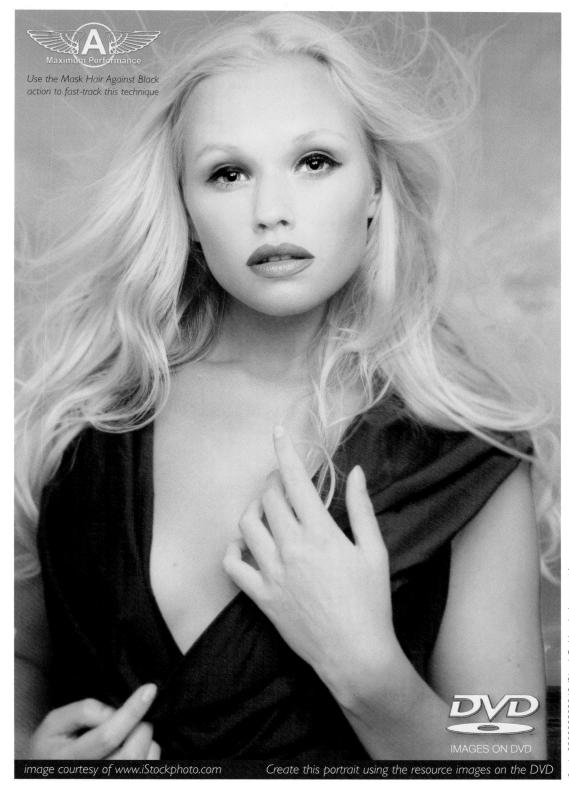

Stock_00000803940 (Blond Goddess by Iconogenic)

Jargon Buster

A

Adjustment layers: Non-destructive (always editable) image adjustment placed on a layer.

Adobe gamma: A calibration and profiling utility supplied with Photoshop.

Aliasing: The display of a digital image where a diagonal or curved line appears jagged due to the square pixels.

Anti-aliasing: The process of smoothing the appearance of lines in a digital image.

Artifacts: Pixels that are significantly incorrect in their brightness or color values.

B

Bit: Short for binary digit, the basic unit of the binary language.

Bit depth: Number of bits (memory) assigned to recording color or tonal information.

Blend mode: The formula used for defining the mixing of a layer with those beneath it.

Brightness: The value assigned to a pixel in the HSB model to define the relative lightness of a pixel.

Byte: Eight bits. Standard unit of data storage containing a value between 0 and 255.

0

CCD: Charge-coupled device. A solid-state sensor used in digital image capture.

Channel: A division of color or luminance data.

Clipboard: The temporary storage of something that has been cut or copied.

Clipping group: Two or more layers that have been linked. The base layer acts as a mask limiting the effect or visibility of those layers clipped to it.

Cloning tool: A tool used for replicating pixels.

Color fringing: Bands of color on the edges of lines within an image.

Color gamut: The range of colors provided by a hardware device, or a set of pigments.

Color management: A system to ensure uniformity of color between the subject, monitor display and final print.

Color Picker: Dialog box used for the selection of colors.

Compression: A method for reducing the file size of a digital image.

Constrain proportions: Retain the proportional dimensions of an image when changing the image size.

Continuous tone: An image containing the illusion of smooth gradations between highlights and shadows.

Contrast: The difference in brightness between the darkest and lightest areas of the image or subject.

Crash: The sudden operational failure of a computer.

Crop: Reduce image size to enhance composition or limit information.

Curves: A control in the full version of Adobe Photoshop only for adjusting tonality and color.

D

Default: A 'normal' or 'start' setting as chosen by the manufacturer or user.

Depth of field: The zone of sharpness variable by aperture, focal length or subject distance.

Download: To copy digital files (usually from the Internet).

Dpi: Dots per inch. A measurement of resolution.

E

Editable text: Text that has not been rendered into pixels.

Exposure: Combined effect of intensity and duration of light on a light-sensitive material or image sensor.

Exposure compensation: To increase or decrease the exposure from a meter-indicated exposure to obtain an appropriate exposure.

F

Feather: The action of softening the edge of a digital selection.

File format: The code used to store digital data, e.g. TIFF or JPEG.

File size: The memory required to store digital data in a file.

Format: The orientation or shape of the image or the erasure of a memory device.

Freeze: Software that fails to interact with new information.

G

Galleries: A managed collection of images displayed in a conveniently accessible form.

Gaussian Blur: A filter used for defocussing a digital image.

Gigabyte: A unit of measurement for digital files, 1024 megabytes.

Grayscale: An 8-bit image used to describe monochrome (black and white) images.

H

High Dynamic Range (HDR): A subject brightness range that exceeds the ability of the capture medium (film or sensor) to record both the highlight and shadow information simultaneously.

Highlight: Area of subject receiving highest exposure value.

Histogram: A graphical representation of a digital image indicating the pixels allocated to each level.

Hue: The name of a color, e.g. red or green.

T

Image size: The pixel dimensions, output dimensions and resolution used to define a digital image.

Interpolation: Increasing the pixel dimensions of an image by inserting new pixels between existing pixels within the image.

ISO: International Standards Organization. A numerical system for rating the speed or relative light sensitivity of a film or sensor.

1

JPEG (.jpg): Joint Photographic Experts Group. Popular but lossy (i.e. destructive) image compression file format.

K

Kilobyte: 1024 bytes.

L

Lasso tool: Selection tool used in digital editing.

Latitude: Ability of the film or device to record the brightness range of the subject.

Layer mask: A mask attached to an adjustment layer that is used to define the visibility of the adjustment. It can also be used to limit the visibility of pixels on the layer above if that layer is grouped or clipped with the adjustment layer.

Layers: A feature in digital editing software that allows a composite digital image where each element is on a separate layer or level.

Levels: Shades of lightness or brightness assigned to pixels.

LZW compression: Lossless compression that may be used in the TIFF format.

M

Magic Wand tool: Selection tool used in digital editing.

Marching ants: A moving broken line indicating a digital selection of pixels.

Marquee tool: Selection tool used in digital editing.

Megabyte: A unit of measurement for digital files, 1024 kilobytes.

Megapixels: More than a million pixels.

Memory card: A removable storage device about the size of a small card.

Minimum aperture: Smallest lens opening.

Mode (digital image): The tonal and color range of the captured or scanned image.

N

Noise: Electronic interference producing speckles in the image.

0

Opacity: The degree of non-transparency.

Opaque: Not transmitting light.

Optimize: The process of fine-tuning the file size and display quality of an image.

Out of gamut: Beyond the scope of colors that a particular device can create, reproduce or display.

P

Pixel: The smallest square picture element in a digital image.

Pixellated: An image where the pixels are visible to the human eye and curved or diagonal lines appear jagged or stepped.

Primary colors: The three colors of light (red, green and blue).

R

RAM: Random access memory. The computer's short-term or working memory.

Reflector: A surface used to reflect light in order to fill shadows.

Resample: To alter the total number of pixels describing a digital image.

Resolution: A measure of the degree of definition, also called 'sharpness'.

RGB: Red, green and blue. The three primary colors used to display images on a color monitor.

Rubber Stamp: Another name for the Clone Stamp tool used for replicating pixels.

S

Sample: To select a color value for analysis or use.

Saturation (color): Intensity or richness of color hue.

Save As: An option that allows the user to create a duplicate of a digital file with an alternative name or in a different location.

Scale: A ratio of size.

Scratch disk: Portion of hard disk allocated to software such as Elements to be used as a working space.

Screen redraws: Time taken to render information being depicted on the monitor as changes are being made through the application software.

Sharp: In focus. Not blurred.

Sliders: A sliding control to adjust settings such as color, tone, opacity, etc.

Stamp Visible: The action of copying the visible elements from a number of layers and pasting them on to a new layer.

System software: Computer operating program, e.g. Windows or Mac OS.

T

TIFF: Tagged Image File Format. Popular image file format for desktop publishing applications.

Tone: A tint of color or shade of gray.

Transparent: Allowing light to pass through.

U

Unsharp Mask: See USM.

USM: Unsharp Mask. A filter used to sharpen images.

W

Workflow: Series of repeatable steps required to achieve a particular result within a digital imaging environment.

Z

Zoom tool: A tool used for magnifying a digital image on the monitor.

Shortcuts

Action

Keyboard Shortcut

Navigate and view

Fit image on screen Ctrl + 0

View image at 100% (actual pixels) Alt + Ctrl + 0

Zoom tool (magnify)

Ctrl + Spacebar + click image or Ctrl + +

Zoom tool (reduce)

Alt+Spacebar + click image or Ctrl + -

Show/hide rulers Shift + Ctrl + R

Hide palettes Tab key

File commands

Open Ctrl + O
Close Ctrl + W

Save Ctrl + S

Save As Ctrl + Shift + S

Undo Ctrl + ZRedo Ctrl + Y

Selections

Add to selection Hold Shift key and select again

Subtract from selection Hold Alt key and select again

 Copy
 Ctrl + C

 Cut
 Ctrl + X

 Paste
 Ctrl + V

Paste into selection Ctrl + Shift + V

Free Transform Ctrl + T

Distort image in Free Transform Hold Ctrl key+move handle

Feather Alt + Ctrl + D

Select All Ctrl + ADeselect Ctrl + D

Reselect Shift + Ctrl + D

Inverse selection Shift + Ctrl + I

Pa	int	ing
1 0	.11 11	.11 19

0	
Set default foreground and background colors	D
Switch between foreground and background colors	X
Enlarge brush size (with Paint tool selected)]
Reduce brush size (with Paint tool selected)	[
Make brush softer	[+ Shift
Make brush harder] + Shift
Change opacity of brush in 10% increments (with Paint tool selected)	Press number keys 0–9
Fill with foreground color	Alt+Backspace
Fill with background color	Ctrl+Backspace

Image adjustments

ge orongere arrive	
Levels	Ctrl + L
Hue/Saturation	Ctrl + U
Group layer	Ctrl + G

Layers and masks

Add new layer	Shift + Ctrl + N
Load selection from layer mask	Ctrl + click thumbnail
Change opacity of active layer in 10% increments	Press number keys 0–9
Add layer mask - Hide All	Alt + click Add Layer Mask icon
Move layer down/up	Ctrl+[or]
Stamp Visible	Ctrl + Alt + Shift then type E
Disable/enable layer mask	Shift + click layer mask thumbnail
View layer mask only	Alt + click layer mask thumbnail
View layer mask and image	Alt + Shift + click layer mask thumbnail
Blend modes	Alt + Shift + (F, N, S, M, O, Y) Soft Light, Normal, Screen, Multiply, Overlay, Luminosity

Crop

Commit crop	Enter key
Cancel crop	Esc key
Constrain proportions of crop marquee	Hold Shift key
Turn off magnetic guides when cropping	Hold Alt + Shift keys + drag handle

Index

16-bit editing, 14	Brightness:
	channels, 190
Accuracy: printing, 83-4, 86, 88, 89	character portraits, 135
Adams, Ansel, 42	contrast, 52
Add Noise, 139-40, 290	definition, 294
Adjust Color, 123	slider, 25, 48, 180
Adjustment Layers:	tonality, 44
car makeovers, 168	Brush picker, 95
contrast, 46, 48–50	Brush tool, 20, 151, 164, 169
definition, 294	Burn tool, 122, 133, 244
hair transplant montage, 289	Bytes, 294, 296
Hue/Saturation, 64–7	
Levels, 18–19	Calibration of monitors xiv-xv, 80–1, 88, 89
low-key images, 182–3	Camera Raw, 22–39
montage dynamic range, 223	data processing, 24–7
target tones, 41	low-key images, 178–80
Adjust Sharpness, 182	montage dynamic range, 220–5
Adobe Camera Raw see Camera Raw	new features, 28-39
Adobe gamma, 294	Photomerge montage, 269
Adobe RGB, 81, 86	tonality, 43
Aliasing, 294	workflows, 28–39
Aligning images, 266–78	Cars, 160-75, 244-55
Amount slider, 38, 74	Cartridges: printing, 82
Anti-aliasing, 294	CCD(charge coupled device), 294
Artifacts, 294	Channels, 19, 115, 184–93, 294
Aspect ratio, 5	Character portraits, 130–43
Auto bracket exposure mode, 226	Charge coupled device (CCD), 294
Auto layout setting, 271	Circular Marquee tool, 170, 206
	Clarity slider, 32
Backdrops:	Clipboard, 294
hair transplant montage, 280, 288, 292	Clipping group, 294
montage displacement, 246–50	Clone Stamp tool, 98, 162, 167, 169, 205, 294
shadow preservation, 258	Color accuracy, 37, 83–4, 86, 88, 89
Background blurring, 167–70	Color adjustments, 239
Background sharpening, 73	Color balance, 146
Batch processing, 28	Color to black and white conversion, 112–19, 18
Bevels, 235	Color consistency, 76–89
Bits (binary digits), 294	Color Curves, 46, 48–50
Black backdrops, 292	Color fringing, 294
Black Point eyedropper, 44	Color gamut (range), 81, 88, 294
Blacks slider, 25	Color Management, 78, 87, 294
Black stops: gradient, 106	Color Midpoint, 53
Black and white conversion, 112–19, 181	Color Noise Reduction, 26, 221
Black/White Gradient Map, 53	Color Picker, 44, 127, 294
Blending images, 266–78, 294	Color Replacement Brush, 66
Blend modes:	Color Settings xv, 81, 86, 89
black and white conversion, 116–17	Color Variations: Levels, 13–14
character portraits, 135	Color Vision devices, 80
contrast, 55, 56, 58–60	Compression, 294, 296
hair transplant montage, 282, 284, 286	Constrain proportion, 294
montage displacement, 246–50	Continuous tone, 294
montage dynamic range, 227	Contract/Expand Slider, 95
red channels, 186–8	Contrast, 46-61, 140, 216, 218-31, 294
shadow preservation montage, 262	Convert to Black and White, 114-19
Blue channels, 185, 189	Copy Merged, 126, 170, 285, 289
Blurring, 17, 72, 160–75	Correct Camera Distortion, 7-9, 181
see also Gaussian Blur	Correct tools, 2–9
Bracketing exposure, 226–31	Cosmetic enhancement, 157-9

Crash, 294	Fill Light sliders, 30–1
Create Adjustment Layer, 223, 289	Filter menus, 108
Creating shadow, 265	Find Edges filter, 163
Creative montage, 196–207	Flags, 244-55
Crop, 2–9, 29, 274, 294, 299	Flatten, 247, 272
Curves, 46, 48–50, 60, 294	Flowers, 256–65
Custom Overlay Color, 211	Focus, 96
Custom printer profiles, 83–4, 86, 88, 89	Fonts, 232–43
Cylindrical options in Photomerge, 271	
a process of the second	Foreground/background balance, 225
Data processing in Camera Raw, 24–7	Foreground to Transparent, 138
Default, 295	Formats, 295
Defringe Width, 201	Free Transform:
Deleting content xix	car makeovers, 172
	creative montage, 198, 205, 206
Depth, 27, 221	crop and correct, 2
Depth of field, 92–101, 289, 295	montage displacement, 248
Depth masks, 204	montage dynamic range, 227
Detail slider, 26, 38	replacing skies, 212
Difference, 227	type effects, 234
Digital Negative (DNG) format, 27	Freeze, 150, 295
Displacement Filter, 246–50	
Displacement in montage, 244–55	Galleries, 295
Distortion, 107, 149, 181, 249	Gamma slider:
Dither, 126	car makeovers, 173
DNG (Digital Negative) format, 27	hair transplant montage, 287
Dodge tool, 132, 147	Levels, 12, 18
Download, 295	replacing skies, 216
Dpi (dots per inch), 295	shadow preservation montage, 263
Drop Shadow, 254	tonality, 45, 124
Dust marks, 225	Gaussian Blur:
DVD contents x-xi	car makeovers, 163, 165, 166
Dynamic range, 12-14, 218-31	channel masking, 191
	character portraits, 134
Edge Extension sliders, 8	creative montage, 204, 206
Effects palette, 242	definition, 295
Elliptical Marquee tool, 56, 99	depth of field, 92, 98
Enhance:	
black and white conversion, 112–19	glamor portraits, 152–3
channels, 184–93	hair transplant montage, 289
character portraits, 130–43	montage displacement, 247, 253
contrast, 46, 49	montage dynamic range, 228
	shadow preservation montage, 264
depth of field, 92–101	shafts of light, 108
glamor portraits, 144–59	sharpening, 72
Levels, 12, 19	tonality, 125
low-key images, 176–83	Gigabyte, 295
motion blur, 160–75	Glamor portraits, 144–59
shafts of light, 102-11	Glossary, 294–7
sharpening, 74	Gradient Editor, 106–7, 127–8, 138
toning, 120–8	Gradient Map:
Eraser tools, 73	contrast, 51-5, 59-60
Expodisc (reference image capturing), 35	creative montage, 203
Exposure, 25, 178-83, 226-31, 295	hair transplant montage, 289
Eyedropper tool, 40, 42	tonality, 126, 128
Eyes, 151–2	Gradients:
	black and white conversion, 118
Facial makeovers, 144-59	channel masking, 192
Facial manipulation, 278	tonality, 122–3
Feathering, 16–17, 139, 295	Gradient tool:
File command shortcuts, 298	car makeovers, 173
File formats, 295	character portraits, 138–9
File size, 295	creative montage, 204
Fill Layer, 164, 213	depth of field, 96

Index

hair transplant montage, 290	car makeovers, 165-6, 168
montage dynamic range, 224	channels, 190
montage type effects, 238	character portraits, 134, 138-9
replacing skies, 214	definition, 296
shadow preservation montage, 260	depth of field, 96, 97
and the state of t	glamor portraits, 152
shafts of light, 102, 106–7, 109	hair transplant montage, 285, 288
Graphics:	
car makeovers, 172–3	low-key images, 182–3
montage type effects, 232–43	montage displacement, 246–50, 251
Graphics tablets, 259	montage dynamic range, 227, 229–31
Gray Point eyedropper, 44–5	montage type effects, 235–9, 242
Grayscale, 125, 247, 295	motion blur, 168
Group with Previous, 236, 239, 258, 285	Photomerge, 275–7
Group Shot option, 275–7	red channels, 186–8
Grow, 4	replacing skies, 213–14
	shafts of light, 105–6
Hair transplants, 280–93	shortcuts, 299
Halos, 202	tonality, 124, 125, 126
HDR (High Dynamic Range), 295	Layer Styles, 242
Healing Brush, 133, 148, 162, 225, 244	Levels, 10–21
High Dynamic Range (HDR), 295	black and white conversion, 119
Highlights:	car makeovers, 165
character portraits, 137	channels, 190
contrast, 55–7, 60	creative montage, 200, 203, 206
definition, 295	definition, 296
Levels, 13, 18	glamor portraits, 146, 151, 153
low-key images, 178, 179	hair transplant montage, 284, 287–8
montage displacement, 249	montage displacement, 251
montage dynamic range, 218–31	montage dynamic range, 228
printing, 89	montage type effects, 237
shadow preservation montage, 259	replacing skies, 215
tonality, 40, 44, 124, 126	shadow preservation montage, 258–65
High Pass filter, 70, 140, 156	tonality, 122, 124
Histograms, 12, 18, 295	Light/lighting:
black and white conversion, 119	Levels, 12
character portraits, 137	replacing skies, 208–17
glamor portraits, 146	shafts of light, 102–11
tonality, 43	see also Soft Light
Horizontal Type Tool, 239	Linear gradient, 107
Hue/Saturation:	Liquid pixels, 245
adjustment, 62–7	Liquify filter, 149–50
black and white conversion, 116–17	Load Selection see Save/Load Selection
channels, 186, 187, 189	
The state of the s	Logos, 172–3
definition, 295	Low-key images, 176–83
glamor portraits, 150, 153, 158	Luminance Smoothing, 26, 221
tonality, 123	Luminosity:
I 200	black and white conversion, 115
Image adjustment shortcuts, 299	channel masking, 193
Inkjet printers, 82	character portraits, 141, 142
Inverse: Layers, 96	contrast, 53–4, 60
Invert, 108	low-key images, 181
ISO, 295	red channels, 188
	shadow preservation montage, 262
Jargon buster, 294–7	
JPEG formats, 296	Magic Eraser tool, 73
	Magic Extractor, 201
Keyboard shortcuts xvi, 136	Magic Wand Tool:
	character portraits, 139
Lasso tool, 15, 162, 169, 192, 287, 296	creative montage, 198–9
Layer masks, 18, 223, 296	definition, 296
Layers:	montage displacement, 250, 253
black and white conversion, 116, 117, 118	replacing skies, 210

shafts of light, 104	Opacity:
Magnetic Lasso tool, 162	channel masking, 192
Makeovers, 144-59, 160-75	character portraits, 138
Marching ants, 15, 18, 296	definition, 296
Marquee tools:	glamor portraits, 148, 151, 154
contrast, 56	montage dynamic range, 230
creative montage, 206	shafts of light, 104–8
definition, 296	Optimization:
depth of field, 99	Camera Raw, 22–39
montage displacement, 251	contrast, 46–61
motion blur, 170	crop and correct, 2–9
Masks/masking:	definition, 296
car makeovers, 165	hue and saturation, 62–7
channels, 189–93	Levels, 10–21
creative montage, 196–207	printing, 76–89
hair transplant montage, 280-93	saturation, 62–7
Levels, 16, 18	sharpening, 68–75
montage displacement, 245-55	tonality, 12–14, 25, 40–5, 46–61
option, 16, 104	Organizer xvii, 147
shortcuts, 299	Outer Glow, 240
Slider, 39	Out of gamut, 296
Materials: printing, 82, 89	Overlay mode, 229, 282, 292
Maximum Performance Actions xviii-xxi, 115, 117, 243, 292	
Memory xv, 296	Painting shortcuts, 299
Merge Down, 282	Pantone devices, 80
Merge Layers, 187, 189	Perspective, 2, 8-9, 271
Minimum/Maximum filters, 263	Photomerge, 266–78
Mode (digital images), 296	Photomerge Faces, 278
Monitors:	Photomerge Panorama, 270, 276
calibration xiv-xv, 80–1, 88, 89	Pixel mountains (histograms), 12, 18
workshop optimization, 79, 89	Pixels:
Monochromatic option, 140	definition, 296
Monochrome layers, 282	liquid pixels, 245
Montage:	Portraits, 130–43, 144–59
contrast, 218–31	Preserving shadows, 256–65
creative montage, 196–207	Presets: printing, 87
displacement, 244–55	Printers: Inkjet, 82
dynamic range, 218–31	Printing, 76–89
hair transplants, 280–93	low-key images, 183
Photomerge, 266–78	Printer Preferences, 85–6
preserving shadows, 256–65	Print Settings, 84–5
replacing skies, 208–17	Process Multiple Files, 269
shadow preservation, 256–65	Profile targets: printing, 83–4, 86, 88, 89
type effects, 232–43	Proofing: printing, 83–4, 86, 88, 89
Motion blur, 160–75	
Motion Blur filter, 167–75	Quick Mask mode, 16
Move Tool, 207, 212, 214	Quick Selection Tool, 94, 198–9
Multiply mode:	D It I DI CI
character portraits, 135	Radial Blur filters, 172, 175
depth of field, 96	Radial options, 138
hair transplant montage, 286, 290	Radius slider, 38
montage displacement, 248	RAM memory, 297
shadow preservation montage, 262	Rasterization, 240
shafts of light, 109	Raw format see Camera Raw
tonality, 125	Recovery sliders, 30–1
Navigation shortcuts 200	Red channels, 185, 186–8
Navigation shortcuts, 298	Reference image capturing, 35
Noise, 26, 139–40, 221, 290, 296	Refine Edge:
No Restriction option, 274 Normal mode, 292	creative montage, 200
Normal mode, 272	depth of field, 95
	hair transplant montage, 286
	montage displacement, 252, 253

Index

replacing skies, 210-11, 215	Silk-stocking technique, 125
Reflected Gradient, 290	Simple Glow, 240
Remove Color, 112, 123, 181, 282, 284	16-bit editing, 14
Replacing skies, 208–17	Skies:
	channel masking, 189-93
Resample, 297	contrast, 54–5
Resize: crop and correct, 2	montage, 208-17
Resolution fields, 5	red channels, 184–8
Resolution (sharpness), 297	replacement, 208–17
Reverse options, 138	shafts of light, 102–11
RGB channels, 115, 181, 184–93, 297	Skin makeovers, 144–59
RGB gamut, 81	Soft Light:
Rubber Stamps tool, 148	character portraits, 140
see also Clone Stamp tool	contrast, 60
Saturation, 62–7	glamor portraits, 154
channel masking, 193	montage dynamic range, 225, 229
channels, 186, 187, 189	replacing skies, 216
definition, 297	Spinning the wheels, 170–1
glamor portraits, 150, 153, 158	Spot Healing Brush, 133, 148, 162, 225, 244
montage displacement, 244	SRGB: printing, 81
replacing skies, 216	Stamp Visible:
Vibrance slider, 33	character portraits, 136, 137
Save/Load Selection, 17	contrast, 55–7, 60
car makeovers, 164, 167	definition, 297
replacing skies, 211, 213	glamor portraits, 152, 156
shafts of light, 105, 108	montage dynamic range, 231
tonality, 125	Photomerge, 272
Scratch disk, 297	Step wedges, 42
Scratches, 244	Stitching, 266–78
Screen Blend mode, 292	Straighten, 2, 3–6, 29
Screen Mode, 135, 292	Style Settings, 235
Screen redraws, 297	Stylize submenu, 163
Selection borders (marching ants), 15, 18	Swatches palette, 156
Selection Brush tool, 16-17, 104, 199	
Selection shortcuts, 298	Tagging images, 86
Shadows:	Target tones, 40–5
car makeovers, 168-70	Temperature sliders, 24
character portraits, 137	Text Tool, 207
contrast, 55–7, 60	Texture, 236, 240
creation, 265	Threshold filter, 71–2, 74, 141, 163
glamor portraits, 155	TIFF format, 297
Levels, 13	Tint sliders, 24
low-key images, 179	Tires, 170-1, 244
montage displacement, 252–4	Tonality, 120–8
montage dynamic range, 218–31	black and white conversion, 120
motion blur, 168–70	Camera Raw, 25
preservation, montage, 256–65	character portraits, 134, 137, 140-2
printing, 89	contrast, 46–61
tonality, 40, 43, 124, 126	glamor portraits, 152, 154-5, 156
Shadows slider, 25, 40, 43, 124, 126	Levels, 12–14
	low-key images, 180
Shafts of light, 102–11 Sharpening, 68–75, 297	shafts of light, 105-6
Camera Raw, 26, 38–9	target tones, 40–5
	Tone, 297
character portraits, 140–1	Trains, 196–204
depth of field, 99	Transform, 107, 172, 234
low-key images, 182	see also Free Transform
motion blur, 174	Transparency Layer, 230, 297
Photomerge, 274	Transparent Stripes' gradient, 106
see also Unsharp Mask	Type effects in montage, 232–43
Shortcuts, 298–9	71
Show Bounding, 212	Type Tool, 234, 239
Shrink Canvas, 4	

Unsharp Mask (USM), 68–75 character portraits, 140, 141 definition, 297 glamor portraits, 156 hair transplant montage, 291 Levels, 20–1 low-key images, 182

Vibrance sliders, 33, 221, 222
View shortcuts, 298
Vignetting:
Correct Camera Distortion filter, 9 depth of field, 99–100 hair transplant montage, 290 low-key images, 181 motion blur, 174 Visibility, 240, 241

Wheel spin, 170–1 White backdrops, 258, 280, 288 White Balance Tool, 24, 34–7, 180 White Gradient Map, 53 White Point eyedropper, 44 White Slider, 260 White stops, 106 Workflow, 297 Workshop optimization, 79, 89

Zoom tool, 297